LATINX ART ╱

LATINX
ART /

ARTISTS / MARKETS / POLITICS

ARLENE DÁVILA

DUKE UNIVERSITY PRESS *Durham and London* 2020

Designed by Matthew Tauch
Typeset in Whitman, Trade Gothic LT Std by Westchester
Publishing Services

Library of Congress Cataloging-in-Publication Data
Names: Dávila, Arlene M., [date] author.
Title: Latinx art : artists, markets, and politics /
 Arlene Dávila.
Description: Durham : Duke University Press, 2020. |
 Includes bibliographical references and index. Identifiers:
LCCN 2019053175 (print)
LCCN 2019053176 (ebook)
ISBN 9781478008569 (hardcover)
ISBN 9781478009450 (paperback)
ISBN 9781478008859 (ebook)
Subjects: LCSH: Art, Latin American—Political aspects. |

 Museum exhibits—Political aspects. | Hispanic
 American artists. | Anthropology—Political aspects. |
 Ethnology—Political aspects. | Cultural policy.
Classification: LCC N6538.L3 D38 2020 (print) |
 LCC N 6538. L 3 (ebook)
DDC 700.98—dc23
LC record available at https://lccn.loc.gov/2019053175
LC ebook record available at https://lccn.loc.
gov/2019053176

Cover art: Teresita Fernández, detail of *Island Universe*,
2018. Installation at the Ford Foundation, NYC. Charcoal,
108" × 360" × 3". Courtesy of the artist.

DUKE UNIVERSITY PRESS GRATEFULLY ACKNOWLEDGES
CAROLYN DINSHAW, DEAN FOR THE HUMANITIES AND
DAVID STASAVAGE, DEAN FOR THE SOCIAL SCIENCES AT
NEW YORK UNIVERSITY, WHO PROVIDED FUNDS TOWARD
THE PUBLICATION OF THIS BOOK.

CONTENTS

ACKNOWLEDGMENTS & READER INSTRUCTIONS

I started this book in the midst of increased calls for greater representation of Latinx art in US museums and art institutions and it has been rewarding to witness promising changes in the span of a few years. Some of the artists I interviewed have finally received more attention, including important museum shows and gallery representation while many gallery dealers and curators who stared at me blankly a mere year ago have shown a marked interest in learning about these artists. This growing recognition and appreciation of Latinx art and artists give me hope about what is possible and what comes next.

At the same time, my hopes are tempered by past experience. If I could reduce my decades-long studies on Latinx culture into one lesson, it is that visibility is merely the first step to recognition, which in turn, has very little to do with equity. Equity demands structural and lasting transformations in society, and in the context of the arts, in the makeup and functioning of all institutions that are part of the larger ecosystem of artistic evaluation—from art schools, to museums, to galleries, and more. And in these realms, changes are unfortunately very slow to come by. Consider that as I write, and despite a mayoral mandate for art institutions to embrace diversity or risk losing funding, the staff at the New York City arts and culture institutions remains three-quarters white, even when whites represent only one quarter of the city's population. [1] My hope then is that five, ten, or twenty years from now, readers will look back at this book to gauge signs of progress and gain inspiration to continue transforming what today stands as one of the most elitists spaces in society, and also one of the most recalcitrant to change.

This book draws from collective conversations and participant observation with colleagues, artists, curators, and Latinx studies stakeholders that took place from the summer of 2016 to the fall of 2019, and I would

like to acknowledge each and every one of them for their collaboration and trust in my analysis. They include friends and acquaintances I have known for years, and others I met for the first time through my research and writing, most of whom are identified by name with their permission, though I used pseudonyms for people who either preferred not to be identified, or I was unable to consult about the interviews and observations that I incorporated into my writing. In particular, I am grateful for the generous feedback and encouragement provided by Yasmin Ramirez, Teresita Fernández, Karen Davalos, Adriana Zavala, Olga Herrera, Elizabeth Ferrer, Naomi Guerrero, Elia Alba, Max Durón, Cecilia Jurado Chueca, Marina Reyes Franco, Marta Moreno Vega, Rita Gonzalez, Pilar Tomkins Rivas, and Rocío Aranda Alvarado. All of them are amazing artists and artivists pushing boundaries through their work, their writings, and their activism, and I am grateful they were able to provide contacts and resources, and always pushed me to enrich my analysis. I also want to thank Patricia E. Banks and Mary K. Coffey for making the project stronger by providing generous feedback on earlier drafts of the book, and Marcela Guerrero, María Elena Ortíz, Karen Davalos, Barbara Calderón, Néstor David Pastor, Nicole Mouriño, and Marty Correia for providing comments on chapters and sections of the book. Speaking invitations by Tatiana Reinoza, Adriana Zavala, Deb Willis, Patricia Zavella, and Darrel Wanzer-Serrano led to productive insights from students and general audiences, while the support and enthusiasm from Deb Willis and Edward Sullivan to the grant proposal that led to this book provided the necessary encouragement to turn a research proposal into a book. Special thanks to Teresita Fernández for producing the powerful work that graces the cover. I am also grateful to Pilar Tompkins Rivas, Javier Arellano Vences, and Joseph Daniel Valencia from the Vincent Price Art Museum for helping me to compile a list of West Coast artists to make appendix A more diverse.

I wrote most of the book while I simultaneously launched the Latinx Project at NYU and artists Shellyne Rodriguez and Barbara Calderón made up the most perfect team for our inaugural year. Our rich collaborative exchanges and the enthusiastic response from artists and audiences to our work provided continuous and inspiring jolts to my writing. In terms of research and production, Carolina Maestre and Kassandra Manriquez assisted on earlier stages of the work, and Eva Jensen with the art program and with securing permits and other publishing logistics. Javier Esteva, my loving and brilliant hus-

band who I started dating during the research and writing process, proved an invaluable supporter and I can't thank him enough for his patience and for his newfound and genuine interest in learning about Latinx artists. I also want to acknowledge photographer Luis Carle, best known for his images of New York City Latinx queer life, and also as the founder of the former Organization of Puerto Rican Artists, Inc., one of the many artists-led initiatives artists have historically launched to challenge their erasure. Despite battling illness, Luis Carle served a steady dose of inspiration during all facets of this work. Last, Carolyn Dinshaw, dean for the Humanities at New York University, and David Stasavage, dean for the Social Sciences at New York University, provided a publication subvention that made it possible to produce an image dossier in color to accompany the text.

The image dossier includes sixteen works by some of the artists interviewed or discussed in the book. Some of this work is referenced in the text, while others are included to help readers visualize the diversity of works produced by contemporary Latinx artists. Readers should note that both the image dossier and the list of artists included in appendix A represent a fraction of the artists who were interviewed or mentioned during my interviews, or whose work I saw exhibited during the length of my research. They are also more representative of artists in the New York City area where I wrote and researched the book. I also decided to focus on living and working artists rather than on legacy artists, though many of them are also listed throughout the text. The artists in the list also tend to be younger, reflecting the greater opportunities available for younger artists to be exhibited, part and parcel of the markets' growing interest in newer generations of artists right out of art school. In other words, neither the image dossier nor appendix A should be treated as a complete representation of the totality of Latinx artists working across the United States. Instead, I hope readers use them as working documents in which to fill in with more names of artists discovered on their own.

Likewise, appendix B provides additional resources where readers can continue learning about Latinx artists and where to find them. This list is also not comprehensive, but includes some of the museums and institutions with key archives and collections on Latinx artists, as well as research centers and Instagram accounts and other digital sources where readers can learn more about Latinx artists and their work. More locally, readers should reach out to Latinx-focused or culturally focused community organizations in their area, as well as libraries,

universities, and not-for-profit organizations and stay tuned about their programming as these types of institutions have historically been pioneers in showing more diverse artists.

I did not consult the artists in appendix A about whether they identify as a Latinx artist. The categorization of artists by museums, libraries, curators, scholars, and archivists is not a process of mutual consultation, but follows dominant designations used in society at large, as I discuss throughout this book. However, it is important to note that while most Latino/a/x people generally accept, recognize, or use these categories in their daily lives, the gender neutral use of Latinx is not as familiar or as widely accepted by everyone. Also, most artists prefer national, racial, or ethnic designations of identity, as is also true to the Latinx population at large. For the purposes of drafting this list, however, I refrained from adding ethnic, racial, national, and other types of identifications to individual artists, though it is my hope that readers are encouraged to continue exploring these artists' histories and backgrounds.

Together, the image dossier and appendixes are meant to stand on their own and provide the most important lesson of this book: That it is impossible and futile to narrow Latinx art to a single aesthetic. Nor should we try. Most of all we must never treat Latinx art as a simple reservoir of Latinx identity.

It was frustrating to realize how many people I talked to believed or assumed that, if looked at closely, Latinx art will always reveal itself on its own as Latinx art. These views reproduced the facile stereotypical assumption that there is a one-to-one relationship between the identity and the artistic expression of artists of color that is unfortunately very prevalent and that we must always fight hard to resist. These views are dangerous not only because they are false, simplistic, and reductionist but because they also serve as powerful veils for stereotypical assumptions and assessments. This is why I hope the art program provides a resource and a summary of this book's most important points for those who may not even read into its content. Latinx art is as diverse and complex as any other category of art or visual arts expression. Likewise, we should never make assumptions about Latinx art without looking at it closely or checking our own personal assumptions and expectations about this work. Latinx art is a social project and an intervention and we should always resist the impetus to narrow its scope, its meaning, and its look. What we should always do, though, is show these artists, appreciate them, and really see them.

Making Latinx Art

In May 2017, a painting by Jean-Michel Basquiat sold at auction for $110.5 million, a record high for any American artist in history. Because Basquiat is commonly identified as a Haitian American or African American artist, few people know that he was also Latinx. Haitian-Americans are also Latinx; Basquiat's mother was Puerto Rican, and he was immersed in Nuyorican art worlds and incorporated Spanish words in many of his works.[1] In fact, chances are that it is Diego Rivera, Frida Kahlo, Fernando Botero, or other Latin American artists who come to mind if one is asked to think about a Latinx artist, as I confirmed whenever I posed this question out loud to my students. This paradox raises several questions: What is Latinx art? How does it relate to American art? Why don't we know more about Latinx artists, and why should we care?

This book answers these questions by exploring the place and future of Latinx art and artists in the contemporary art world. Latinx refers to artists from Latin American background in the US, whether they are first generation or have a longer history here, who work primarily in the United States and identify with the US Latinx experience. These artists have been central to the artistic vitality of the United States though they remain largely eclipsed from its history. They are the largest majority missing from most museum collections and commercial gallery circuits, a self-perpetuating omission that affects the evaluation

of Latinx artists into the future.[2] In this book I explore this predicament by examining how contemporary art critics, museums, gallery owners, and others define, (mis)understand, and engage with Latinx artists in exhibitions, museums, and the market, and by considering what is at stake when Latinx art and artists remain so invisible from mainstream art worlds. Foremost, I ask how their invisibility affects our ability to achieve a more equitable and diverse contemporary art world, and a more just society.

I ask these questions at a moment of contention and reassessment in the arts when there is renewed attention to issues of inclusivity, equity, and representation across museums and art institutions. Calls for addressing the historical exclusion of artists, curators, and creators of color are highlighting the pressing need to diversify museums to meet changing demographics everywhere. Where Latinx artists are concerned, however, these issues are complicated by their heterogeneity across nationality, race, class, and more—leading many to question whether Latinx art is a meaningful category. This book suggests Latinx art is in fact a productive category especially for revealing how matters of class, race, and nationality are operationalized in contemporary art worlds.

The book draws from interviews with artists, curators, gallerists, and other stakeholders of the contemporary art circuit and is devoted to challenging the overwhelming focus on white North American and European artists while complicating many of the generalizations made about contemporary art markets.[3] I also draw from almost two decades of studying the politics of Latinx and Latin American culture, examining the rise of marketable and sanitized hemispheric representations of Latinidad. From "Hispanic" media to "Latin" music and "multicultural" advertising, my previous work shows how much creative industries capitalize on larger and more marketable constituencies spanning US, Latin American, and even Spanish-language speaking populations beyond. These slippery and marketable formulations of Latinidad consistently tell us that "Latin" culture is all the same, while US Latinxs remain invisible. My goal is to correct some of the slippery definitions generated in contemporary art and to call attention to the inequalities and hierarchies of value produced in the representation of US Latinxs, especially when Latinx and Latin American art are fused as one and the same. I show how the blurring of Latinx and Latin American groups and histories furthers racial and class inequalities, making the full evaluation of Latinx artists, and their richness and complexity, impossible to imagine.

"Latinx," "Latin American," and even "American" art are not fixed, homogenous, or universally accepted terms. These categories are specially contested in the art world, where any hyphenated art has long been regarded as less genuine, less creative, and of generally lower quality and value, than "unmarked" art. Art and aesthetics are ruled by their own set of blinders. Essential here is the idea that matters of identity and history are irrelevant even when they are intrinsically involved in the creation of value. Hence, we seldom recognize race in categories such as "American art" and "contemporary art" that index whiteness, while "Latinx art" or "Black art" cannot be read apart from signifiers of race. All the while, "contemporary art" and "American art" remain uncontested, made-up, and homogeneous categories that hide more than they reveal. The sale of Leonardo da Vinci's five-hundred-year-old painting *Salvator Mundi* at Christie's 2017 postwar and contemporary art sales, on account of its "contemporary significance," is a perfect example of the market-driven malleability of the category of "contemporary art." Still, the dominant art world regularly accepts these made-up determinations and categories. By contrast, "ethnic" categories such as Latinx art are always bemoaned, supposedly for "erasing complexity," especially when used to identify and gain recognition for artists of color. The racial politics of the art world become normalized through these unequal assessments and through the racialization of selected categories while "the mainstream" continues to signal "white" as the norm. This explains why many curators and artists of Latinx, African American, Caribbean, and Latin American art bemoan these categories as "necessary evils." Everyone recognizes that these categorizes ghettoize artists into sectors apart from the white-dominant center, yet at the same time they have opened up spaces that would have otherwise remained even more exclusive and inaccessible.

All of this points to the art world's "possessive investment in whiteness," or the incentive to maintain whiteness in the form of an imaginary postracial art world, because it provides resources, power, and opportunity to those who have historically most benefited from it (Lipsitz 1998).[4] This possessive investment in whiteness is at play in the white-only spaces that dominate the art world, especially those most involved in markets and profits. Whenever I enter New York City's galleries, auctions, and conversations around collecting, I see mostly white-only spaces, in contrast to the more diverse audiences that may converge in contemporary art events, particularly in the few instances when artists of color are shown. However, the possessive investment

in whiteness is also evident in the most intimate spaces, such as in the ways in which artists choose to identify or are identified by others. Racist and Eurocentric ideas of universality in the arts still impact these identifications, fostering a continuous tiptoeing around identifying or embracing any identity that is nonwhite. Hence the disinvestment in "Latinx" identities, because they are seen to compromise artists' quality and artistry; "universality" becomes a key indication of the whiteness of the art market, and any artists that cannot come across as "unmarked" (i.e., white) are immediately devalued.

Interestingly, these ideas persist alongside a seemingly coming of age of identity, seen especially in the growing popularity and "discovery" of some Black artists in contemporary art markets. This trend indexes the currency of identity in art markets, raising questions about its long-term effects and about what categories are more marketable and why. One noticeable pattern is a preference for the more appreciated category of "Latin American art" or "Caribbean art," never that of "Latinx art." In fact, Latinx artists often do better if they were born or have links and connections with their home countries, allowing them to be branded as a "Latin American" artist. The representation of Carmen Herrera is a good example of this preference for national identifiers. Even though she's lived in the United States for over fifty years, she's always labeled "Cuban-born," never "a Latina." The United States' dominant Black/white racial binary also contributes to the invisibility of Latinx artists. Accordingly, while some Afro-Latinx artists are rightfully finding opportunities in a rising number of galleries and collectors focusing on Black artists, most Latinx artists remain at the margins of contemporary art markets. A young curator expressed regret about this situation, predicting that "Black Latinxs will end up in Black galleries, white Latino/as in white or Latin American galleries, and Indigenous Latinx in Native American exhibitions" but that everyone else will fall under the radar. Her prediction that only "white Latinxs" would be absorbed in the "white or Latin American" art sector reveals why it is so important to center race and class in discussions of Latinx art in order to halt the whitewashing and erasure of Latinx artists.

This is the impetus behind the growing emphasis on Latinx art among many curators, art historians, and artists. The goal is to define a space for Latinx art, and about attaining respect and visibility and gaining a foothold in museums, institutions, and the market while fostering a position of antiracism in the arts. A common goal is seeking to

bring recognition to US-based Latinx art currently "lost" in the categorizations of Latin American and American art, from which these artists remain invisible.[5] Like Latinx identity itself, Latinx artists span differences along the lines of nationality, citizenship, race, language, and more. Some have been here for generations, while others are more recent immigrants, and most work in a variety of topics and genres that defy categorization under any recognizable rubric. What unites them is their shared minoritized position as Latinx artists in the United States, the key variable underlying their historical erasure notwithstanding their achievements, and in some cases, mainstream success.

In particular, the Latinx *artivist* moment is about rescuing all of the issues lost by subsuming Latinx art as an appendage to "Latin American art," the dominant rubric around which Latinx art has been understood since the so-called Latin art boom of the 1990s. This is why I define Latinx art as a project, not a fixed identity, a blueprint for the acknowledgment and identification of the work of artists who have been consistently bypassed by the American and Latin American art history. In other words, this is a project of "culture making" following anthropologist of art Fred Myers, who pushes us to examine the production of cultural categories, the work of interpreting these categories, and the forces at play involved in evaluating and institutionalizing art. I agree with his argument here: "The point is to imagine conditions of cultural heterogeneity, rather than those of consensus, as the common situation of cultural interpretation" (Myers 2002: 351).[6] When thinking of Latinx art, I suggest that the dominant categories for thinking about contemporary art must be problematized and expanded for the full richness of Latinx art and artists to be recognized, beyond the search for a readily recognized aesthetic, a distinct expression, or "a look."

Throughout, I use "Latinx," a term that is increasingly used in the arts, to index an openness to gender, sexual, and racial inclusivity. I also use "Latinx" to index that most contemporary "Latino" projects generated within culture industries, from TV to mainstream museums, are too co-opted and whitewashed to fully represent any sense of progressive Latinidad, and to mark a break toward more inclusive definitions. This does not mean that Latinx is not being co-opted, or likely to be in the future, as have many previous terms to designate a complex pan-ethnic and racial community in our neoliberal economy so hungry for marketable ethnicity.[7] The argument is that at least for now the category "Latinx" points to the urgent need to raise questions

and to call attention to the silencing of Latinx artists and communities. As Adriana Zavala put it so neatly: "To me, the X in LatinX is about addressing structured absence. But it also marks presence. It says I am here and I will be counted. The X also insists on queering structures of knowledge in order to make this presence visible."[8]

I consider myself part of this movement and call for greater Latinx visibility. I have known and worked with Latinx artists for decades, especially with Nuyorican artists, since I first came to New York City as a graduate student in the 1990s. First, my early work at the Museum of Contemporary Hispanic Art and El Museo del Barrio sensitized me to the racialization of anything Puerto Rican, Nuyorican, and Latinx in the art world. Then, when writing about the gentrification of New York City's El Barrio/East Harlem, I learned about the significant work of Nuyorican artists to mark identity onto space and to visualize social and political movements. Throughout these decades, I have seen artists struggle to make a living, and I have seen them gain very little transformation in the visibility and recognition of their work.

I was additionally inspired by the renewed activism among artists and scholars stating out loud, in numerous panels and events addressing this issue, "Latinx art is American art." In particular, the US Latinx Arts Futures Symposium (2016) held at the Ford Foundation organized by artist Teresita Fernández generated multiple conversations about the nationwide invisibility and devaluation that Latinx artists experience in museums, art schools, and all structures in the art world. Tired of being the only Latina in contemporary art spaces, Teresita gathered artists, curators, scholars, and other art world stakeholders to explore what accounts for the invisibility of Latinx art, and how we can change things. It was especially eye-opening to hear artists from Texas, Chicago, Los Angeles, and beyond share tales with uncanny commonalities to those I have been hearing for decades from artists in New York.

These conversations honed in on the importance of delving into the workings of race and the market by exploring the difficulty of naming, branding, and marketing Latinx art. This issue permeated most discussions and conversations at the symposium even though it was never addressed directly beyond my own short remarks on the marketing of Latinx culture. Because my work, reputation, and livelihood do not depend on the art world, or on the ecosystem of museums, art critics, and galleries that sustains it, I am freer to address issues that are known to everyone but that few can express so easily. In the art world, everyone seems to be in constant fear that their careers and reputation will

suffer if they rescind the dominant "artistic positioning" demanding polite silence around matters of race and the market. This positioning is very different from the more open critical stances I am used to as an academic, and I marveled how change could actually take place when discussions of racism in the art world are so repressed, even when recognized as the greatest challenge for visualizing Latinx artists.

By building and strengthening African American spaces, artists and stakeholders have brought national and international recognition to African American artists throughout the US, and to Black art on a global scale.[9] At the same time, African American and Latinx artists occupy different places in the contemporary art world that underlie the challenges of achieving a similar level of recognition for Latinx art. African American artists in the US have been historically marginalized, yet the dominant US Black/white racial binary nevertheless anchors African American artists as undeniably "American," recognition often denied to Latinxs. Instead, Latinxs have been historically racialized as unbelonging and forever foreigners, despite their historical presence in the United States prior to its establishment (as with Mexican Americans), or despite their citizenship status (as with Puerto Ricans). In this way, the quest for attaining visibility and recognition of Latinx art as central to the "American" art story in the United States presents a necessary challenge to narrow visions of US identity, at play not only in the arts but also in society at large.

I make a case for specifying Latinx art well aware of the transnational histories and relations between the US and Latin American art worlds, and the Latin American origins and histories of many Latinx artists. A considerable amount of work has been devoted to documenting such linkages, exposing the forces from US cultural policy to transnational corporations that have shaped the very idea of Latin American art, as well as the different types of hemispheric migrations and exchanges among artists, and the existence of transnational artistic movements.[10] The issue is that after decades of explorations of Latinx and Latin American connections in the arts, we are no closer to achieving equitable transnational exchanges than we were when these issues were initially debated at the height of the so-called Hispanic arts boom of the 1990s. Arguably, two decades of connecting Latin American and Latin art have done more to legitimize Latin American art as a category of art scholarship and the market than to bolster the legibility of Latinx art.

In this way, I wish to complicate how we summon "transnationalism" across the Latin American–Latinx spectrum by anchoring matters

of class and race, and an art market that continues to trade in the currency of nationalism. I want to challenge the unquestioned spread of "aesthetic cosmopolitanisms" that have become normalized with the globalization of art markets and that revolve around imaginary, representational, and consumption-driven imaginaries.[11] Instead, I focus on the actually existing social worlds of art fairs, gallery shows, museums, and exhibitions to inquire who participates in their creation, and who benefits and why. These questions are necessary to examine issues of equity and understand the social worlds and the different types of cultural consumption and forms of participation and sociability that are created or erased when we appeal to the global or transnational.[12]

For instance, the transnational Latinx–Latin American appeals and networks of Latinx artists are very different than those circulated in the international contact zones of art schools and art fairs.[13] The transnational moves of Latinx artists tend to be expansive or antiracist or to center on migrants' rights or on bringing about visibility to groups, such as Black Latin Americans and Salvadorans, who are consistently bypassed by dominant definitions of "Latin American art." One example is LA-based artist Beatriz Cortez, who is very committed to maintaining linkages with El Salvador as part of her Central American activism in Los Angeles.[14] For her though, the issue is about battling racism, which should rightfully be seen as a transnational battle. As she put it: "For me what is important is talking about a community that is Indigenous and Black, separating the idea of Central America as an exclusively Hispanic space." In other words, the transnational linkages of many Latin American immigrant artists are of a different reiteration of those espoused in Art History's scholarly circles or in contemporary art markets. This is one of the reasons we must foreground matters of race and class when locating Latinx artists and trouble the dominant Latin American–Latinx framework as the most appropriate rubric for understanding Latinx art. I argue that this dominant formula regularly marginalizes Latinx artists as I examine in the example of the "Pacific Standard Time LA/LA" project funded by the Getty Foundation, which showcased over eighty Latinx and Latin American art exhibitions held throughout Los Angeles in 2018. Instead, I suggest that Latinx art must be foregrounded in relation to US discourses of race, as well as to the transnational dominance of anti-Black and anti-Indigenous racism in both the US and Latin America.

Toward this goal, I highlight the need to challenge vague notions of "Latin" culture as being one and the same generated by the homog-

enization of Latinx and Latin Americans artists. This representation elides the different histories and particularities of what it is to live and work as an artist, as a racial minority working in the US, or as a national or unmarked artist in Latin America. In particular, Latinx artists are more likely to be unmoored and unrecognized in both the US and in their home countries, while Latin American artists, even those living in the US on a temporary or long-term basis, often have some level of recognition and linkages with their countries of background in Latin America. In other words, these artists differ in what throughout this book I call "national privilege," or the benefits based on different degrees of connection to Latin American cultures and art worlds. This book shows how national privilege is a key medium of differentiation used to rank the value of different Latin American artists, as well as to separate and devalue Latinx artists, and thus one of the elements we most need to expose and debunk in order to create more equitable art worlds. Moreover, while both Latin American art and Latinx art are compromised categories in the art world, this book shows why it is *Making* so important to recognize that they are so at very different registers. *Latinx Art*

Understanding the politics and currency of categories also requires accounting for the many identifiers—Nuyorican, Puerto Rican, Dominican, Chicanx, Colombian, and so forth—among other categories that inform individual Latinx identities and reveal important information about the history, location, and experiences of individuals and communities, as well as about the historical collectivity of Latinx. These multidiverse identities are especially important because the category of "Latinx" (like Latino/a/o and Hispanic) is not exempt from erasures and challenges, especially when promoted to sanitize histories and meet the preferences of the market. This is why we need to consider Latinx a "term of entry, not a term of closure," in the words of artist Ronny Quevedo;[15] in other words, it is a term to open up conversations on all the different Latinx stories, backgrounds, and identities that have seldom been given the necessary attention. For instance, when thinking about individual histories within larger categories, the Dominican artist Pepe Coronado's training with Chicanx and Latinx printmakers from Self-Help Graphics in Los Angeles is important to his work; likewise with the street art, hip-hop, and graffiti background of Dominican Puerto Rican interdisciplinary artist CarlosJesús-MartínezDomínguez. Both are regularly known as "New York–based Dominican artists," yet their histories, training, trajectories, and collaborations with other artists are different, and this information is

important to understanding their backgrounds and their work, and the multidiverse influences at play in the work of most Latinx artists.

Finally, as someone who has been studying Hispanic, Latino/a, and Latinx cultural politics for almost two decades, I offer this analysis hopeful that the Latinx artivist movement may represent a significant break and intervention away from many of the dominant "Latino" projects that have been advanced on their behalf, including what I have elsewhere termed "Latino spin," that promote assimilationist and conservative representations of Latinos as "model minorities" (Dávila 2008). I also write as a call for progressive Latinx specific spaces and projects that are expansive and open to simultaneity of identities and allow room for appreciating and exploring differences.[16] Most of all, I hope that by examining the making of hierarchies and distinctions in contemporary art markets we get a little bit closer to breaking their pull and to fostering more diverse art worlds.

The Unequal Terrain of Global Art Worlds

For decades, a network of institutional spaces and interests have forged "Latin American art" as a differentiated sphere of production, study, collection, and consumption. This recognition stems from the Good Neighbor Policy of the 1930s and the Pan-American visual art exchanges between the US and Latin America and was congealed in art markets from the 1970s onward, when major auction houses like Sotheby's (1979) and Christie's (1977) and Phillips (2009) began to hold regular Latin American art auctions.[17] Major exhibitions followed, making Latin American art a fashionable subject for collectors, institutional spaces, and stakeholders devoted to its study, promotion, and marketing across the United States and beyond.

The result is that, while still relegated to a dominant Anglo- and Eurocentric art history canon, Latin American art counts, with important institutionalizing spaces creating and sustaining "regimes of value" for the evaluation and valuation of Latin American art.[18] Research on Latin American markets attributes their origins to the nationalist imperatives of collectors, embassies, and governments fueling their own national markets (Dávila 1999; Martin 2009). But today the rising profitability is leading to new arrangements whereby Latin American elites are no longer invested in their own national art worlds; rather, they are sustaining the profitability of Latin American art to ensure

their greater alignment of national markets with this larger and more profitable category. The rise in regional Latin American art fairs, such as ArteBA (1991), ArtRio (2010), ArtBo (2005), and Art Lima (2013), modeled after international megafairs like Art Basel, point to a growing globalization of "Latin American" art worlds. So does the growing visibility of Latin American art in major international art fairs from Art Basel in Miami Beach to ARCOmadrid (Borea 2016: 315–337).

Having visited galleries and attended art fairs and interviewed stakeholders in Bogotá and Buenos Aires, I can attest that the entry of Latin American art into these global spaces represents not the "diversification" of the mainstream art world, but the expansive spread of Latin American elites all over the world.[19] As Giuliana Borea writes with regard to Lima, Peru, the globalization of Latin American art markets has neither transformed dominant epistemologies in the field of art, nor accepted Indigenous artists or racial minorities as equals, nor led to a more open and democratic art world. Most galleries I visited in growing arts districts in Latin America looked and felt like galleries in New York City's Lower East Side, and most of the white and middle-class artists I met insisted that their work was not different than contemporary artists anywhere else in the world. The world of Instagram provides access to global standardized visual vocabularies, and there is enormous convergence in the tastes of the global art elites of the world. Aware of this, the organizer of ArtBA even shared plans to bolster tourist offerings to differentiate and brand the larger city of Buenos Aires as a major draw during the art fair, realizing that art fairs on their own no longer provide enough differentiation to justify travel.

We see similar trends in other sectors of the global contemporary art market. For instance, the Chinese and Asian art renaissance has not translated to a wider recognition of Asian American artists in the US. Curators of Asian American art confirmed that the experience of Asian artists in the US is similar to that of Latinx artists. In particular, there is a greater number of galleries, institutions, and collectors interested in Chinese and Asian artists over Asian American artists, leaving some groups, such as Filipino Americans, entirely invisible. The rising category of "African art" provides another example of the types of inequities reinforced through globalization. In recent years, "African art" has become a key category of contemporary global art, yet at the 2018 edition of the 1-54 Contemporary African Art Fair in New York City there were only three African-owned and African-based galleries among the twenty-one international exhibitors present, representing

a field that is primarily dominated by white-owned European galleries. I met Dolly Kola Balogun, the twenty-four-year-old cofounder of Retro Africa Gallery in Abuja, Nigeria who was forthright about this problem and presented her gallery as "a cultural intervention to put a halt to a new form of colonialism." As she put it: "Before they would take our art by force, but now artists are exporting themselves abroad." With her gallery, she hoped African artists would no longer have to travel abroad to work with galleries with international contacts.

In other words, matters of political economy can be determinant when deciding who profits from global art markets, what artists are promoted, and on what grounds. In regard to Latin American art, we see the dominance of artists who emerge with the financial backing of national elites and institutions like cultural embassies, such as Mexican, Argentinean, or Brazilian artists, who are considered trendier and more profitable for speculation. By contrast, Latinx art has historically lacked institutional support, hence the growing consensus on the need to specify, define, and promote Latinx art as a space of scholarly, curatorial concern and as a market category. Latin American art curator Mari Carmen Ramírez put it simply when recalling the role Latin American elites have played in launching mainstream interest for Latin American art: "It was from the beginning tied to an elite, and it has been that process that has built the infrastructure . . . which Latinx art still does not have, and more appropriately put, never had" (Ramírez 2016).

Latinx artists' presence in American art predates the very foundation of the United States (Carmen Ramos 2014). However, the contemporary history grew out of the Nuyorican and Chicano art movements, as a space of resistance and assertion inspired by the Black Arts and the civil rights movement and their demands for recognition, equity, and redress (see Cahan 2018). Nuyorican and Chicano/a artists were involved in a cultural revolution to challenge and transform mainstream museums' historical Euro-centrism, which marginalized the artistic creation and input of people of color. In New York City, the creation of alternative spaces and institutions such as El Museo del Barrio, Taller Boricua, and the Alternative Museum was also part of the art- and culture-based social movement of the times. So was the development and validation of a different aesthetic. The result was art connected to communities and informed by larger social movements around equity, antiracism, and social justice. Market prerogatives were never the incentive; rather, what drove this movement was the desire

to expand a symbolic and visual repertoire that validated the history of Latinx as people of color in this country.[20] Since then, Latinx artists have been making contributions in graphic arts, muralism, conceptual arts, photography, destructivist art, social art practice, and so on, in ways that art historians are only beginning to examine.[21]

Despite this rich history, Latinxs' racial minoritarian status continues to obscure their value and creativity. "I think of the ghetto, I think of Washington Heights or the Bronx, or the lady who cleans your house," is how one of the first Latin American art dealers I spoke to put it, among the many statements that make it so clear that ingrained racism in the arts is the number one reason affecting the evaluation of Latinx art. This is why we must question assumptions that "there are no great Latinx artists" and look at the institutions and infrastructures that underpin this situation, akin to how Linda Nochlin wrote an essay asking "Why Have There Been No Great Women Artists?" in 1971 and Michelle Wallace made a similar inquiry for Black artists in 2004 (Nochlin 1995; Wallace 2004). This book shows that there are indeed a lot of amazing Latinx contemporary visual artists, even though racial logics deny their value, and "globality" blinding us from imagining Latinxs as agents, as artists, as collectors, and even as arts entrepreneurs.[22]

These issues take on added meaning in light of the larger xenophobic environment, where Latinx lives are under attack and there is a push to whitewash "American" history. They are also more prescient amid a political climate hostile to government funding for the arts and to matters of cultural equity, and amid a general retreat from investing in arts and culture. With the expedited financialization of art markets, art becomes a coveted commodity and a financial investment for the new elites throughout the world. In this context, art is increasingly sold, purchased, and treated as a financial asset, evident in the spread of new venues for purchasing art, and even of art storage facilities where people can store their acquisitions as investments.[23] Not surprisingly, as the art world becomes more of a terrain of financial speculation, most observers admit that it has also grown less diverse and more unequal. The result is a growing eliticization of art spaces and cultural institutions in New York City and other cities across the Americas, at the very same time that the US is becoming more racially and ethnically diverse than ever and that its arts institutions are in greatest need of transformation.

These trends hit Latinx artists especially hard. Their exclusion from art markets represents a significant erasure that impacts artists' lives,

their economic well-being, and the evaluation of generations of artists into the future. It stifles any impetus for collectors, institutions, and stakeholders to invest in our artists—relegating Latinx art collection to a matter of "love and rescue," as anthropologist Karen Mary Davalos (2007) has put it. She notes that for generations, Latinx activists, communities, and friends and family have been acquiring Chicanx and Latinx art to support our artists and rescue our visual tradition—without which there would be no visual arts archives and collections from which curators could now turn to fill in the void in their collections.

Whereas the Latin American art market has decades of legitimacy and a track record for evaluating artists, the general omission of Latinx art from the market results in a void of data about its value that makes it impossible to price. This represents a circular and self-perpetuating problem: lack of access to markets hinders the evaluation of their work, and hence their ability to enter the market in the future. The result is that even the most canonical artists, those who were foundational in the Chicano and Nuyorican art movement of the late 1960s and 1970s, are impossible to price. Most of this work has never been bought and sold, and this alone saps their value and hinders their evaluation. Even artists who have been collected by important national museums face this problem of evaluation. This is one reason that museums and nonprofit cultural institutions have played an important role in promoting Latinx art: these institutions have historically played a determinant role in legitimating the work of artists who are shut out of other means of evaluation. Then there is the added challenge that Latinx art is highly diverse: many of our artists produce work that is not market driven, or work with political content that is not seen as palatable to the dominant sensibilities for what makes a marketable political art. As someone asked, "Who'd like to live with work that is so politically driven in their home?" Or work that would make them uncomfortable?

This book tackles some of these myths, discomforts, and misunderstandings about the work of Latinx artists to suggest that debates over Latinx art in contemporary society are an index of the larger place of Latinxs in larger society, and of the contemporary art world's continued possessive investment in whiteness. My goal is to open up a space of debate where we can fully appreciate the challenges involved in theorizing Latinx creativity, as well as in exhibiting Latinx art and artists. I also hope to show that, notwithstanding the current disavowals of discussion of race, contemporary art worlds continue to create value

by reifying identities, sometimes highlighting them and other times, whenever profitable, muddling and obscuring them.

My argument is that matters of race and markets have historically impacted the evaluation of Latinx artists. Efforts to market Latinx art and artists by whitewashing or linking them to more established categories such as "American" art or Latin American art will continue to be of limited use unless we grapple with the continued racialization that makes Latinx creativity impossible to imagine.

Five Guidelines for Understanding Latinx Art

Before we start, let me address five misconceptions about Latinx art in a way that may help readers navigate the following pages.

Myth 1. Defining Latinx is too confusing and does not make sense.

Latinx artists are highly diverse. They span differences of class, race, ethnicity, region, history, citizenship status, and more—just like the Latinx population at large. Many artists of Latin American background have historically resisted identifying as Latinx artists, despite living in the United States for decades. Others embrace the category even as recent migrants. Thus, what makes a Latinx artist? Is it a matter of being born and raised and of having worked primarily in the US? Is it a matter of self-definition? I want to pose that the issue is never one of "authenticity," or neat boundaries between US-born and Latin America–born artists. Latinx artists include those who have been here for generations and those born in Latin America but raised in the United States, what sociologists term the "1.5 generation." Instead, I suggest that the definition of "Latinx artists" is more richly seen as a matter of politics, identification, and access. As curator E. Carmen Ramos states, "I use the term 'Latino art' not as a sign of cultural essence but as an indicator of descent, shared experience, and art historical marginalization" (C. E. Ramos 2014: 36). In sum, no person or artist from Latin American backgrounds in the US is born Latinx; they become Latinized by being racialized into, or socialized or acculturated into US racial frameworks and by developing articulating identifications with larger Latinx communities.

In particular, this book argues for the need to account for national privilege as a key element of differentiation and evaluation. With this term I call attention to the fact that while all artists of Latin American

descent in the US are minoritized in one way or another, Latinx diasporic ones are especially racialized, particularly those who are Black and Brown. These artists are characterized by an absence of ties to home countries and of elements rewarded in the creative industries of Latinidad (from media to advertising and museums)—where it is the currency of "authentic" Latinidad, such as fluency in Spanish language, Spanish-sounding names, or "Latin looks" favoring light-skinned and white features, that is most rewarded.[24] National privilege also allows many Latinx and Latin American artists living in the US to get respite from their US experiences of marginalization by traveling home and by being recognized in national rather than minoritized ways. These artists may experience dislocation, and questions about their belongingness, but their previous ties to home countries can nevertheless generate networks of institutional support. By contrast, Latinx artists who are born and raised in the US or are undocumented, or exiled from their home countries, or Black or Brown are seldom seen beyond their minoritarian status in the US or anywhere else in the Americas. In other words, Latinx diasporic identities are out of place everywhere, while those with national privilege can access cultural currency by more easily inserting themselves or by others into Latin American and global art and creative worlds. As a result, while it is not uncommon for people from Latin American backgrounds in the US to identify with countries of origins, the extent to which national identifications become a medium of hierarchy and differentiation vis-à-vis other Latinx groups, or against people of color more generally, is almost always a symptom of racism. Finally, national privilege differs across the region—it carries significantly more weight for artists hailing from countries with leading art and culture industries such as Mexico or Brazil, than countries lacking similar infrastructure. However, recognizing national privilege as a key element of hierarchization is essential for addressing the inequalities that exist and are being rapidly exacerbated through global art worlds.

Arguments can be advanced about the aesthetics, themes, and concerns that may distinguish Latinx artists working in the US from those of Latin American artists. Undoubtedly, these artists have different histories and distinct histories and engagements with Latin American or US lived experiences, though I leave arguments about the interplay of these different experiences and visual cultures to art historians. However, aware of what Darby English (2010) has termed "viewer complicity," or the tendency to limit the work of Black artists to ideas of racial

character or social identity, beyond what the works are or the artists intend, I caution against the quest to define Latinx art in terms of any identifiable aesthetic. Because as he warns, narrowing "the look" of any identity is one of the key ways that whiteness operates in the art world.

Instead, my main concern is to explore why we recognize and talk about Latinxs in a variety of settings—for instance, as a political constituency or as a market—yet find it difficult to conceptualize and acknowledge the existence of Latinx art and Latinx artists. I ask, what makes it impossible to think about Latinxs as equal participants in the arts/creative sector? Ultimately I argue that the lack of recognition of Latinx art and artists is a testament not to their quality or originality, but to processes of racialization that deny creativity and visibility to US Latinxs. These issues inform chapter 1.

Myth 2. There is no place for identity in the art world.

Matters of race and identity implicate the art world everywhere, which marks and erases identity whenever profitable. This book shows that the whitening of the category of "contemporary American art" and the exotification of Latin American art are essential processes to their current evaluation as collecting categories. I show that Latin American art became valuable because of the existence of networks of stakeholders invested in creating and fostering this space (in opposition to Latinx art). The art world has changed since the Latin American art institutional skeleton was forged, and it increasingly favors more "global" positions, but I will show that identities continue to have a lot of purchase in the contemporary art world. As such, naming and creating Latinx institutional spaces continues to be central to their ability to be seen, exhibited, archived, and valued. Chapters 2 and 3 make these points.

My work thus challenges most race-blind analyses of art markets, which fail to account for race and racism and for the purchase of identity categories as criteria for establishing value. For decades, scholarship on art has touted its "special" nature, especially when considerations of markets are concerned. We are told that art is ruled by "noneconomic logics," to the point that most contemporary research on art markets harks back to Bourdieu's description of the field of cultural production as "the economic world reversed" (1993: 29) to refer to art's irreducibility to economic logics. In sum, art is seen as the outmost transcendental thing because its value is never contained to economic logics, while the work of an "artist's artist" is still defined by its

putative negation of economic motivation or any other political or social influence. However, we must remember that evaluation processes are never arbitrary. Research on art and aesthetic markets shows that claiming "disinterested positions" in prices and the market is a key medium to establish art's irreducibility to economics (Velthuis 2007). Value is also created by what Isabelle Graw (2009) calls "the market of knowledge," or the range of symbolic and prestige-giving institutions and publications that help position artists as "priceless."

I suggest that claiming "disinterested" positions in race and identity is also a key value-making strategy in contemporary art markets. However, just as the reality of market logics is not denied by the adoption of "disinterested" positions in prices, so is the reality of racism not belied by refusals to name it. In fact, commercial success is predicated on the complicity to not talk about racism, which means few people dare to challenge it outright for fear of compromising their own artistic prestige and position. Unfortunately, this silence is exactly why contemporary art remains so whitewashed. For clarity, racism is neither a matter of intent or feeling, but effects. Its clearest diagnostic is inequality and, on this regard, it is evident that racism embeds the entire contemporary art world despite the dominant liberal anti-racist positions that dominate this space. This is why art critic Aruna D'Souza uses the apt metaphor of Whitewalling for the historic and cyclical processes of reinforcing whiteness at play in US museums despite open invocations to openness and "artistic freedom" (D'Souza 2018). This is also why scholars maintain that it is not enough to claim to not be racist. The only way to not be racist is to be an anti-racist, by actively struggling to understand, tease out and challenge policies and naturalized frameworks that lead to inequalities (Kendi 2019). In this book, I suggest that centering the experiences of artists and creatives of color within key institutions of the contemporary art world provides a great starting point for this analysis.

Myth 3. Identity is becoming hot in contemporary art markets, and it is just a matter of time until Latinxs get the same interest as many contemporary African American artists are currently receiving.

African American and Latinx artists are affected by racism in the arts, but in very specific ways. Although African American artists are marginalized, there is greater recognition that they belong and are part of American art history and should be represented equally in all of its institutions, whereas Latinx have been historically racialized as

foreigners, undocumented, and unbelonging. This is why Latinx curators continue to insist that "Latinx art is American art": because Latinx are constantly treated as newcomers who need to repeatedly prove that they are also "part of America" and hence should be represented in US museums and cultural institutions.

The category of Black art/artist is also highly diverse, encompassing artists who differ in nationality, class, and language; this diversity is akin to what one finds with Latinxs. For instance, "Black artists" also includes Caribbean and African artists, and Afro-Latinx and Black artists in the diaspora, not solely African Americans. Arguments can be made about the shifting relationship between African American and Black artists in relation to the rise of new global markets categories, such as African art and Caribbean art. Certainly, the currency of nationalism is also at play in the evaluation of these artists. But at this moment there is a more level relationship between African American and the larger category of Black artists than there is with Latinx and Latin American art. For instance, the sociologist of culture Patricia A. Banks (2018) has found evidence that, historically, African American artists were better positioned in the contemporary art market in the United States than African artists were.[25] Additionally, some important museums in Africa, such as Zeitz Museum of Contemporary Art Africa in Cape Town, South Africa—the largest contemporary art museum in Africa—collect and feature African American artists in their collection (Banks 2019b). This is in direct contrast to the current situation of Latinx artists in relation to Latin American art markets: US Latinx artists are rarely included in Latin American museums, with the exception of the internationally famous Ana Mendieta and Félix González-Torres.

This difference is undoubtedly related to the hegemony of anti-Black racism in the United States and globally. For instance, Patricia A. Banks shows that across Black upper middle classes everywhere, racial identification trumps nationality, strengthening their collecting practices toward the collection of Black art across ethnicity and nationality (Banks 2010). By contrast, among the upper middle-class communities of Latin American migrants, racism has led to the overvaluation of Latin American art compared to Latinx art. As one collector explained about his own and other collector practices, Latin American collectors in the United States have been primarily wealthy upper-class migrants seeking to re-create a sense of community by building collections that reminded them of their home countries. In other words, they had little

to no interest in the cultural empowerment or assertion of Latinx communities in the United States. In fact, to date, it is not Latin American galleries but emerging galleries representing Black artists that are making headway in representing Latinx artists. My hope is that this book centers matters of race and class in the Latinx art conversation and becomes an incentive for future collectors from all backgrounds to focus their eyes and wallets on the work of Latinx artists. These issues are woven throughout the book, but especially chapters 4 and 5.

Myth 4. It is up to Latinxs to build markets for Latinx art.

It was white US elites who built North American museums, and African American upper middle classes and Latin American elites who first patronized African American, Black, and Latin American artists. Why, then, should anyone be concerned with the invisibility of Latinx art, except US Latinx artists, curators, and scholars? The pages that follow argue that the invisibility of Latinx artists is everyone's concern. Latinx art and artists are central to the intersecting histories of Latin American, US, Native American, Asian, and African diaspora art. They include Afro-Latinx artists, Indigenous Latinx artists, and those who are not Indigenous but nonetheless draw inspiration from Indigenous cultures and traditions across the Americas. They also include Asian Latinx descendants from Asian migrations across the Americas, and many others whose work examines and straddles the borders of the US and Latin America and extend to Latinx diasporas all over the world. As a result, no Latin American, "American," or African American institution—in sum, no art institution, archive, or collection across the Americas and beyond—can be considered complete, nor can any of these spaces tell complete and capacious stories, if Latinx artists are not recognized as a key component of all of these histories.

Myth 5. Art can bring about change.

Decades of research into the representation of Latinxs across a variety of media have led me to one conclusion: on their own, representations can do little to challenge racism. It takes structural change to create a visual revolution that can fully change and destroy our racist illusions. It is in this spirit that I offer this analysis of racism in contemporary art worlds as a starting point to challenge dominant perceptions and treatment of Latinxs in the arts. This requires going against the nationalist, colonial, and racist hierarchies of value that are normalized by market logics. It also involves recognizing that value

is always a social creation, the product of institutional structures of evaluation that feed into the evaluation of some artists and categories of art over others. There's nothing innocent or natural about art markets, and we need to demystify them to challenge the pull and purchase they have on the entire ecosystem of museums, critics, collectors, and so on involved in the process of evaluation. This is why art alone is not going to save us. However, learning to see how race and racism structures the arts could help to bring about change. US Latinxs make up 18 percent of the US population, and it is estimated that by 2040 they will be the "majority minority" in the United States. But how many people of color were present at the most recent art fair, museum opening, or MFA class? Readers should remember these questions as we thread our way through the world of Latinx artists, markets, and politics.

What Is Latinx Art?

Lessons from Chicanx and Diasporican Artists

"I am glad that there is some discussion, but unless we center race and color in the Latinx conversation, we as a community are going in circles." So stated María Elena Ortíz from the Pérez Art Museum in Miami whenever we broached the topic of Latinx art. María Elena is not the typical contemporary art curator. She's a Black Puerto Rican woman straddling contemporary art circles at the Pérez Museum in Miami, where she works with wealthy Latin American collectors, many of whom are white or do not see themselves as being of color, as well as with growingly diverse Latinx communities in Miami whom she seeks to court and attract to the museum. Maneuvering race and class borders has been central to her trajectory, first as a Black woman growing up in Puerto Rico, where people tend to shy away from overt racial identifications and discussions of racism; and then as a graduate student of curatorial studies in San Francisco, where her Afro-Latina identity was not legible in a primarily Mexican American context of Northern California; and now, following a curating stint in Mexico City, as one of the few curators of color trying to show Latinx artists at the Pérez Art Museum and other contemporary art spaces.

These experiences have sensitized her to the roles that class, race, and nationality play in contemporary art worlds, and to the difficulties

Latinx art faces in getting a foothold in any major US art institutions. Her own career path is revealing of these power dynamics. "I would not be here if I had had not made the contacts or had important professional experiences in Mexico," she offered, reflecting on the importance of Mexico as a key exporter of Latin American curators to the United States. It was her position at the Sala de Arte Público Siqueiros in Mexico City, gained through contacts and networks acquired in the former Museum of Crafts and Folk Arts at the California College of Arts, that she met a curator from a mainstream US museum who eventually hired her in the United States, turning Mexico into the surest path for her to land a job in Miami. It turns out that the museum was seeking to expand its mission and audiences, and her name rose to the top, allowing her to land the type of position that is seldom open to arts professionals of color like her. Like other curators of color, Ortíz is extremely qualified, with an MA in curatorial studies, and she is also worldly, having traveled and worked abroad. We marveled about the lack of jobs available for Latinx and Latin American art professionals like her in the United States, which led her to find better luck in Mexico, and about the linkages between art professionals from mainstream institutions in the United States and Mexico that led to her hire, which are almost nonexistent with Latinx institutions in the United States.

She shared this story over a breakfast meeting in New York City, where she stressed the importance of centering matters of race and class whenever we seek to define and understand Latinx artists. She had come to this conclusion after five years of living and working in Miami, a city where Latin American art worlds index cosmopolitanism, wealth, and status, and where national identities are often deployed to index whiteness and avoid racial identifiers. In this context, Latinx art is the little brother that seldom gets recognition and attention. She echoed conclusions similar to many Latinx art stakeholders who were tired of seeing class, status, and value bestowed on Latin American art and artists, while US Latinx artists are racialized and devalued.

This chapter explores why it is so important to center matters of race, class, and nationality when we seek to understand Latinx art and artists. For one, many Latinx artists are people of color and more likely to identify as such, which is part and parcel of processes of "Latinization" in the United States, or of their socialization in regard to US categories of identifications. As such, Latinx sensibilities to race and to racism, and to the classism of mainstream art worlds, are often at

odds with the white-centric premises at play in many contemporary art circles, and with the nation-centric ideologies that dominate Latin American societies, which have historically disavowed race.

These issues are reinforced by the highly segregated and exclusive worlds of the market (art galleries, art fairs and auctions, and mainstream museums) dominated by white stakeholders, white Latinxs, and white-identified Latin American migrants from middle-class and upwardly mobile backgrounds. In this context, it is important to recognize that despite being consistently conflated with Latinx creatives, many Latin American art stakeholders have been historically complicit and directly involved in the racialization of US Latinx artists and are often the first to distinguish themselves from US Latinx art/culture art worlds.

I will focus on the case of Chicanx and Puerto Rican artists, especially Diasporican artists living stateside. Chicanxs and Puerto Ricans are two of the oldest US Latinx groups, and they have long faced marginalization by race and class from a variety of art stakeholders. The case of Puerto Rican artists, in particular, is especially revealing. As US citizens, Puerto Ricans move back and forth with ease in ways that rebuke the possibility of any stark distinctions between artists living on the island and Stateside. Yet despite being a highly mobile population, Puerto Rican artists still experience different levels of recognition and evaluation based on their identification with Latinx identities, such as Nuyorican and Diasporican, or with national ones (i.e., Puerto Rican from the island). The case of Puerto Rican artists hence provides powerful evidence of the racialization that most Latinx artists undergo when they and their work are located in the United States and seen through US racial lenses rather than through national ones. Indeed, while many Latinx artists have roots or connections with their home countries, at the root of the Latinx identity is the "neither here nor there" condition that places them at the margin of geographically bounded definitions of authenticity. This placement has repercussions in a contemporary art world that favors exoticism and values national over diasporic and racialized identifications.

In all, I suggest that what ultimately makes Latinx art a category that must be recognized are issues of politics and dynamics of race and racism that hinder the full appreciation of Latinx creativity. In other words, Latinx art and artists have nothing to do with content and everything to do with the racialized position they are forced to occupy; in addition, engaging with Latinx artists in their diversity and

on their own terms poses a challenge to the white-centric spaces that dominate the contemporary art world. In particular, most Latinx artists lack "national privilege," making them unintelligible within the national frameworks that dominate contemporary art worlds.

Chicanxs Challenging Borders

The 2017 "Pacific Standard Time: LA/LA" initiative (PST) supported by the Getty Foundation in Los Angeles was revolutionary for presenting a rare and massive display of over seventy Latin American and Latinx art exhibitions in one of the most Latinized cities in the world. But for many, it was also a display of the classist frameworks that impinge on the evaluation of Chicanx and Latinx art and artists in the United States. Even at the planning stages, the "problem" that Chicanx and Mexican American artists represented to the conceptualization of the exhibit were evident. The exhibition was initially conceived as a Latin America/Los Angeles project that bypassed LA's Latinx population, and it took pressure from artists and activists to ultimately expand the initiative's frameworks to also showcase their work.

When I saw the shows, the disparities were everywhere evident between the greater attention paid to the Latin American component of the exhibit relative to the latecomer status of the Chicanx Latinx component. Activists had complained that proposals from Chicanx and Latinx local organizations were bypassed and poorly funded, limiting the Chicanx content of the formal program (see A. Durón 2018). Many Chicanx shows, such as a low-rider exhibition curated by Denise Sandoval or an exhibition of Chicana artist Carmen Argote, were not even included in the main list of events and satellite programs. I was told they had not completed the necessary paperwork for inclusion, lessening even more the number of Chicanx art offerings that were publicly advertised. Additionally, because the Chicanx component was added later, there was less time for research and development of the exhibitions with Chicanx artists from the very conceptualization of the programs.

The devaluation of Chicanx and Latinx art relative to the supposedly more "sophisticated" Mexican and Latin American art was especially evident during Art Basel Miami 2017 at a panel featuring the PST initiative. My Latinx artists and colleagues described the panel as a perfect expose of class distinctions, and readers will soon learn why. The panel was moderated by the director of the Getty Research In-

stitute and included Los Angeles artist Judy Baca; Alexander Gabriel, the director of a premier gallery in Brazil; Julia Halperin, the executive editor of *Artnet News*; and Magali Arriola, a curator from Museo Jumex in Mexico City. There and in as many forms possible, Arriola insisted in drawing differences between Chicanx and Mexicans as if it was her job and responsibility to perform and demarcate these differences to the mainstream art world represented there by her copanelists and the Art Basel audiences. On and on, Arriola used the language of distance, insisting that "the Chicano phenomenon is not a Mexican phenomenon," while disavowing herself from any identification with Chicanxs by claiming that "migration plays out very different in different contexts" and that she had nothing to do with this culture because migrants come from rural areas not big cities (unlike modernites like her).

I appreciate that Mexican and Chicanx art have different histories and influences. However, as she dismissed the entire premise of a Latin American–Latinx arts initiative, Arriola seemed to intimate that Chicanxs are seen as Martians by people in Mexico City. In her view, the whole concept of the PST shows was produced for American audiences, not for Latin Americans, who have little interest in seeing Latinx and Latin American artists placed in any type of conversation. For her, the whole thing was a mere project of "identity politics"— words that she did not use that but were all over her dismissive remarks that Mexico had "already" done initiatives like this. Arriola brought up the 1990s "Mexican Splendors of Thirty Centuries" as an example of the type of projects that Mexico had long done and had since moved away from, to emphasize her "I'm so over this" attitude. In her view, Mexican artists are now conversing with the United States and Europe, not Latin America, where younger artists don't want to be branded as Latin American or Mexicans. If they identify as such, it is only as "an initiation" to break into the Latin American art market; sooner or later Mexican artists always move on.

I was surprised to hear Arriola's remarks in conversation with Chicana artist Judy Baca, who is a well-known critic of the legacy of classism that has long impacted the recognition and evaluation of Chicanx artists. Baca regretted the lack of understanding and dearth of productive exchanges between Latin American and Latinx artists and curators. She offered the example of how her work *Pancho Trinity* (1993) was dissed and misunderstood when it traveled as part of the *Art of the Other Mexico* (1993) exhibition at Museo de Arte Moderno in Mexico

City to make a point about the classist gaps that still dominate conversations around Chicanx and Mexican art. The "offending" piece, *Pancho Trinity* (1993), consists of three kitsch mixed-media sculptures of the stereotypical sleeping Pancho, painted over with scenes of the life and trials faced by migrants and Chicano communities. A metal wall protruding from the face lines the spine of Pancho II (La Tierra) to mark the divided landscape of the border inhabited by Mexicans, which, shown alongside Panchos I (Espiritu) and III (La Familia), provides a vivid statement of resilience, and also a critical commentary about value, stereotypes, and commercialism (see Lowe 1995; Sims and Mallet 2017). Yet when shown in Mexico, the premier art critic Raquel Tibol would not have it. I searched for Tibol's original review and learned that the critic had even questioned the suitability of these pieces for display at a museum. In her view, such "grotescas esculto-pinturas burdamente planfetarias" (grossly didactic grotesque sculpt-paintings) should never have been shown alongside paintings of great aesthetic value by "the very talented" John Valadez (Tibol 1993). The realist painter and muralist Valadez was the only artist the critic seemed to like from the entire Chicano group exhibit, perhaps because he worked in a more a traditionally recognized medium. In other words, Tibol was unable to read *Pancho Trinity*'s powerful commentary and the play on hierarchies of value represented by mixing kitsch, popular, and commercial references that are so central to the rascuache aesthetics of Chicanx art.[1]

The "offending pieces" were included in the PST show *The U.S.-Mexico Border: Place, Imagination and Possibility* at the Craft and Folk Art Museum, and I was immediately moved by their powerful relevance twenty-four years after they were produced. The same was true to most of the Chicanx art produced from the 1970s that was exhibited anew in the PST shows. All of it seemed as timely and politically urgent in the midst of "Trump America" and the threat of more walls as it was when initially produced. Altogether the work pointed to the continued salience and relevance of border and migration issues that have long preoccupied Chicanx artists and continues to be just as politically significant.

I heard Baca discuss the panel the next morning at a breakfast celebrating Teresita Fernandez's book launch for *Wayfinding*, which gathered many Latinx artists, curators, and friends. For Baca, experiences like this are unfortunately very familiar: "It hits at the heart of the classist sentiment, that we [Chicanx and migrant communities]

crawl across the border and we cannot bring our heads up again—that we're just 'disembodied Mexicans' without culture," she told artist Elia Alba and me as we gathered around her after the program. In her view, this is the same type of thinking that has historically devalued Chicanx art as lacking substance or value and that, for decades, has motivated her challenge to classist ideas about Chicanx art at play on both sides of the border. She wondered when we would finally realize that the border does not exist and that artists' work is to bridge borders, not reify them. Or, as she put it, "The fact is that the border does not exist; birds cross it, our art crosses it, and our art is about blurring this border."

In sum, the Art Basel panel put on display the type of Eurocentric views that have long affected the evaluation and recognition of most Chicanx artists, most of whom remain misunderstood and undocumented. Art historian Anna Indych-López is one of the scholars of Mexican and Latin American modernism who is looking to create bridges with Latinx art. Her monograph of the artist attributes Baca's dismissal to the overwhelming focus on the artist's social activism and her feminist-centric perspective on the Chicanx movement, over her role as an artist, her artistic work, aesthetics, and contributions to American art history (2018). At the presentation of Indych-López's monograph at the Brooklyn Museum, Baca confirmed this trend when recalling that she was often confused for a gang member or a gang worker when painting the *Great Wall of Los Angeles* mural; she was seldom seen as an artist. In a moving moment, she thanked Indych-López, author of the first art history monograph on her, for "looking at the work."

Indych-López's book does look at the work and places Baca within art history on her own terms. She shows how the artist helped recharge the format of muralism by challenging the masculine aesthetics of Mexican muralism and centering female images, and drawing from American pop art and the urban realities of Los Angeles. The artist is also shown departing from Mexican muralism's realism to reflect the surreal and dramatic elements of urban dispossession and urban modernization that were displacing Mexican communities in Los Angeles. In particular, her muralism work seeks to complicate the dominant view that artistic influence between Mexico and US artists has been one-sided, only from Mexico to the United States, by showing that Los Angeles new muralism has also had an influence on Mexican artists.

At the panel, it was evident that Arriola and Baca were operating from two very different registers. It was as if they were performing the

dissimilar histories of Mexican and Chicanx art and exemplifying exactly why Chicanx art cannot be understood solely through a Mexican lens, rather than within the US context.[2] It felt as if Arriola would have been more likely (and more enthusiastically willing) to speak about Mexican artistic collaborations with European artists than to discuss such mundane and "passé" issues as those of borders, identity, and Chicanx art.

Yet a question from the audience pressed the issue. It turns out that Josh Franco, Latino Collections Specialist at the Archives of American Art at the Smithsonian, and also one of the founders of the US Latinx Art Forum, was also at the Art Basel panel and was unconvinced by the curator's comments about Mexican artists being unconcerned about matters of identity. He wanted to learn whether this was in fact the case, or whether there were analogous movements in Mexico that resemble what he's seeing with Chicanxs in the United States. "What I've seen from thinking only about Chicanos and US Brown people is the total upswing in the taking up of the pigeonholing," he said. "A lot of the work of Beatriz Cortez and rafa esparza if you follow them on Instagram is 'I'm Brown, I'm Brown, I'm Chicano, I'm Chicano.' . . . I myself am a Chicano art historian and very happy to reside in that pigeonhole." Josh drew a contrast with the period when, during the exhibition *Phantom Sightings: Art after the Chicano Movement* at LACMA (Los Angeles County Museum of Art) less than decade ago, a lot of Chicanx artists did not want to participate or identify as Chicano, in contrast to the current embracing of this category today. He wondered, In the same way that it happened with Chicanxs, will things change? Will we see a more willing embrace of racial categories in Latin America too?

Arriola's inability to answer the question hinted at the segregated world she is likely to inhabit there, with little linkages to the vibrant social movements around race that are also at play in Mexico. In fact, it was not difficult to find other curators who knew about contemporary artists in Mexico who are drawing on indigeneity and on identity in their work, and developing different registers for their work, away from the white European aesthetic that Mexican curators are pushing internationally as "Mexican art." For instance, Marcela Guerrero, curator of the Whitney Museum's *Pacha, Llaqta, Wasichay: Indigenous Space, Modern Architecture* exhibition (2018), which explored how Latinx artists are drawing from Indigenous cultures and traditions, offered numerous contemporary artists doing similar work in Mexico, such as Pablo Vargas Lugo and Tatiana Parcero. Parcero is especially

interesting because she was educated in New York City and shows internationally, yet her self-portraits of her body stamped with Aztec codices and cosmological maps belie the facile view that Mexican artists reject Mexican culture and "identity" themes to project themselves internationally.

Cecilia Fajardo-Hill, a cocurator of the *Radical Women* show, had a lot to say about Latin American art stakeholders' reticence to fully embrace Latinx artists. Curating this show was a great learning experience for her, especially having to directly confront criticisms of Chicanx artists and communities. In her words, "It made me become cognizant of my own prejudices and my limited formation studying in Europe and in Latin America, where anything Latinx is either invisible or seen through stereotypes. . . . You're told this story and it's very difficult to not see through it." Working in Los Angeles and meeting Chicana artists has been transformative for her, she acknowledged: "All this racist and classist thinking is so much of the DNA we breathe, even when we supposedly adopt decolonial positions in the art world." One of her upcoming shows battles this thinking. *Chicanx Xperimental* will discuss race and class, focusing on the idea of the Brown body, through works by artists such as Laura Aguilar and Yolanda Lopez. That said, she confessed that it was difficult to get funding support for the exhibition or raise awareness about the value of Chicanx art. Funders have difficulty understanding how radical it was for Laura Aguilar to wrap herself in the American flag, or for Yolanda López to play with the iconography of the Virgin de Guadalupe, or to see low-riders as experimental art, she tells me. "The Warhol can, they get it. What's kitsch is accepted if a white man makes it, not a Chicano," she argued.

Many contemporary Chicano/a/x identified artists are following up on Baca's legacy more closely than the European pretenses espoused by the dominant Latin American art establishment. Consider the case of Carmen Argote, the single young Chicana artist with whom I spent an afternoon in Los Angeles when her work was included in the PST landmark show *Home: So Different/So Appealing* at LACMA. Carmen came to Los Angeles at age five and straightforwardly self-identifies as a Chicana, in her words "to recognize that I would not be where I am without struggle of other artists who have really fought to be able for me to have a voice in Los Angeles." This clarity and ease in her identification is itself a hard-won battle. Like most artists I spoke to, she was never formally taught Chicanx history at school. At UCLA she was introduced primarily to white male artists, and like most Latinx artists

I talked to, she was not taught about Latinx art or artists. Interestingly, Judy Baca teaches at UCLA, but in the Chicano Studies Department not in UCLA's MFA program. Instead, Carmen had to meet other artists of color on her own, just as she had to learn to learn how to see, appreciate, and revalue her city, her surroundings, and her experiences as important resources to be examined in her art.

What most impressed me about Carmen's work was the ease with which she also grappled with matters of class and economy in her work and her willingness to share how matters of class had played out in the PST exhibitions and programs. She was at the center of it all as one of the young Chicana artists whose work was exhibited in the PST flagship show *Home—So Different, So Appealing*, at the Los Angeles County Museum of Art (LACMA), a museum noted for its historical erasure and exclusion of Chicano artists. Yet she admitted not fully identifying or feeling represented by most of the shows. "It was the first time I felt the fresa thing," she says, drawing on the Mexican slang for stuck-up upper-class youth she had learn to distinguish while visiting middle-class family members in Mexico. She had not felt this fresa thing in Los Angeles, she tells me. "Here Latinos learn that it does not matter how much you have, you're going to be seen a certain way. The landscape won't spare you, so you have to leave your pretentions at home."

Carmen's work is informed by this sensitivity to issues of class and its idioms. Her installations are highly conceptual, minimal, and polished, yet the materials she uses and the topics she straddles offer contrasting perspectives. For instance, her work *720 Sq. Ft.: Household Mutations*, exhibited in *Home*, is made of the carpeting her migrant family lived on, with the spills and stains accumulated through decades of overuse because her family could not afford to replace it. The carpet stains make up a central part of the "painting" component of the installation piece. Argote's exhibition *Pyramids* at Panel LA (an artist-run space that months later succumbed to gentrification) also drew on matters of economic insecurity. We toured the space, where she had composed a large-scale installation out of a metal park fence beautifully adorned with pine needles. She tells me that she uses these mundane objects to comment critically on the hierarchies of cultural value that plague the art world, as well as her community. This piece in particular was inspired by the largely Central American and Mexican immigrant and working-class community she grew up with, and their inability to access parks and other spaces of leisure. "These are people

who live day to day without safety nets for whom leisure and free time to walk freely around a public park is a luxury out of reach," she tells me. She ends her exhibition description with the assertive statement of belonging and participation for everyone: "We deserve to participate in the creative economy."[3] I immediately thought back to Baca's words, "Our art is about blurring this border," and saw Carmen's "We" contained in her "Our." These two Chicana artists from different generations find themselves in spaces we associate with privilege in the art world—a solo show at a gallery and a panel at Art Basel. Yet both choose to use these platforms to contest the invisible borders of value, nationality, and class in the art world. It made me wonder whether abolishing these invisible hierarchies of value could also help break through the symbolic border separating Mexico and the United States and, eventually, the physical border too.

A final note is about how these dynamics translate to art markets. Chicanx artists are the only Latinx artists that are currently recognized as a collecting category, with selected collectors and dealers who have been focusing on Chicanx art for decades. But here too we can see how racism has affected the evaluation and market for Chicanx art. I talked to Chicano collector Cheech Marin, who for over forty years has been challenging stereotypes with his mantra "You cannot love or hate Chicano art unless you see it." Over the phone he tells me that before he started the *Chicano Visions* tour of his collection, some museums dismissed Chicano art as "agitprop folk art," not fine art. "We don't have the same head start, we are not abstract expressionism or pop art, and we do not have an informed public about who we are." Some museums resisted showing his private collections, but he reminded them, "I have this collection because you don't." *Chicano Visions* went on to tour major art museums in twelve cities, and at each site it attracted record levels of attendance. When we spoke, he described his current efforts to continue the momentum of building collectors, creating audiences, and changing perceptions by leading efforts to build a national Chicano art center in Riverside, California. This groundbreaking center is slated to open in 2020. "Chicano art is American art. We need to be in these museums," he said, stressing the centrality of nurturing new collectors to change the conversation on Chicano art.

Art stakeholders hope Cheech Marin's museum of Chicano art will bring visibility, value, and more collectors to Chicanx art. However, everyone feared that unless Chicanx art is recognized, collected,

and sold by "the right collectors," whether New York City collectors or white collectors, it will remain undervalued. Robert Berman, from Robert Berman gallery—a "JewCano," in his own words—has been selling Chicano art since the 1980s from his contemporary art gallery in Santa Monica, California. He has sold work by Carlos Almaraz, John Valadez, and Gronk, all of whom are recognized masters of the Chicano Art Movement; though he regrets they are always sold for under their worth. He offered the example of Gronk's canonical painting *La Tormenta* (1985) advertised during the PST shows to capitalize on the massive initiative. Although it had been shown in several museum traveling shows, the work sold for $65,000—a high price relative to other works by Chicanx masters, but extremely undervalued by contemporary art market standards. Berman insisted that a work with a similar lineage by a white artist would be worth more than $250,000. "We are still dealing with a provincial market of mainly upper middle-class Jewish collectors who see you can get really great work for low prices, and institutions and collections run by people of Hispanic origin."

So far we have yet to see New York City's collectors turning to Chicanx art. But perhaps they will soon, via the category of Latinx art, as I discuss in chapter 5. Another interesting trend is the posthumous visibility of Laura Aguilar, a poor, queer Chicana woman who was entirely unrecognized as a "Chicano master." Aguilar's first major show, the retrospective *Show and Tell* curated by Sybil Venegas at the Vincent Price Museum for PST, took place a year before her death at fifty-nine years old, and the show has had an enormous impact on her visibility. As I write, the Whitney Museum and the Getty Museum in Los Angeles have both announced the posthumous acquisition of photographs by the artist and I wonder what she would say about of this late recognition of her work. I will never forget seeing her work and meeting her briefly at the Vincent Price Museum, months before she passed. While ill, she attended a program related to the exhibition, and her quiet, humble, and wise demeanor presented a perfect complement to the silent strength and beauty of her photographs. In particular, Aguilar's self-portrait *Will Work for #4* (1993) was extremely prescient. The portrait shows Aguilar holding a cardboard sign that reads "ARTIST WILL WORK FOR AXCESS" as if she was panhandling for money. She poses in front of a concrete wall with the word "Gallery" while staring straight to the camera with a tired, exasperated look. I thought, *Wow, this is the same thing we're still struggling for.*

Placing Nuyorican and Diasporican Artists on the Map

I met interdisciplinary artist David Antonio Cruz after his painting *La Pieta* was featured in the cover of an issue of *Puerto Rican Queer Sexualities* published by the Center for Puerto Rican Studies in 2007. The painting, a moving self-picture of his mom holding his head lovingly in her lap, stands as a powerful statement about love and tolerance and a challenge to stereotypical portrayals of intolerant sexuality among Latinx communities through a loving display of acceptance and protection within the intimate context of the family. Born in northern Philadelphia to Puerto Rican working-class parents, David Antonio had a lot to say about how his work was shaped by intersecting permutations of racism. These range from his experiences as one of the first cohorts of students of color at Yale's MFA program, to tales from the first exhibition of his work in Puerto Rico. At Yale, Cruz experienced how difficult if not impossible it is to explore matters of race, identity, and sexuality in simultaneity and in complexity. "You are put in a box. I was the 'gay Puerto Rican' and that was the only way my work could be addressed." His presence alone was questioned—people assumed he was a staff member, rather than a student, at Yale's prestigious MFA program.

But a bigger turning point came from confronting how his work was received when it first traveled to Puerto as part of El Museo del Barrio's *S Files* show in 2005, a rare occurrence for an institution that has generated a lot of exchanges from the island and Latin America to New York City, but not the other way around. The work shown was David's earlier work, *Jibaro Series* (2000–2005), a proud assertion of his sexuality, his body, and his urban/PR and Latino identity through a painting that also paid homage to Puerto Rico. The pastel-tinted paintings featured aspects of the island's jibaro (peasant culture) architecture, such as pava straw, that provide a background reference for the entire series. Then, he was shocked to discover that his name and those of the other two New York–based Puerto Rican artists in the show, Wanda Raimundi-Ortíz and Yasmín Hernández, had been excluded from the Museo de Arte de Puerto Rico's press release listing the Puerto Rican artists in the group show. He was most ashamed that his mom would have to see what he felt was a public refusal of his Puerto Rican identity. Adding insult to injury, his *Jibaro Series*, along with works of the three US-based Puerto Rican artists were placed

in the back of the exhibition, as if to make an added statement about their value. Cruz recalled the dismissive treatment that his work and that of the two other New York Puerto Rican artists received, calling it an example of how Latinx artists are treated: "We're not authentic anywhere, you're always shafted, we become this hybrid and they don't see as authentic Latin experience anywhere."

One would think that things have changed in the fifteen years since David Antonio Cruz felt invisible on the island.[4] But unfortunately little is different now. Invisible boundaries continue to disavow and devalue diasporic cultural creation. This historical disregard for Nuyorican poetry and literature and for any other creative endeavors in the diaspora among island intellectuals is a well-known and well-documented trend, resulting from racist and colonial hierarchies that prioritize the geographically bounded territory as the legitimate site for "Puerto Ricanness" (J. Flores 2008). Scholars like Juan Flores have long documented these distinctions, whose whys and hows remain peculiar and pernicious, considering that unlike most Latin American countries, as a US colony Puerto Rico has historically lacked the national infrastructure to build and project "national" Puerto Rican artists internationally, separate from its diaspora. Puerto Rico has no embassies abroad and cannot project itself as a "nation" in important international art contests like the Venice Biennale. However, since the 1970s, the Biennial del San Juan del Grabado Latinoamericano, now reincarnated as the Poly/Graphic Triennial (2004–2015), has projected Puerto Rico as an arts national capital and played a key role in inserting Puerto Rican stakeholders into Latin American art worlds. As art historian María del Mar González notes, the biennial sought to reposition Puerto Rico's colonial status into an asset, presenting it as a geopolitical interlocutor to Latin America, the Caribbean, and the United States.[5] She notes, however, that Latinx artists were not allowed to participate until 1981, and only after Chicano artists challenged the biennial's nation-based residency requirements. Some Nuyorican artists had participated in the biennial before Chicanos' public challenge opened it up to Latinxs, but they were always subsumed as "Puerto Rican," with a marked preference for artists with national privilege (born in PR) and having connections with the island.[6]

It is undeniable that Puerto Rican art and artists are marginalized in both US and Latin American art worlds, irrespective of whether they reside on the island or in the diaspora. As a colony they are largely bypassed by the nation-centric focus of Latin American art, whereas

in the United States they do not even register in the imagination as "American artists." At the same time, it is notable that Puerto Rican artists born and raised on the island have also had more success in inserting themselves into Latin American art networks and in accessing international art markets than US-based Diasporican artists, who like most Latinxs, are invisible in Latin American art networks and barely recognized by North American art and culture institutions. Angel Otero, Enoc Perez, Antonio Martorell, Arnaldo Roche, Bubu Negrón, Chemi Rosado-Seijo (who not surprisingly are all male artists)—are some of the Puerto Rican artists who have gained some international notoriety. They all display a clear pattern of being either born and raised (which allows them to establish networks with island-based arts establishment and to be "authentically" recognized as Puerto Ricans) and internationally networked through global art centers like New York, after leaving the island to pursue MFAS or art training and other opportunities in the United States. This pattern follows a global trend wherein artists and creative workers are forced to move to New York City and other "global centers" to "be creative," as Angela McRobbie puts it, because only recognition in these centers provides them with access to cultural capital to bring back home. However, for PR artists these migrations have been the product not simply of the neoliberalization of creative economies, but of long-established networks that stem from the island's long history as a US colony (McRobbie 2016). The point is that there seems to be value in residing in Puerto Rico or maintaining an easily recognized Puerto Rican connection. For a very good reason, the most internationally known Puerto Rican artists— Allora and Calzadilla, a Cuban and North American artist duo—reside in Puerto Rico (a fact the art press regularly remarks on).

My interviews with Puerto Rican curators revealed that statewide Puerto Rican artists are underrepresented in the holdings and exhibitions of Puerto Rican museums. Even artists who have received major retrospectives in the United States (such as Juan Sánchez, shown at El Museo del Barrio and at BRIC, or Rodriguez Calero, the first Puerto Rican woman to have a one-person show at El Museo del Barrio), are absent in local collections, part and parcel of the artificial yet pervasive cultural and artistic divide between island arts institutions and Puerto Rican artists in the diaspora. Further, Puerto Rican students are never taught about Puerto Rican artists living in the diaspora at local universities. They learn about North American and Latin American contemporary artists, but Nuyorican artists they have to "discover"

on their own. US-based artists, in turn, are seldom invited or included in Puerto Rican exhibits. Like David, US-based Puerto Rican artists who have had arts exchanges with island institutions recalled painful experiences of being dismissed, ignored, or having their Puerto Ricanness questioned.

In part, this nativist emphasis on island-based Puerto Ricanness is a by-product of the island's colonial status, which has led many artists and intellectuals to reject US categories of identification. Indeed, as curator E. Carmen Ramos notes, many Puerto Rican artists from the island "do not fit comfortably into a category [of Latinx art] predicated on civil rights and bicultural affirmation, not only because they have not experienced living as racial minorities in the United States, but also because many purposefully reject any category that identifies them as "American" on political grounds (E. C. Ramos 2014:63). Unfortunately, this dominant island-bound definition of Puerto Rican identity has also had negative ripple effects for the evaluation of the work of artists working in experimental formats, abstraction, minimalism, feminism, and so on.[7]

Then there's the fact that many US-based Puerto Rican artists have been inserted in wider Nuyorican and Latinx antiracist social movements and often draw on themes that often clash with the dominant denial of racism on the island, around the view that "we're all mixed."[8] The Afro-Taíno aesthetic of the work of Jorge Soto and the Taller Boricua artists, or the highly anticolonial sensibilities of Juan Sánchez, are among some of the works that Puerto Rican art stakeholders told me made their work "unmarketable" and unpalatable on the island. A Puerto Rican art historian confirmed how these dominant racist and classist frameworks have repercussions on the rejection of diasporican culture when she said, "The thing is, the idea of Nuyoricans on the island is not you," pointing to me as we sipped coffees in Washington Square Park during a short trip to New York City. "Sorry to say, but we think about the guy with the tattoo of the flag and the coqui in the hustle in the barrio, and we don't want to identify with that. We want to identify with 'all these Latin American thinkers and literati.' We love Pedro Pietri, but . . . Urgh," she gestures in disgust to emphasize the pervasive ideas that she and newer generations of art historians are working so hard to challenge.

Here it is important to remember the key role that Nuyorican artists played in opening up grassroots/ethnic specific arts and cultural institutions in New York City in order to challenge their exclusion

in the arts. El Museo del Barrio, Taller Boricua, the former MoCHA (Museum of Contemporary Hispanic Art 1985–1990), and the Alternative Museum are some of the alternative and vanguardist spaces that Puerto Ricans artists and activists created in New York City that were central to cultivating the careers of many Puerto Rican, Latinx (then called Hispanic), and Latin American artists who were entirely shunned by the New York City arts and culture institutions. Some, like the Alternative Museum (1975–2000), disavowed ethnic specific identifications, while others, like El Taller Boricua (1969–), were more politically identified with the Nuyorican social movement. Still others, like Cayman Gallery (1975–1984), developed within the umbrella of Friends of Puerto Rico, and MoCHA, showed other Latinx and Latin American artists from the beginning.[9]

The short-lived MoCHA, founded by Puerto Rican Nilda Peraza, was especially influential. It was not only the first contemporary space for Puerto Rican, Latinx, and Latin American art, but it was purposefully located in Soho, the fastest-growing arts district at the time, as a political statement to avoid its ghettoization during a period when the only Latinx art spaces were located in predominantly Black and Puerto Rican communities. Looking back, Nilda attributed MoCHA's fate to the racist argument that one institution dedicated to Latinxs and Latin Americans in the entire city will do, which made it impossible to compete for funding from the same sources that were already supporting other Nuyorican organizations. Interestingly, many of the Latin American artists who launched their careers by exhibiting at MoCHA still hold tight to their Latin American and transnational identities, while disavowing their Latinx identities, despite having launched their careers in these early Nuyorican carved spaces and having lived up to fifty years in New York.[10]

Today, most Puerto Rican–founded cultural institutions that emerged in New York City as part of cultural struggles for representation in the 1970s and 1980s have succumbed to disinvestment in the arts and gentrification. In particular, El Museo del Barrio, the flagship of the Nuyorican arts movement, plays a very different role today than it did in its first decades of operations. Succumbing to global art market prerogatives, its mission of "representing the art and culture of Puerto Ricans and Latin Americans in the United States" now translates to minimal engagement with emerging Puerto Rican and Latinx artists.[11] This transformation has also involved a move away from the original mission that made these institutions so powerfully alternative, toward

those more palatable to collectors and the market. Its current director Patrick Charpenel, imported from the Jumex Museum—one of the most neoliberal corporate collections in Mexico City—had no experience working with nonprofit museums or with Latinx artists and communities, issues seemingly unimportant in his hire given his "global" Jumex credentials and ties to Latin American and international art stakeholders.

The transformation and eliticization of institutions like El Museo are especially distressing because New York–based Puerto Rican artists, like many Latinx artists, have depended on community organizations, museums, and the nonprofit cultural institution sector which has been more historically open to working with diverse artists. In this sector, the public demand for serving communities has provided greater opportunities for artists to work as educators or in public programming or in commissions. However, neoliberal trends in the arts (diminished government funding and greater influence of the private sector in the arts) have hindered the historically important role of the noncommercial arts sector ability to provide venues and spaces for diverse artists. In particular, alternative Latinx art spaces face constant threats to their survival, as they are the most vulnerable to rising rents and to the increasing neoliberal gentrification in US cities.

Shellyne Rodriguez, a multidisciplinary artist born and raised in the Bronx, had a lot to say about the voids encountered by many New York–born and –raised Puerto Rican artists who have grown amid a void of arts infrastructures in which to learn about Nuyorican artists. Unlike Juan Sánchez, her teacher and mentor at Hunter's MFA program, Rodriguez lacked an active Taller Boricua workshop that allowed her to meet and learn about other New York–born and –based Puerto Rican artists. Instead, graffiti and hip-hop became her conduit: "I look at old graffiti artists from the '80s so I can get a tidbit of what was happening back then. Unfortunately, I have to go back to Piñero and Martin Wong, who was in proximity with Piñeiro, cause I don't know who else to look at." That she named Piñeiro and Martin Wong is revealing of the vitality of Nuyorican poetry in giving visibility to the Nuyorican art movement and urban aesthetics over the visual arts. Her identification with Martin Wong, a Chinese American artist who was deeply immersed in the 1980s Lower East Side arts scene and the Puerto Rican communities facing displacement and gentrification, also speaks to lack of models for visual artists engaging the urban milieu of Black and Latinx communities. The more nationalistic Taíno-

and African-centric mythmaking aesthetics of Nuyorican artists in the 1970s were not as resonant to her peers coming of age in the 1980s as that of Nuyorican poets and an artist like Martin Wong, and/or graffiti artists who were delving into the urban milieu for their inspiration.[12] In fact, the marginalization of US Latinx street and urban art has been one of the casualties of El Museo del Barrio's eliticization and turn to Latin American art. Today, anyone interested in Latinx street art and works by Lee Quiñones and Lady Pink will need to turn to the Museum of the City of New York, which holds Martin Wong's collection of graffiti art.

Rodriguez's work draws from the contemporary urban reality, examining matters of resilience and survival in all of its contradictions. Works such as a chandelier sculpture made up of mousetraps, rhinestones, and gold chains, along with assemblages of cigarette butts, lotto tickets, toy soldiers, food stamps, and other found objects, speak to the false hope narratives and strategies of survival she sees all around her. Rodriguez had to carve a prideful place for her Bronx–born Nuyorican history on her own, finding El Museo del Barrio too whitewashed to fully evoke the ethos of new generation of artists like her. "In the diaspora, we tend to be really Black and really hood and they do not know what to do with us. Our stuff is not clean, fresh Latino shit. It's always peppered with something else." She added with pride, "I'm Nuyorican, I'm the hybridity and the scars of capitalism and colonialism and all of these things, but you've got to deal with me."

The gaps between island- and diaspora-based cultural work is most evident at the level of markets and collaborations, where we see how the rise of the Latin American art market has provided greater opportunities for collaborations between Puerto Rico and Latin American art worlds, over and beyond those between Puerto Ricans artists from the US diaspora. For instance, Embajada Gallery in San Juan, founded in 2005 by artist Christopher Rivera and his wife, Manuela Paz, grew out of Rivera's connections with Latin American and international curators he met at Puerto Rico's triennial who helped launch his career in the arts (through art handling jobs with Latin American artists in New York). "We're called Embajada because Puerto Rico lacks embassies," he told me when sharing his vision for his gallery as a space to project Puerto Rican artists internationally. Interestingly, although based in New York for almost a decade, Rivera operates Embajada squarely from Puerto Rico, projecting the gallery as one of the few international art spaces for contemporary art. Embajada has since

become a regular presence at international fairs, such as NADA (New Art Dealers Alliance) during Art Basel and Zona Maco in Mexico, and he told me he plans to participate in ARCOmadrid, bringing a roster of primarily island-based Puerto Rican artists, such as Bubu Negrón, Chemi Rosado-Seijo, and Jorge González. To date, he has yet to show or represent any Diasporican artist in his roster.

Artist-run spaces on the island have also had years, if not decades, of collaborations with Latin American artists in ways that have also helped linked Puerto Rico to larger Caribbean and Latin American art worlds. Beta Local, an experimental practice think tank founded in 2009 and the premier artist-run space in San Juan, has been especially central to these exchanges. This collaborative space has been welcoming artists, curators, and thinkers from all over Latin America and the world through its events and residency programs, helping to insert Puerto Rico into larger conversations around art, social practice, and action. I talked to one of its founders, the film and video artist Beatriz Santiago, who was very open about the centrality of establishing these larger networks to overcome the island's colonial situation and overdependence on the United States. She openly attributed her own artistic trajectory to the larger networks created by this space, given that her own work would not have been known beyond Puerto Rico if not for these exchanges and her artistic trajectory in Latin America. Tellingly, it was only after she had exhibited all over Latin America that US curators began to catch up to her work, which to her served as unquestionable evidence that "they neither know nor care about Puerto Rican art in the United States."

The Puerto Rican collective Km 2.0 has also been making exchanges and collaborations with Latin American artists for over a decade, as reflected in their mission to "exhibit, investigate and develop contemporary artistic practices specifically of Central America, Latin America and the Caribbean." Finally, similar networks are behind the newly founded international art air MECA (short for Mercados Caribeños, 2017–), In fact, MECA's organizers—the Dominican Puerto Rican duo Danny Báez, from Gavin Brown's enterprise in the United States, and Tony Rodriguez, formerly of Espacio 20.20 in San Juan, Puerto Rico—met in the art fair ArteBA in Buenos Aires, where they bonded over the lack of Caribbean artists and decided to create an international art fair on the island. The first MECA (2017) brought internationally recognized galleries—including some who have never worked with Latin American or Latinx artists but saw bargain prices

as incentive—just as the island had declared bankruptcy. Rodriguez described the fair as an intervention: "Our focus was not selling work but creating exchanges, and calling attention to Puerto Rico as a destination for these type of events. People wondered about coming to a fair to a US colony but for us this was a reclaim that we are part of the Caribbean and part of Latin America."

However, it remains to be seen how inserting Puerto Rico into larger art markets affects local artists and spaces, given these are generally bypassed by most post-Maria "visitor economy" events.[13] In particular, bringing internationally renowned galleries to the island to sell work to local collectors does little to address the needs of local artists, who were a minority of the artists represented in the booths of MECA 2017 and 2018. This strategy also does little to help link Puerto Rican artists to Diasporican and Latinx artists, who were almost entirely invisible at both events.

Diasporican artists are neither known nor supported by the few collectors on the island, who focus their patronage on selected Puerto Rican artists, especially those who have pursued MFA educations in the States, or else on international artists. The key example is the Berezdivin Collection at Espacio 1414 in Santurce, Puerto Rico, which started with a focus on contemporary art from Latin America and has since expanded to international contemporary art. A Puerto Rican collector I met at an event on Puerto Rican art at Sotheby's New York City co-organized with El Museo del Barrio, confirmed these trends, especially the lack of knowledge about Nuyorican and Diasporican artists among island collectors, when he asked me, "Where are these artists? I'd like to meet them. I do not see them in galleries. I just don't see them." Not even on Instagram, he noted, explaining that he did not know any US-based Puerto Rican artists (beyond those whom he had met in Puerto Rico and who had since moved to art school in New York or Chicago).

Most frustrating was being confronted with stereotypical ideas about Diasporican artists whenever I discussed their work with Puerto Rican curators, dealers, and collectors. Quite often they described artists from Puerto Rico as more "conceptual, sophisticated, and political" than artists in the diaspora, who they felt were "always doing work about Puerto Rico." These responses repeated the same stereotypes historically used to dismiss Latinx art, "assumptions that it is monolithically concerned with identity politics and/or is lacking in aesthetic and conceptual experimentation" (Zavala 2015: 125). As one

explained: "Bubu Negrón's work can be placed anywhere in the world, but art by Nuyorican artist always reads Puerto Rican." Not surprisingly, the person claiming this generalized view about Nuyorican artists could not name one Diasporican artist to exemplify his point.

I was met with blank stares whenever I asked about the possibility that Puerto Rican art spaces could also generate collaborations between Puerto Rico— and US-based Puerto Rican and Latinx artists more generally. Getting Puerto Rico inserted into greater Caribbean, Latin American and the international art world was always the main goal. As we have seen, this position is informed as much by an anticolonial rejection of the tendency to always look toward the United States as by the friendship networks that fostered collaborations toward existing art networks in Latin America and by the push to insert Puerto Rico into legitimated networks. In this context, US Latinx art worlds seemed far too distant and far-flung. Even the short flights from the island to New York City (three and a half hours) or Miami (two and a half hours) seemed insurmountable in a context where the racial politics of art markets makes it far easier for Puerto Rican artists to make community with artists living farther south, and at a greater travel distance.

44 Yet while I wrote this book, hopeful signs of a less fragmented Puerto Rican community were also at play in post-Maria Puerto Rico, as Puerto Ricans everywhere were emboldened in a new solidarity after the United States' ill treatment of the island. As a matter of fact Puerto Ricans in the diaspora have been historically involved in Puerto Rican social and political causes, often helping to amplify the causes most subject to colonial repression on the island, such as the struggle to free political prisoner Oscar Lopez Rivera. The DefendPR collective of multimedia photography and film artists comes quickly to mind. However, it is important to note that most of these diasporic collaborations have revolved around social justice art activism and have done little to insert Diasporican artists into larger markets and institutions on the island. Most interestingly, they have been primarily generated by Puerto Rican artists living in the diaspora and reaching out to Puerto Ricans on the island, not the other way around, so it remains to be seen whether and how Puerto Rican art networks expand to represent the diversity of voices in the diaspora.

What is certain is that the lack of collaborations between Puerto Rican and Diasporican artists has been a direct outcome of the scarcity of spaces to foster such exchanges and can therefore be expedited

by carving US Latinx art spaces, beyond the nation-centric conversations that have made Latin American and Caribbean art worlds such a dominant register for Puerto Rican artists on the island. Already the Whitney Museum's hiring of a Latinx curator, Marcela Guerrero—who is Puerto Rican and knows and works with Puerto Rican and Latinx artists—resulted in the largest inclusion of Puerto Rican artists at the 2019 Whitney Biennial, even though, not surprisingly, five of the artists were born and currently reside in Puerto Rico, leaving Elle Perez, born in the Bronx and living in Brooklyn, as the only Diasporican artist in the group.

In all, Puerto Rico–Stateside artistic exchanges depend on the existence of opportunities, networks, and institutions engendering opportunities for Puerto Rican artists of all backgrounds to be inserted in both Puerto Rican and US art spaces with equity. Only then can diaspora exchanges be engendered with ease, making it possible for Puerto Rican artists to be recognized and to also imagine themselves as part of US art worlds, alongside their continued and necessary insertion into Caribbean, Latin American, and international art worlds. These multiverse engagements are as essential for Puerto Ricans as they are for most artists across the Americas. Also certain is that any centering of Nuyorican and Diasporican artists will also be generative for other Latinx artists experiencing similar erasures.

The Latinization of New York's Art Landscapes

From Dominicanyorkers, Colombians, Salvadorans, MexiRicans, and Blaxicans to the many other artists who increasingly identify simply as Queens- or Pilsen-based, Latinx artists are here to stay, even though they remain under the radar. And New York City is at the center of this artistic Latinization. The city contains one of the most diverse Latinx artistic communities, representing every single Latinx group and demographic. It also attracts Latinx transplants from all over the United States coming to study, work, or insert themselves into the city's artistic communities. Thus, I want to end this chapter by introducing readers to some interesting trends in the work these artists are doing.

First, there is a visible push to center race and to reevaluate the debased components of Latinx culture. This revival echoes the very early work of Nuyorican and Chicanx pioneers who addressed the Indigenous and African elements of Latinx identity through their work.

However, today this move is bolstered by the rising xenophobia toward all things Latinx, by the continued white-centrism of the art world, and by an emphasis on nuancing identity binaries by highlighting the spaces in the middle. Afro-Dominican artists, especially women, are central to this conversation. Artists such as Elia Alba, Sherezade Garcia, and Firelei Báez, among others, are confronting whitewashed definitions of Latino identities that have limited awareness of Black Latinxs in all of their diversities, as well as narrow definitions of Blackness that leave little room for Black Latinxs. Elia Alba's "The Supper Club," a multifaceted art project of food and dialogue with over sixty contemporary artists of color, has been a catalyst to these conversations. The project is accompanied by a photography component where Elia photographs some of the artists/participants, inspired by the glamour of *Vanity Fair*'s "Hollywood issue," except it is Black/Brown bodies that are styled and photographed in luxurious poses and costumes. Elia's work is about challenging the strict distinctions between Black artists and Latinx artists that make it incommensurable for Latinx artists who are Black to also be seen as Black artists, or that make their Blackness suspect if they identify as Latinx. As she tells me, "What I do is explore a lot of the gray areas—that's what it is to be Latinx. We reside in the middle. It's hard for people to understand when they can't box you in."

Latinx artists are also centering race in their identities by claiming indigeneity as central to their backgrounds and visual vocabularies. Ronny Quevedo, an Ecuadorian American artist raised in the Bronx, had a solo exhibition at the Queens Museum where the Suyu Wiphala flags (emblems) representing the four regions of the Inca empire anchored the installation inside the museum, as well as the institution's entrance. Waving outside, the flags served to welcome the mostly immigrant communities that gather in front of Flushing Meadows Corona Park. He tells me, "It was a matter of reclaiming this space, giving homage and tribute to the people who live there, who are predominantly Latin American and Ecuadorian, Colombian, and from the Andes."

Indigeneity has been a foundation for the majority of Quevedo's abstract works, inspired by Indigenous textiles, architecture, and designs. He was moved to action by comments from a chief curator of pre-Colombian cultures at the Metropolitan museum that "nothing definite was left from the pre-Colombian Indigenous repertoire," and speculation was all art historians could do. For Quevedo, the nonexistence of records served as a challenge to continue "going back to the source," not only to revalue what is there but also to build and create

new objects and materials with which to valorize Indigenous invention in the present. At the Queens Museum show, Quevedo turned the museum's atrium floor into a giant drawing resembling a court, akin to the inside courts in the soccer league his father had helped organized when he was a kid, evoking a space where working-class migrants could make community.

Like Quevedo, other Latinx artists are channeling popular culture, urban experiences, and the material culture around them into works challenging the white-centric BFA and MFA programs that taught them to be "universal." For instance, Dominican York Lucia Hierro's exhibition *Mercado* (2018) at Elizabeth Dee Gallery presented a giant lovefest to the traditional bodega. Her oversized pop art assemblage sculptures of shopping bags are filled with the grocery items that Latinxs grow up consuming, such as plantain chips, malta bottles, and other Goya staples and products. A popular assemblage with audiences displayed giant versions of the ingredients for "habichuelas con dulce," subtly communicating, to those in the know, that this is a "Dominican thing." During her talk Hierro insisted that she's not doing anything different from other artists—her "ethnic" materials are as legitimate as the materials Warhol or any other white artists used in their pop art. She asked, "We don't look at these objects as ethnic. Why is it that when Latinx artists draw from their lived experiences, they are seen as 'ethnic'?" Hierro's question was echoed by other Latinx artists in different iterations, joining larger demands to see and valorize Latinx art as American art. Hierro's question was echoed by other Latinx artists in different iterations, joining larger demands to see and valorize Latinx art as American art.

These artists are resourceful and resilient. They are experimenting and eschewing formal guidelines for what makes up a "professional" artist. Their works engage with topics as varied as their inner feelings and their everyday lives and proudly express and validate new narratives. They shout: we're here and our voice matters—we are doing art history. However, this position requires scholars, curators, and writers who fully get these artists and their work, and as I discuss in the next chapter, the lack of people in the know remains one of the most insurmountable challenges. Scholarship and criticism has yet to match the revival, resistance, and resiliency of artists who are no longer buying into their devaluation. The next chapter addresses this impasse and why it is so important for Latinx art stakeholders to generate value on our own terms, rather than relying on the rare interlocutor who sees and recognizes the work and what is possible.

Exhibiting Latinx Art

On Critics, Curators, and Going "Beyond the Formula"

Latino art, today, is a meaningless category.
/ **PHILIP KENNICOTT**

For the installation at the Williams College Museum of Art,
museum staff asked us to define Chicano and Chicana, which we
did not, and my response was, we would under one condition if
they went through the museum and defined all the other terms
by which they identify artists: American, Syrian, Egyptian, and
Japanese, etc., and then we'll provide the definition.
/ **C. ONDINE CHAVOYA**, on curating ASCO exhibition,
remarks at US Latinx Arts Futures, 2019

When E. Carmen Ramos organized *Our America: The Latino Presence
in American Art* (2013) at the Smithsonian's American Art Museum,
art holdings of Latinx artists at the institution were minimal and un-
balanced. The museum lacked works by foundational figures; entire
groups, such as Dominican Americans, were missing, as were genres
like abstract art; and with a collection dominated by colonial and folk
art and work focusing primarily on Mexican Americans, it was im-

possible to produce any comprehensive exhibition of contemporary Latinx art, much less one that represented the diversity of artists and trends. Ramos was one of the few Latinx curators hired in the aftermath of the infamous "*Willful Neglect* report" (Smithsonian Institution Task Force on Latino Issues 1994), which documented a historical pattern of discrimination at the Smithsonian Institution and called for the hiring of Latinx curators to help direct the Smithsonian's priorities in research, collections, and exhibitions.[1] The task of reworking a mostly white canon institutional art history and collection was a daunting one, and whatever she did would be a politically charged intervention. This would be the first major scholarly survey exhibition of Latinx art, a statement inserting it as central to American art, and the first major show of its type in a major North American museum in decades.

The last was the highly contested *Hispanic Art in the United States: Thirty Contemporary Painters and Sculptors*, organized by the Museum of Fine Arts Houston (1989). I was a recent New York City arrival and an entry-level staff member at the former Museum of Contemporary Hispanic Art when it opened at the Brooklyn Museum, and I still remember the uproar it caused among artists, curators, and community activists. Everyone was excited but also disappointed to see how such an overdue show stereotyped and reduced "Hispanic" artists to color, expressionism, tradition, and loudness. In sum, the exhibition evidenced the Eurocentric curatorial approach and aesthetic biases that dominate most survey exhibitions of Latinx/Latin American art, as Mari Carmen Ramírez (1992) cogently argues in her now-classic essay "Beyond 'the Fantastic': Framing Identity in U.S. Exhibitions of Latin American Art." In the *Hispanic Art* show, there was a marked emphasis on works that drew on mythical, spiritual, and traditional cultural idioms, over contemporary and urban references, and a reliance on literal readings that failed to explore anything beyond paradigmatic displays of authenticity. Moreover, by the time of *Our America*, it was evident that the expectation that Latinx art and artists would undergo a "boom" after this exhibition had long dissipated. If anything, over the past twenty years, only Latin American art had experienced a significant increase in interest. By contrast, Latinx art and artists remain unknown and unvalued, and almost as invisible as during the *Hispanic Art* show.

This remains true despite the myriad Chicanx and Latinx art exhibitions that Chicanx and Latinx artists, curators, and cultural creators have been producing for decades. These are what Chicana art scholar

Karen Mary Davalos terms "errata exhibitions" because of their corrective intervention on the misrepresentation of Chicanx and Latinx art in American art history.[2] However, segregated within Latinx specific museums and institutions, these exhibitions have done little to challenge the invisibility of Latinx artists from most contemporary art museums.

Given this, a survey show at a nationally recognized mainstream landmark institution like the Smithsonian American Art Museum was an overdue intervention into the North American art history canon. It was also essential for launching a collecting effort within the "national" collections to ensure that Latinx artists could never again be so easily erased and excluded. Hence the importance of *Our America* and the predictability of the ensuing backlash. Mainstream art reviewers are renowned for their hostility to anything that indexes race or ethnicity in the art world, especially when it concerns racial minority groups art historians are relatively unfamiliar with. But Philip Kennicott's review in the *Washington Post*, which claimed that "Latino art was a meaningless category," reached a higher level of spite, especially because it highlighted what is at the crux of the Latinx art curatorial dilemma: that any Latinx art show will always be reduced to identity, no matter what curatorial or scholarly efforts are put to the fore to highlight their complexity and larger significance. Filmmaker Alex Rivera referenced this when he faced Kennicott in a published head-to-head *Washington Post* debate (Kennicott 2013). As if channeling the outrage of the Latinx art community commenting on his Facebook page, he explained, "Time and again reviews of shows that feature work of 'minority groups' (who are in many instances majorities in cities where the art world thrives, but whatever) become the occasion not to talk about the show at hand, but to attack the fundamental gesture of curating shows featuring our work." He continued, "It seems like the absence of Latino artists is normal, not newsworthy, but the organizing of our presence causes questions about our existence." Most powerfully, Rivera questioned Kennicott for regularly reviewing shows of "American art," without critiquing the very concept of "American," which is far broader than the category of "Latinx."

The exchange made it clear that the problem was not necessarily the survey format, but the fact that it was Latinxs who were being foregrounded. Survey type shows are always limited, yet the Smithsonian and most mainstream museums regularly resort to this format for a variety of topics without creating such critical ire. Then there is the ques-

tion: How are Latinx curators to move forward in their exhibitions and analyses when their entry into mainstream spaces often requires, and demands, survey type shows that begin to place Latinxs into the white spaces of galleries, collections, and archives where they've been historically absent?

On the Lack of Critics

Latinx curators have learned that it is not uncommon for their shows and interventions to be subject to the same dismissal whenever Latinx art or artists are concerned. This is the case even in shows that are purposefully designed to adopt postidentity rubrics to avoid being reduced to identity. For instance, Ken Johnson's *New York Times* review of the traveling exhibition *Phantom Sightings: Art after the Chicano Movement* starts by asking whether it's time to retire identity-based group shows. He goes on to make the deluded claim that diverse artists had been "assimilated into the art world," entirely missing that the show was aimed to trouble, not reinsert, Chicano identity in the first place (K. Johnson 2010).

At the root of the issue is the inability to understand who Latinxs are and what their history is, or to comprehend work that is largely unknown in art historical terms. In fact, C. Ondine Chavoya's survey of major issues at play in the reception of Chicano art exhibit identifies similar patterns also visible in the reception of Latinx art. These issues include critics' frustration over the heterogeneity of the work and the lack of unified or recognized aesthetic, and their confusion over questions of inclusion and authenticity around where Chicano art belongs and where it should be exhibited, and for whom (Chavoya 2019).

A key concern is the "Dominance of the White Male Critic" as put forth in the title of Méndez Berry and Yang's important 2019 *New York Times* editorial describing a general lack of cultural critics of color in all types of media and limiting their ability to shape the dominant discourse about art and culture (Méndez Berry and Yang 2019). In contemporary art markets, this void is even more pressing, given the central role that critics play in underwriting the symbolic value of artists in a context where much of the value of artwork comes from it becoming the *subject* of communication.[3] The result of this void in critics of color came to the fore during the 2019 Whitney Biennial. This was the most diverse biennial to date, yet it was white critics who reviewed the work

in most major media outlets, raising questions about their misinterpretations of the artworks, the language used to describe the works and their overall dismissal of the key political and social issues involved in the artists' works evidencing critics unfamiliarity with artists of color, and the themes they draw from (Méndez Berry and Yang 2019).

A young woman who works as a writer at a major arts publication who preferred to not be identified told me about an office that was 95 percent white, where no one seemed troubled that the only two African American people were in human resources. She was very sensitive to the role she occupies as a light-skinned mixed person of color in an industry that has pigeonholed her as the "person who can speak about race" in a context where she feels her hire is not even close to addressing the spectrum of representation the magazine needs. Our conversation was a reality check. She explained how ignorance about artists of color is commonplace and even sanctioned in these spaces, such as tales of people expecting all Latinxs to be Mexican, even in New York City, where you're more likely to encounter Puerto Ricans and Dominicans. Most frustrating was the difficulty of covering shows beyond the grid of MoMA, the Guggenheim, or the Drawing Center. That week, she wanted to review *Her Art Will Be Cannibal*, curated by interdisciplinary artist Alicia Grullón at the Longwood Art Gallery at Hostos College in the Bronx, but had not gotten the go-ahead from her editor. That frustrated her: these shows do not get written about because people do not want to go to Harlem or the Bronx.

Unfortunately, the art industry is structured to sanction ignorance about Latinx artists by making it impossible for diverse candidates, or anyone who is not independently wealthy or supported by others, to get jobs or break into the art world. Art salaries for entry-level jobs in the arts have remained stagnant, ranging from $20,000 to $35,000, often on a part-time basis, so workers have to be subsidized by rich parents or spouses. I met a senior editor at a major art magazine with over twelve years of experience in publishing who made a mere $49,000 and, tired of being unable to make ends meet, was transitioning to marketing. Ironically, these stagnant salaries have been accompanied by a growing inflation in the type of degrees and backgrounds that are demanded from candidates. This is part and parcel of neoliberal trends in creative labor and the arts in general, where MFAs are "expected" from any artists, as is an MA in some field such as curatorial studies, museum studies, art education, or visual arts administration, for art professionals in order to break in.[4] Similarly, a PhD in art history is

becoming standard for major curatorial positions—a concerning trend given art history's lack of diversity in comparison with other interdisciplinary fields such as African-American studies.

The scandal over the Brooklyn Museum's hiring of a white female curator with a Yale art history PhD during the spring of 2018 comes to mind here. Advertised as a part-time position, and in a field that is recognized to be primarily white and female (Salam 2018), the position was structurally biased in regard to who had the credentials or the ability to take such a prestigious yet precarious position. Then there is the issue of debt among artists and art workers, or what artist/critic Coco Fusco has described as the rise of "the artist as debtor," which results from the growing competition among art workers to pursue MFAS and graduate studies to become "legitimated," at the cost of long-standing or permanent debt (Fusco 2015).

In regard to art writing and criticism, this lack of diversity in the arts leads to a general pattern of neglect of Latinx cultural products. Usually these are either covered in faulty and incomplete ways or ignored altogether. While writing this book I came across enough examples to fill a full manuscript just by focusing on the *New York Times* reporting on Latinx art and culture, including write-ups that used loaded, racist language or that could not even define what Latinx is.[5] A relevant example is the sole *Times* article focusing on the Latinx Art Movement, "Museums Turn Their Focus to US Artists of Latin Descent" (Pogrebin 2018). The title alone is cringeworthy, as "Latin" has been historically used to elide differences between a highly complex population, on the idea that "any Latin" artist would do. But inaccuracies in the content were more concerning. The writer touts the hiring of Marcela Guerrero, the first Latinx art curator by the Whitney Museum, but mistakenly identifies her first exhibition as one featuring works by "Indigenous groups" who are Inca, Quechua, Maya, Aztec, and Taíno, rather than by contemporary Latinx artists who are drawn or inspired by Indigenous culture and traditions. Her interviewees were primarily Latin American curators, the same ones who have advanced Latin American art over Latinx art for decades, while she mistakenly calls the Museum of Fine Arts a pioneer for establishing a department of Latino art (in fact, the museum's initiative focuses on Latin American art, not Latinx art). Within minutes my Facebook page filled with comments of outrage and dismay; the article exemplified why we need diverse art and culture writers in major publications. Still, many colleagues were ready to embrace the piece as a form of acknowledgment,

a comment on the dire underrepresentation of Latinxs. As Ranald Woodaman, from the Smithsonian Latino Center, put it in a tweet, "En serio; this article made everybody groan, and yet we'll take the acknowledgement, faulty as it is. Así está la cosa" (Woodaman 2018).

In fact, while *Pacha, Llaqta, Wasichay: Indigenous Space, Modern Architecture, New Art* opened on July 13, it was not reviewed in an arts journal until August 28, when Ananda Cohen-Aponte (2018), a young Latinx art historian who teaches at Cornell University, pitched the review to *Hyperallergic*. This was the first group show on Latinx artists at the Whitney Museum, yet seemingly art reviewers were not ready for it, or perhaps they did not know what to say. The exhibition was not only the first one to feature Latinx artists at the Whitney, but also the first to have a title in Quechua, and to highlight indigeneity. This marginalized component of Latinx identity challenged viewers to understand the living components of Indigenous culture as embraced by artists who may or may not claim Indigenous identity, while expanding beyond the ways this identity is narrowly understood in terms of blood quantum in the US context. A previous piece in the *Guardian* had reviewed the show (Sayej 2018), but had used a considerable amount of space to discuss who Latinx artists are, and why there is such a lack of knowledge about them, rather than the art itself. As a point of comparison, consider that the exhibition *David Wojnarowicz: History Keeps Me Awake at Night*, which opened on the same night and in the gallery next to *Pacha, Llaqta, Wasichay* was reviewed by the veteran *New York Times* critic Holland Cotter (2018) on July 12, the day before it opened. Finally, two weeks before the show was scheduled to end, a short review of *Pacha, Llaqta, Wasichay* appeared in "Things to See in NY Art Galleries This Week," praising it as a must-see while seemingly missing the point of the exhibition: the author ends by praising the strength of the artwork while claiming that its effects were even more powerful because it was "mounted in a Western museum devoted to modern and contemporary American art," entirely missing the decolonial intervention intended by the show. It is the twenty-first century, and contemporary museums should be showing artwork that draws inspiration from things other than European modernity without doubts raised about their suitability or "out-of-placeness." Also, most of the artists live in New York and other major cities in the United States and are as modern as their interventions, because as Guerrero (2018) made clear in the introduction to her ex-

hibition, "to talk about indigeneity in the Americas is to speak in the present tense."

Similar blinders are evident in Holland Cotter's review of El Museo el Barrio's fall 2018 exhibitions, the show *Down These Mean Streets: Community and Place in Urban Photography*, which featured ten Latinx photographers and was curated by E. Carmen Ramos for the Smithsonian American Art Museum, and a solo show of New York–based Argentinian artist Liliana Porter, traveling from the art museum of Georgia's Savannah College of Art and Design. Cotter is one of the few critics recognized for covering artists of color and for reviewing shows off the grid of major museums. Still, he is not exempt from the pull of stereotypes when discussing art from communities that have been so maligned. In the review, the revered *New York Times* art critic praises the shows' pairing as an example of the institution's "finding common ground" between its "bifurcated" mission to "remain community-identified" and "become a broadband showcase for Latino and Latin-American art" (Cotter 2018). These distinctions are taken for granted; Cotter discusses the exhibitions as if they were on opposite ends of a spectrum. For Cotter, the Latinx photographers echo community, advocacy art, and specific neighborhoods from East Harlem to Los Angeles failing to see any complexity or sophistication in their work or the themes addressed beyond "advocacy art in the form of a kind of extended-family album." By contrast, Liliana Porter's work is described as "not declaratively Latin American or Latina," without specifying what type of work can be declaratively read in these ways. The work is also praised as experimental and treated with the greater care and detail merited by a solo exhibition covering fifty years of the artists' career, spanning her influences and the international references and themes that inform her work.

The irony is that Porter arrived in New York City at the age of twenty-two and has been living in the city since, though she insists on identifying solely in national terms, as Argentinian or as a Latin American artist, while maintaining close ties to Argentina and Latin American art worlds.[6] Like Porter, many New York–based Latin American artists continue to identify in this manner. This is undoubtedly an act of resistance to their racialization and a rejection of imposed categories such as "Hispanic," "Latino/a," or "Latinx," though one that nevertheless feeds into the purchase of national privilege through the devaluation of Latinx over any other nation-based or regional categories.

In sum, from Cotter's viewpoint, only Porter's exhibition embodies openness, not the Latinx photographers. In this way, his review contributes to reproducing the usual dichotomies of value and stereotypes regarding what makes "Latin American art" and artists, and helps to fuel the differential evaluation of Latinx and Latin American art, which is ultimately at the root of El Museo del Barrio's contested and "bifurcated" history. This history would not be as "bifurcated" if critics would treat the institution's Puerto Rican history and the Latinx artists it exhibits as global, as Latin American artists and art are said to be, and as worthy of attracting larger audiences, instead of consistently diminishing them as "local," "activist," or "bound in place." Poignantly, none of the articles discussing debates around El Museo del Barrio's "bifurcated" mission mention the influence of moneyed collectors, and how the intersection of money, power, and influence is affecting not only this institution but also other museums and their impact on larger communities.

Hierarchies of value between these shows were also communicated in the installation, where the ten Latinx photographers of *Down These Mean Streets* were packed into a third of the gallery space, while the rest of the museum was devoted to the work of Liliana Porter. On opening night, the unequal division of space took a racial and spatial dimension: white audiences seemed to gravitate toward Porter's side of the museum, while darker-skinned audiences were concentrated in the *Down These Mean Streets* exhibition and the reception area. In a hallway tucked away from the main galleries, stood Adrián Viajero Román's *PR-Tifacts* installation, which was designed to commemorate the one-year anniversary of Hurricane Maria, reinforcing the spatial hierarchies of the fall exhibits.

Whiteness remains the unspoken neutral against which art criticism is taken for granted, mirroring the racial politics that are everywhere marked in the exhibition of Latinx art. Latinx art advocates complained about the general elitism in art criticism, whereby whatever is not in major museums and galleries or printed in major newspapers in LA or New York or in art magazines is largely ignored; mainstream art coverage bypasses blogs and digital venues, where the most diverse writers are found (Rodney 2018). The result is an oversaturation of reviews focusing on shows and artists appearing in mainstream institutions, and less overall diversity. One gallerist vented with frustration: "How many reviews are we going to have about Joan Mitchell? The *New Yorker*, *New York Mag*, the *New York Times*, they are all writing

about the same thing! For every twenty reviews of write-ups, there is one with something interesting and new, instead of regurgitating what appears elsewhere." Granted, this example is highly atypical because women artists rarely dominate the art news, which is another way the art news press contributes to the invisibility of women artists and artists of color more generally, by not covering their exhibitions and their achievements.[7]

Another problem is the tendency to position all art within the same European frameworks: modernism, minimalism, pop art, conceptual art, and so on. Once again, the sole critic of color at a major art publication, was swift in her analysis: "Modernism itself is European whiteness," she said, then added that MoMA should really be called the "Museum of Early Twentieth-Century Northern European Art," a critique that the "new MoMA" has not eradicated. She bemoaned that while modernist art interventions are made all over the world, the criticism and the writing draws primarily on European and Anglo-American artists, making it impossible to write about artists from all over the world without putting them in a framework shaped by the dominance of European modernism, which renders shows like *Pacha, Llaqta, Wasichay* as aberrations. Much less has art criticism taken up the writings on African American and Latinx artists produced by scholars of color, with the rare exception of Fred Moten, who was recently rated no. 16 in ArtReview 2019 list of the 100 most influential people in the art world. Seph Rodney, an editor at *Hyperallergic* and one of the few Black critics who writes regularly on the New York City art world, is familiar with the trend of fitting POC artists into art history terms where there is a lack of language for discussing artists of color, and it is jargon and distance that is seen as a "mark" of quality in art criticism. As he put it: "Most reviews sound like an art history MA is writing the review. A lot of jargon, talk of absence, presence, multiplicity, ambiguity," but what one will not read about, he added, is how artists critically engage with matters of race or difference, or about the history and cultural registers that may inform the work of artists of color, or the categories or intentions of curators. This explains the visible relief among Latinx artists and curators in the few instances when critics of color reviewed them: they felt these critics approached their work and projects with greater texture and better analysis.[8] Just notice the overdue and unprecedented write-ups on artists Judy Baca, Amalia Mesa Bains, Daniel Joseph Martinez, and Carmen Argote since Max Durón's tenure as writer and editor at

Artnews. This is the difference that having Latinx writers as in-staff arts editors can make.

The dominance of European theorists as the source of vanguard theory making is especially troubling especially when women of color have long advanced similar concepts and insights in the realm of identity and subjectivity (L. E. Pérez 2007, 2019). This is part and parcel of the "epistemic Occidentalism" that Adriana Zavala (2010; see also Coronil 1996) argues pervades most art criticism, where the categories and meanings of a dominant and imaginary West remain unchallenged. This Eurocentric impetus reverberates in exhibitions seeking to lessen the "Chicano" or Latinx content by embracing a postidentity ethos, or in futile attempts to engage with mainstream art critics on their own terms by developing "corrective" type of exhibits to insert Latinx artists in a dominant Western art canon that refuses to recognize them.

I recall the exchange between Ken Johnson and Dominicanyork artist Freddy Rodríguez during the program for *The Illusive Eye* (2016), an exhibition organized by Jorge Daniel Veneciano, the then-director of El Museo del Barrio. The exhibition sought to challenge formalist art history by highlighting the work of Latin American artists and a few Latinx artists, who contributed to the op art and kinetic art movements but had been omitted from the art history (and from the canon-forming 1965 MoMA exhibition). The public program paired Veneciano and Johnson in a highly frustrating exchange where Johnson seemed to miss the point of where he was—East Harlem, and El Museo del Barrio—and the entire corrective tone of the exhibition by presenting a formalist discussion about the origins of psychedelic art (no surprise, in European artists). Finally Freddy Rodríguez, one of the few Latinx artists in a mainly Latin American show, elegantly and assertively named the world-renowned Argentine writer Julio Cortázar as the biggest influence on his geometric and abstract paintings, rather than any European interlocutor, prompting Johnson to confront his Eurocentric biases. The audience's approving response to Rodríguez's intervention made clear that whoever Cortázar was, it had to be someone of consequence he needed to know about, so Johnson quickly asked Rodríguez to clarify whom he had mentioned.

This impasse of seeking to value Latinx art through more legitimate registers is also behind the politics of exhibition titles. For instance, many curators shared the difficulty of finding "edgy" exhibition titles that did not index Latinx or any other "identity word" to

avoid compromising their value. "We can't even name an exhibition without getting into trouble," grumbled one curator as she noted the differential value of identity categories as one of the challenges for bringing visibility to Latinx art. Granted, titles and names that prioritize an exhibition's concept are always preferred over "identity-sounding titles." Most curators prefer exhibitions to just be, and to include artists of color without having to name them. The issue is that when identity references are used in exhibition titles, we see a consistent disinvestment in the category of Latinx art, relative to the seemingly greater acceptance of categories like Latin American and American art.

Seeing the same hierarchies of value Chicanos and Nuyoricans fought against in the 1970s continuing to affect the representation of Latinx artists today is especially frustrating. The impetus behind the creation of alternative arts institutions and ethnic specific museums at this time was the need to establish spaces where artists and communities of color would not need to jump through the hoops of mainstream validation.[9] Unfortunately, much has changed since these alternative spaces were founded. In New York City, many of the original Puerto Rican cultural spaces have disappeared, while others have become "Latin Americanized," in ways that put them closer to meeting the needs of the global art market. In so doing they have also become less of a provocation and more complicit with the white-dominant ideas of "value" espoused by the art world and the market. Meanwhile, after decades of social protests and criticism, mainstream places have been slowly hiring POC and Latinx curators to address the voids in their collections and programming. In fact, the current Latinx art movement needs to be seen in relationship to these trends, where we see formerly "ethnic" museums seeking validation along mainstream terms, while mainstream museums endure pressures to "decolonize" and diversify everything from their staff to their collections.

This has led to an interesting moment where we see the rise of professional "Latinx curators" working in all different types of spaces, including mainstream museums, or what artist Amalia Mesa-Bains has termed the "white airports" after the way travelers from the South rely on transfer via European and US capitals to reach other destinations in the South. "We cannot know each other without passing through that airport," she explained at the US Latinx Art Forum meeting, making the case for why these spaces need to be avoided, or in the least intervened on, and transformed.[10]

Today, the slow but growing presence of Latinx art curators in mainstream museums is a significant trend anchoring Latinx creative and knowledge production. In light of the continuing challenges and aesthetic hierarchies undervaluing Latinx art in museums, galleries, and art history more generally, I ask, How are Latinx curators and exhibitions intervening in these spaces, and what lessons can we glean about their transformations and what may be possible?

The Rise of Professional Curators and the "Lack of Experts"

As with the missing critics, where are the curators who know about Latinx artists and/or are inserted in their art worlds? The past decades have seen the professionalization of the arts, where fields formerly filled by teachers, artists, or activists with deep ties to artists and communities, now demand advanced degrees in art history or any other art-related field. Unfortunately, many of these professionalized curators know little about Latinx art and artists, because of their very professionalization in a field that remains highly Eurocentric and reticent to change. Latinxs in art history programs are a rare minority, and those who seek to write about Latinx art need to educate themselves and survive what Adriana Zavala has described as the "faulty educational pipeline" that marginalizes Latinx art history at most North American universities. In her analysis of the underrepresentation of US Latinx art history in most universities, Zavala (2016) found that few departments offer coursework inclusive of Latinx art and that most Latinx art historians were in fact trained as Latin Americanist but had crossed over to the field (Zavala 2016). Beyond art history, more scholars are focusing on Latinx art subjects in related disciplines. However, they are unable to train students who will be recognized as "art historians," so the rise of interdisciplinary Latinx art scholars has done little to affect the "faulty pipeline" within the discipline.[11]

I don't agree that only academically trained art historians should be hired for curatorial jobs—this view results in the narrow view that only art historical training, as flawed as it is, generates the best art and museums professionals. Augmenting the pipeline through formal training in narrowly defined disciplines can also backfire by placing the focus on training for the future rather than reaching out to existing Latinx arts professionals today and in the present.[12] Having said

this, I also agree that addressing art history's disciplinary segregation is a necessary priority to challenge the divisions between the "disciplines" and Latinx studies.[13] As an anthropologist working in Latinx studies, I have documented how similar disciplinary boundaries have functioned in anthropology, where, to date, anthropologists working in African American, Latinx, or Asian American studies are concentrated in ethnic or other interdisciplinary programs and are seldom hired within anthropology departments. Still, art history remains relatively behind other disciplines, almost entirely unrepresented in the growing Latinx studies academic professional circuits. When Zavala reported in 2016 that only one dissertation had been completed in Latinx art and that the College Art Association (CAA) lacked categories to recognize Latinx art, except within a larger rubric of race/ethnicity/cultural studies, it became obvious that Latinx art scholarship suffers from a lack of recognition and validation within art history.[14] In fact, the erasure of Latinx art panels at the CAA's 2015 annual conference was a primary motivation for the formation of the US Latinx Art Forum (with Adriana Zavala from Tufts University; Rose Salseda, then an art history PhD student at UT Austin; and Smithsonian curator Josh Franco as founding members).

During her presentation at US Latinx Arts Futures, Zavala added the erasure of Latinx art from most American art history textbooks, and the substantial errors that characterize its coverage, as additional examples of the disregard that plagues the representation of anything Latinx. She pointed to the reduction of Latinx art to "Chicano muralism" and to the inclusion of faulty information because "there are no consequences for not knowing." Artist Freddy Rodríguez's recalled an instance of this when his work *Cuando lo vi (When I Saw It)* was mistitled during one of the first exhibitions in New York City as *Cuando Levi*, as if Rodriguez had been invoking the then-fashionable French structuralist anthropologist Claude Lévi-Strauss.[15] He was not, but only Lévi-Strauss seemed legible. This example dates to the early 1970s, though examples like this are not uncommon today. In fact, when Rubén Ortiz Torres and Freddy Rodríguez were shown in Frieze 2019, a *Hyperallergic* piece on overlooked artists misspelled both names (as "Ruben Ortiz Toress" and "Freddy Ortiguez") (Bishara 2019). Then there is the careless mispronunciation of the names of Latinx artists, writers and curators I heard from so many interviewees that actively communicates there is no consequence for not knowing. This thoughtless treatment of Latinx creatives echoes Minh-Ha T. Pham's discussion

of "citational colonialism"—actions of active erasure in the authorship of creative work by nonwhite creators that reinscribe art and art criticism as normatively white (Pham 2019). In this way, the task to diversify the discipline of art history demands more than opening up to diverse topics and students and scholars. At heart, as Zavala's suggests, it demands challenging the "epistemic Occidentalism" that makes it so difficult to discuss matters of inequality, colonial histories, and the engrained racism behind the categories, methodologies, and modes of thinking—what most affects the evaluation of Latinx artists and other artists of color.

The curators I spoke to graduated from art history programs where the closest faculty working in their areas of interest were specialists in Latin American art or Spanish art. A few had had African American teachers and mentors, but mainly they faced a discipline that had remained isolated from Latinx studies scholarship. Most significantly, Latinx curators make up a minority of the entire universe of curators.

According to a Mellon Foundation report on museum demographics, non-Hispanic whites continue to dominate in most creative fields, such as curators, educators, and directors. In these types of positions 84 percent are Non-Hispanic White, 6 percent Asian, 4 percent Black, and 3 percent Hispanic (Mellon Foundation 2015). Finally, Latinx art curators are seldom in positions to transform the canon and the organization of museums and institutions where they work. For instance, my interviews showed that few curators are able to work on shows that are not specifically focused on Latinx or culturally specific topics, and curators are seldom recognized for their expertise in other areas. Most significantly, most curators work freelance and in extremely precarious conditions, and few hold steady curatorial jobs that give them the authorial power to develop shows from conceptualization to production. In all, curatorial interventions are seldom the outcome of autonomous creative processes; rather, they are usually the product of negotiations with the funding priorities and missions of specific institutions and informed by matters of marketing and audiences.[16]

The Formula

Against this context, exhibiting Latinx art has been historically mired by a variety of external interests. First, the need to reevaluate Latinx art has driven curators to seek curatorial frameworks with greater

commercial and mainstream recognition. This is where "the formula" (as numerous collectors described the dominant practice of linking Latinx to Latin American art) comes in, led by the greater number of patrons and stakeholders for Latin American art eager to fund shows within US art and culture institutions.[17]

One curator shared how she was only able to include a "Latinx" component to a show after a patron learned that his own compatriots were among the groups that migrated to Los Angeles. Others shared tales of being pressed to "expand" shows initially intended as Latinx shows at the request of board members and sponsors. On and on, shows with a "national" reference were seen as more marketable than shows where Latinx artists were presented as just "American" artists. By contrast, exhibitions focused on Latin American art were seldom pressed to expand or open up to Latinx artists—unless there had been a public outcry, as with the PST shows. Elizabeth Ferrer, a Mexican American curator who worked at the Americas Society and later at BRIC Arts in Brooklyn, echoed similar experiences by other curators when recalling that it was relatively easy to get funding for art exhibitions from her board members, many of whom are Latin American art collectors, or from embassies, or from other Latin Americans interested in promoting their culture, relative to how difficult it is to find funding for Latinx art shows.

For years, the Latinx–Latin America formula has been a common framing device to bring about appreciation and value to Latinx artists akin to Latin American artists just by their mere association. Some artists included in the PST shows shared this view. They welcomed their inclusion, seeing it as a political challenge to the white-centrism that tended to expunge Latinx artists from the Latin American canon and that had kept Latin American curators ignorant about US Latinx artists. At the same time, the PST shows confirmed the limits of this exhibition formula.

The exhibition *Radical Women: Latin American Art, 1960–1985* provides a telling example because it was the most heavily researched and most expansive, and most highly publicized and reviewed exhibitions within the initiative.[18] Let's start by following up on my discussion of the politics of naming exhibitions by considering how "Latin America" was prominently indexed in the title, but "Latinx" was not. In fact, the *Radical Women* show was initially devised as comprising only Latin American artists and was expanded to include Latinx artists only after activism and pushback from the Los Angeles Chicanx community.

Yet, even the Latin American component of the exhibition was incomplete. There are thirty-three countries in Latin America and the Caribbean, but only fifteen were represented in *Radical Women*, a common trend in most Latin American art shows, which tend to be dominated by artists hailing from the largest countries (e.g., Brazil, Mexico, and Argentina), those with the most links to global art centers in Europe and the United States. The mere inclusion of Brazil in most Latin American exhibitions and the total exclusion of Haiti evidence the racial politics of dominant definitions of Latin American art. Both Latin American countries speak languages other than Spanish, but only Brazil is regularly included as part of Latin America, never Haiti. This exclusion ignores the historical, not linguistic, roots of Latin America, and confirms how much anti-Blackness has shaped the category of "Latin American art." In fact, there was only one Black Latin American artist in the *Radical Women* show, the Afro-Peruvian artist Victoria Santa Cruz, whose video exposing anti-black racism "Me gritaron negra" (They shouted black at me) (1978) spoke volumes about the exhibition's treatment of blackness. As art historian Bianca Moran notes in her review of *Radical Women*: "It is ironic that the one visible black body we encounter in the exhibition is that of Santa Cruz, who is literally exclaiming about the experience of being marginalized, ignored and erased and the burden black bodies carry in Latin America yet, she is the ONLY artist included, which makes the Afro-Latina experience almost entirely invisible" (Moran 2019:6-7). Moran wonders about the very definition of radicalism espoused by curators, considering that it is Black and Indigenous bodies who are most vulnerable to power and politics, and who are also at the vanguard of political resistance across the region. As she notes: "It is not that there are or were no Black women artists in Latin America, it is that there were none whose achievements or practices the curators found worthy of being included." (Moran 2019: 5). In this way, the exhibition revealed the Eurocentricism tendencies behind the idea and definition of Latin American art, which tend to exclude entire regions like Central America and the Andes, as well as Indigenous and Afro-descendant artists, and the entire topic of race.[19]

In particular, the *Radical Women* show featured artists of primarily middle-class backgrounds hailing from the most global and cosmopolitan sectors of their societies, a trend not uncommon among Latin American artists who are used to traveling to global cities like New York for training or professionalization. At a Frieze symposium on

Latin American and Latino art at NYU's Institute of Fine Arts, Cecilia Fajardo-Hill confirmed the upper-class and cosmopolitan background of most of the exhibited artists who were part of a thriving Latin American art community that gravitated to New York City. "Latin American art is an incredible international idea," stressed the exhibition's cocurator, adding that almost everybody featured in the exhibition came from somewhere else—that either they or their parents had immigrated from Spain, Germany, or elsewhere. Fajardo-Hill, who is British and Venezuelan, offered herself—a "cosmopolitan Latina," as she is called by Patssi Valdez, a Chicana artist in LA—as an example of the type of international networks that are common but are seldom recognized to exist among Latin American artists.[20]

There is also the matter of how the Latin America–Latinx art formula promulgates nation-centric curatorial policies, where Latinxs become "one more country" among the many other Latin American countries. Given this, navigating maximum representation of artists in the region almost guarantees the overrepresentation of Latin American artists relative to Latinx artists based on the simple fact that there are far more Latin American countries that need inclusion relative to the "one more country" represented by Latinx artists. This was evident in *Radical Women*, where there were only eleven Latina artists from over a hundred twenty artists exhibited, most hailing from the largest South American countries, and where this "fair" representational formula, in terms of the number and size of countries throughout the region, became the subject of controversy.[21]

The nationalistic tendency to anchor and identify artists by nationality in order to signal the representation of one or another country also gets in the way of appreciating the cross-fertilization of artists working transnationally. One example is when an artist's country of birth is prioritized over where they work, or have lived for many years, or are presently residing. For example, Ana Mendieta and Zilia Sánchez are regularly identified as Cuban, which erases Mendieta's Latinx identity and Zilia Sánchez's Puerto Rican influences, after residing in Puerto Rico for almost fifty years.

Finally, Latinx artists tend to get lost when placed in the larger and more recognized framework of Latin American art. I spoke about this with Tatiana Flores, a Latinx art historian of Venezuelan background who teaches at Rutgers and curated *Relational Undercurrents: Contemporary Art of the Caribbean Archipelago*, one of the two exhibitions in "Pacific Standard Time LA/LA" focusing on the African diaspora in

Latin America. Flores was disappointed to see the Latinx content of *Relational Undercurrents* bypassed and unrecognized in many conversations about the PST initiative. This exhibition challenged the geographical boundaries of the Caribbean by including diaspora artists and by placing Caribbean artists squarely in the Latin American conversation, including artists from Trinidad and Haiti, who are regularly overlooked. "Half my roster are diaspora artists," she tells me, proudest of having shown in Los Angeles, and at the Museum of Latin American Art (MOLAA), for the first time such a strong cohort of Latinx artists of Caribbean background, including Elia Alba, Firelei Báez, Maria Elena González, Guerra de la Paz, Sherezade Garcia, Joiri Minaya, Lilian Garcia-Roig, Miguel Luciano, Angel Otero, Juana Valdes, Didier William, and Lisa C. Soto, among others.[22] Unfortunately, these artists' Latinx identity remained under the radar in many of the reviews of and critical conversations about PST. These conversations were dominated by the Latin American and Latinx conversation, and by the lack of Chicanx artists in particular, so they neglected discussions about the diversity of other Latinx artists being shown.

Fueling these erasures is the general lack of Chicanx and Latinx curators researching and generating shows. So argued Armando Durón, a longtime Chicanx art collector and organizer based in Los Angeles, who has been battling for decades for the equitable recognition of Chicano art. Durón was one of the activists pushing the PST shows to also show Chicanx and Latinx art, and after following its development and seeing seventy-one of the shows, delivered one of the strongest Chicanx-centric criticisms of the entire initiative. At the 2018 CAA meetings in Los Angeles, Durón shared that only 48 (or 19 percent) of the 250 total events were Chicano-centric, while narrating poignant and familiar issues faced by Chicanx artists and activists as they struggled to be recognized as experts and curators in these shows (A. Durón 2018). For instance, the *La Raza* show at LA's Autry Museum of the American West, which focused on the bilingual newspaper published from 1967 to 1977, was one of the most Chicano-centered shows in the entire initiative. However, according to Durón, *La Raza* photographer Luis Garza, who came up with the idea for the show, had to argue for a year and a half with the Getty to be acknowledged as the exhibition's cocurator alongside the Autry's chief curator, Amy Scott. As he added, Garza was the recognized expert, the one who knew about the images, the people featured, their historical context and significance, and the politics of representation involved in narrowing over 25,000

images to the 273 that would make up the show. Still, he was initially dismissed as a fact-checker and assistant to the project on account that he was one of *La Raza* magazine's photographers and could not rightfully serve as its cocurator. In Durón's view, the lack of Chicanx art historians and curators forced Garza to wear multiple hats; similarly, those circumstances explained why it was Durón who delivered the PST critique to the audiences at the CAA panel.

Another example is the pushback against Amalia Mesa-Bains's treatment of the "border" in her exhibition essay, "Baca: Art, Collaboration and Mural Making." As Durón explains, Mesa-Bains is a MacArthur grant awardee and an undisputed expert on Chicanx art. Yet the exhibition catalogue editors could not understand her use of the "border," which, true to Chicanx use, transcends its definition as a physical space. In his words: "In the Chicanx academic and social world we have always understood the border to have a much more expansive meaning. We see borders everywhere. For us it is not just a physical place of demarcation, but a metaphoric, metaphysical, foggy plane. These expansive definitions of the border are about as old as the field of Chicano Studies. Yet is was totally new to the Getty. Rather than accept it, the Getty fought with Mesa-Bains over many months until it finally acceded" (A. Durón 2018). As these examples show, it is extremely difficult to validate Chicanx and Latinx perspectives in white spaces, but even more so when there are so few Chicanx and Latinx curators involved, and such narrow definitions of who counts as an "expert."

Finally, the Latinx–Latin America formula has presented a highly frustrating framework for Latinx curators, who face a lack of resources and scholarship covering Latinx artists, compared to the robust resources that exist for Latin American art. Taína Caragol, the first Latinx curator at the National Portrait Gallery, told me about coming to this realization during her work as a bibliographer at the library of MoMA in the early 2000s. There, she witnessed firsthand how hard it was to find Latinx artists represented in one of the most reputable bibliographic collections of modern art from the United States and also from Latin America. This experience inspired her doctoral thesis on the growth of Latin American art markets in New York City in the 1970s and 1980s, which strategically includes Nuyorican and other Latinx artists (Caragol-Barreto 2013). Born and raised in Puerto Rico, Taína was never taught about Nuyorican artists. She had to wait until college to be exposed to the first course on Nuyorican literature

and to be confronted with the prejudices that dominated discussion of diasporic Puerto Rican culture on the island. Her decision to insert Latinx art into the Latin American art conversation in her dissertation was part of what she described as "a visceral reaction," a desire "to put pie in the face of the white mainstream" that consistently sets Latinx artists apart.

Taína's dissertation stands as the most important record documenting the network of cultural institutions, curators, and corporate stakeholders that contributed to the growth of Latin American art as a market category throughout the 1990s, and how this trend paralleled the sidelining of Latinx art and artists. In particular, her archival research shows how institutions from Exit Art, El Museo del Barrio, Cayman Gallery, and the Bronx Museum of the Arts, among other alternative museums and galleries in New York founded by Puerto Ricans and Nuyoricans, had exhibited Latinx and Latin American art alongside each other, without privileging one over the other, from the 1960s onward. The distinction and favoring of Latin American art over Latinx art is more a product of the late 1980s and early 1990s, she argues, a time when mainstream art museums started collecting Latin American art but not Latinx art. In other words, it was the product of a new Latinamericanism that was more directly aligned to the market. As Yasmin Ramirez put it in her presentation at the 2019 Latino Art Now! conference, comparing the visions of the former director of El Museo del Barrio, Jack Agüeros, to what prevails today: "The type of Latin Americanism advanced by Agüeros was one of struggle, not the type where you end up seeing the same thing as you'd see in a Frieze art fair."[23]

In fact, none of these early Puerto Rican, "Hispanic," and Latin American arts and cultural spaces were inserted in markets. Cayman Gallery, for instance, was about exhibiting work, not selling it. This is a key difference to keep in mind against a nostalgia to recover these projects to reinforce the Latinx–Latin American formula without accounting for the different contexts and different types of Latinamericanisms at play in the early 1980s and 1990s and today.[24] What is more, it was not only North/South conversations that were being generated by Cayman Gallery and MoCHA, but also dialogues with Chicanxs and with other groups, then called "Hispanics" in the West and elsewhere. For instance, Judithe Hernández had a solo exhibition at the Cayman Gallery in 1983, making her "the first Chicana to extend her artistic reach beyond the West coast," while Amalia Mesa-Bains exhibited in various shows between Cayman and MoCHA.[25] Unfortunately, these types of cross-Latinx exchanges

have been largely downplayed by the emphasis on MoCHA's role as antecedent to today's Latinx–Latin American formula.

Indeed, both Latino and Latin American art have been marginalized and subject to stereotypes—whether it is seen as too parochial, too political, too ethnic, or not ethnic enough, relative to racially normative and non-ethnically-marked categories like "American art." However, in a context where Latin American art has grown in acceptance and validation over Latinx art, one must inquire into the continuous fusing of these categories and probe into who is making the connection, and on whose terms. These questions are more necessary than ever, considering that to date, placing artists from such diverse backgrounds in conversation has done more to boost the status of Latin American art than to elevate Latinx artists.

Nilda Peraza, the founder of MoCHA (Museum of Contemporary Hispanic Art, 1985–1990) confirmed the gaps in the development of Latinx and Latin American art when looking back to MoCHA's history and recognizing the different trajectories among the artists exhibited during the museum's short life. At the time, Cayman Gallery was located on West Broadway and in close proximity to popular mainstream galleries such as Leo Castelli, Mary Boone, and OK Harris, while MoCHA was opposite to the New Museum of Contemporary Art. Their location in Soho instead of in a "Latino barrio," like other African American and Puerto Rican institutions of the times, made Cayman Gallery and later MoCHA pilgrimage spaces for Latin American artists seeking a "foot" in the city. She tells me: "We were sought after by artists who did not want to exhibit in El Barrio, who were looking for a place to exhibit in New York so they could say they had shown and had presence in New York and claim status in their countries back home." She tells me, "They came with cards from area gallerists who sent them to us," evidence that MoCHA was always their second choice to the white galleries they had first visited. She listed artists like Eugenio Dittborn, Antonio Amaral, and Ismael Frigerio among those who started their careers at MoCHA and continue to enjoy access to Latin American art spaces and galleries, both in the United States and back in their countries. Unfortunately, the same is not the case for many of the Latinx artists who exhibited at MoCHA, such as Amalia Mesa-Bains, Juan Sánchez, and Judithe Hernández, who never developed a market for their work, or in the case of Hernández, did so only lately as a result of latent visibility. Most of these artists also remain shunned by many Latin American art spaces and collections, even if they have been coexhibiting with Latin

American artists for decades. This disparity explains why, to date, many Latin American artists who have lived in the United States for decades continue to insist on identifying themselves as "Latin American artists," capitalizing on the greater value and opportunities that, for decades, this category has afforded them.

Finally, the Latin American formula has also favored the importation of Latin American curators, leading to a curatorial pool that is whiter and from more class-exclusive backgrounds than the Latinx artists and communities they are hired to serve. Even more problematically, many of these curators have had little to no knowledge and experience working with Latinx artists before being placed at the helm of important Latinx museums, adding tensions and conflicts as they learn and maneuver US racial cultural politics that they are largely unfamiliar with and that boards seemingly dismiss as unimportant when making these hires. Carolina Ponce de León, who had recently moved from Colombia when hired as curator at El Museo (1996–1998), described the political minefield she encountered in a published interview that dates back to 2001, but that is as timeless as it is evocative of the continued tensions that arise when Latin American art curators with little experience in Latinx art and history are hired in historically Latinx-specific museums. As she explained, her Latin American colleagues dismissed El Museo's Latino mandate as a "cultural ghetto," too tied to "community art," while Latinx artists were concerned about the "privileged attention" given to Latin American artists (Ponce de León 2001). Different perceptions of class, race, ethnicity, and relationship with dominant culture also distinguished Latin American artists from US Latinx artists, whose work she felt was more likely to be in conversation with US identity politics than with the "international avant-garde" (Ponce de León 2001). The culture clash and misunderstandings that often ensue from this hiring pattern at El Museo del Barrio range from the mislabeling of a photograph of a resident of El Barrio by renowned artist Hiram Maristany as "Santeria," which prompted him to remove his donated works from El Museo in protest of the exotification of his work, to the brouhaha over naming a spoken-word program with a racial slur ("Spic Up/Speak Out"), to a disrespectful diss from a Spanish curator appointed to El Museo who called East Harlemites "esa gente."[26] Most recently, the failed plan to honor the troubling German socialite Princess Gloria von Thurn und Taxis during El Museo's fiftieth-anniversary gala exposed how matters of race and class are intimately involved in these culture classes. The

princess is publicly known for her connections to Europe's far right and conservative figures like Steve Bannon, and well known for racist comments against Africans, yet was proudly listed as an ambassador of the gala in El Museo's website until public pushback and press coverage hampered the plans. Who made this choice remained uncertain, while gaps between those at the institutions' helm and the interest of larger Latinxs community were put on public display by the drama.[27]

In turn, for Latin American arts professionals, a gig in the United States, especially in global cities like Los Angeles and New York City, becomes a valuable investment—a sure way to jump into the US art world as an "expert" in Latinx art, or as coveted hires to solve the lack of diversity in mainstream art institutions. At El Museo del Barrio, New York City's top "Latino/Latin American institution," this trend has led to the institution's reputation as "the international stamp center," as a local East Harlem resident put it, all while Afro-Latinx, Puerto Ricans, Blacks, and Latinxs of color have become almost invisible, especially in top creative and leadership positions.

The result is a continued disregard for expertise and knowledge in Latinx art in most US museums around the view that hiring any "Latin person" will do. In this way Latinx-specific institutions become complicit in the reproduction of class and race hierarchies among their staff, contributing to the subordination of Latinx art while undergoing little scrutiny. A growing trend is the representation of Latinxs through the fickle realm of programs, temporary social practice installations, or parties, rather than within the ranks of curatorship, directorships, or exhibitions. At the moment, this trend is evident not only in mainstream museums but also in those supposedly focusing on Latinx art, leading Latinxs art and communities to be equally excluded and relegated from both spaces.

Finally, these hiring trends would not be as problematic if they were not so intertwined with dynamics of race and class. In this regard, it is impossible to generalize about the class and education backgrounds and trajectories of all the curators, artists, and stakeholders I spoke to, most of whom felt marginalized vis-à-vis a white-dominated art world. However, for Latinx curators this vision was amplified by their experiences growing up as racial minorities in the United States with very little knowledge and appreciation of anything Latinx. Latinx art artists and curators also grappled with a general lack of infrastructure for promoting Latinx art and with a racial baggage that "Latin American art" was freer from.

Pilar Tompkins Rivas, the first Chicana director of the Vincent Art Museum, spoke to this point when discussing the many stereotypes and misconceptions about Chicanx art she has had to confront in Latin American art spaces, where she often finds herself as the only Chicana in the room. In these spaces, the level of misunderstandings is rampant, as she put it: "They see Chicanos as the children of people who are their servant class." Rivas, who has traveled throughout Latin America and Europe since she was a graduate student, is very sensitized to different understandings of her Chicana identity she has experienced and to racism as a global phenomenon. For her, the key has been pushing Chicanx and Latinx art into global settings and contextualizing the work internationally to move beyond the diminishing structures of Los Angeles, where Chicano art is always debased. She has also turned the "Latin American formula" on its head in her exhibitions of Chicanx art, such as by expanding to other currents that have influenced Latinx art and challenging head-on narratives of influence and circulation. A perfect example is her exhibition *Regeneración: Three Generations of Revolutionary Ideology*, which highlights transnational political activism between the United States and Mexico. The exhibition focuses on the agency and creativity of Los Angeles actors and communities inverting the dominant unidirectional Latin America–to–Los Angeles trope as the only source of artistic and creative inspiration. Instead, the exhibition anchors Los Angeles as the site of these exchanges and cultural production while providing a much-needed spatial perspective on transnational activism across the Americas.

Like Pilar, I found many Latinx art curators well versed in Latin American art scenes and artists, while most Latin American art curators drew a blank whenever I asked if they also knew some Latinx artists. Even Latinx curators were unfamiliar with other Latinx artists beyond their region, nationality, or background. This is another outcome of the dominant Latinx–Latin American formula pushing conversations that are hemispheric rather than across region, history, and genre, limiting the very possibility of Latinx art being referenced and promoted in relationship to other artists in the United States or globally. We still have not had conversations about Latinx art in relation to the Black Atlantic or to larger issues beyond the dominant North/South or Hemispheric geographical reference, or even in robust conversation with other artists of color in the United States. Or even more simply, we are yet to see exhibitions that integrate Latinx artists into any major exhibitions in the United States in ways that insert them

into larger narratives of American art. This is a big concern of E. Carmen Ramos, who has been using the hashtag #IntegrateAmericanArt to promote this more ample and synergetic view of for exhibiting Latinx artists. In sum, we have yet to put the theorizations of newer generations about the expansiveness of Latinx art on full display. Indeed, younger generations crave for more visual displays of the multiplicitous experiences of Latinx artists, such as shows that place Chicanx and Dominican artists in conversation, or that examine themes that Latinx artists may be exploring in similar ways across regions, or that reflect the multiracial and ethnic contexts in which many Latinx artists actually live and work, or that simply respond to whatever themes may surface from their work. Finally, the impetus to represent as many artists as possible in the diminished opportunities to do so left few opportunities for solo shows that honored and valued trajectories of individual artists in ways that art historians would recognize. In sum, most Latinx curators are saying "Basta!" to the formula, and this could not come at a better time.

Here Come the Activist Curators

Latinx art is American art is a necessary political statement. ╱ **E. CARMEN RAMOS**, remarks at panel "Latinx Art is American Art," El Museo del Barrio at New School.

There's so little representation of POC in the arts and zines become mobile archives. Our legacy will be disrupting a canon and radicalizing history and making and claiming space, even if it is the size of a zine. ╱ **CLAUDIA ZAPATA**, remarks at panel "Our Curated Scene: DIY Publishing, Zines & Archives" The Latinx Project, NYU.[28]

I want to end this chapter introducing some of the many voices that are changing the conversation and broadening the definition and appreciation of Latinx art. Key trends include making Latinx art visible as American art, placing it in spaces and conversations that have historically eluded them, creating new platforms in the digital world, and recording what artists are doing in particular spaces and communities.

One long-standing artivist (and a longtime friend of mine), Nuyorican curator Yasmin Ramirez, has spent decades documenting the

worldliness of the Nuyorican art story, what she calls the "East Harlem Renaissance" (the working title of her dissertation/book in progress).[29] A proud Afro-Boricua, Ramirez is an icon of the New York City arts scene. She is the sole Nuyorican art historian and curator who both has formal training and was actively involved in the alternative art scenes of the 1980s and beyond. She can talk from experience about the work of generations of artists involved in all media, from political posters to graffiti, having worked and written on diverse artists ranging from Basquiat to Jorge Soto and Nitza Tufiño. In sum, she's everyone's go-to contact for erudite and hands-on criticism on anything related to the history of Nuyorican art.

In particular, Ramirez has been an advocate of expanding the interpretation of artists who worked with Nuyorican artists or are central to telling the story of Nuyorican communities, such as Martin Wong, who worked alongside poet Miguel Piñeiro and portrayed the multiethnic milieu of the Loisaida community, and Alice Neel, who lived and worked in Spanish Harlem and represented Puerto Rican community in numerous paintings. Yet her biggest concern is inserting the Nuyorican art story into the larger story of New York vanguard arts. One key example is her last major museum show, ¡Presente! The Young Lords in New York at the Bronx Museum (2015), cocurated with Johanna Fernández. The show almost did not happen: funders were skittish about the show's radical content and its lack of "recognizable" art such as paintings. Yet the show challenged skeptics when it ended making the New York Times' "Best Art Shows" list in 2015.[30] In particular, the show reframed the legacy of the radical activist group as a sociopolitical movement with a self-defined style, honed in everything they did, from the styling of their uniforms to their publications and the work they did as a precursor of social practice art with communities so popular today.

At many public conversations and panels on the topic, Ramirez is often the one person pushing against the arts canon and correcting the continuous misrepresentation and omissions of Nuyorican artists and history in New York City. We already saw her correction on different types of Latinamericanisms at the Latino Art Now! conference in Houston (2019). At a "Pre-Latinx: The Veterano Avant-Gardes" panel at the New School, which focused on the generations of artists working in New York City in 1970s and 1980s, she even pushed against the categories "Avant-Garde," "Veterano," and "Pre-Latinx," on the grounds that they constrain an understanding of what Nuyorican artists were actually doing. "[These categories] remind me what happens to us in

graduate school," she says, recalling how Hal Foster had once told her there is no such thing as an alternative art movement, that the times to create revolution are over, among other lessons presenting Anglo-American avant-garde artists as the only examples of radical breaks. "For us," she said, this meant that "artists of color could not claim the same radicalism and originality." Let's call them OGs (Original Gangsters) instead, she proposes. That evening she schooled the audience about the radicalism of artists' creating artist-led spaces, such as the Alternative Museum, founded by Papo Colo; of artists being out and open about their sexuality and documenting the Latinx gay rights movement, as with Nitza Tufiño and photographer Luis Carle; and of the radicalism of Marta Moreno Vega, being an Afro-Boricua museum director and artist in 1973. OG is also what young people call her, she says with pride, and I immediately got what she was after. "Veteranos" indexes the formalized experience and formation of a past, while "OG" evokes the illicit nature of these artists' radicalism.

Josh Franco, a self-described Chicano native of West Texas, is the Latino Collections Specialist at the Archives of American Art at the Smithsonian. He is also a cofounder of the US Latinx Art Forum and part of a new generation of curators and archivists who are changing and expanding the conversation around Latinx art. Josh was inspired to become an art professional by his frequent family trips to visit relatives in Marfa, Texas. Marfa is home to the personal arts oasis of Anglo-American art icon Donald Judd, though Franco only learned this in college. He had visited Marfa myriad times without ever once having heard Judd's name or visited the Judd Foundation properties in Marfa. Learning that his family's town was treated as canonical in the history of American art was a wake-up call for him. The Marfa he learned about in school was devoid of Mexicans and Mexican culture and bore little resemblance to the vibrant landscapes he had inhabited back home, where Judd was not even a reference in the daily lives of residents. He grappled with this realization as an art history student interested in decolonial aesthetics, leading to his thesis on Marfa and the decolonial aesthetics of rascuachismo, a concept he is now committed to legitimating as a Latinx archivist at the Smithsonian.

We talked at the Judd Foundation in Soho, where Donald Judd's living and working space is kept intact as a permanent exhibit of minimalism. Josh dragged me there from the coffee shop where we had agreed to meet, insisting that stepping into this space would immediately convey the importance of his mission to document and

appreciate the Chicanx aesthetics of rascuachismo. The Judd Founda-
tion was mere blocks from my house and almost as hidden as Judd's
Marfa had been for Josh. Yet once I entered the space, I immediately
understood what Josh was up to. Rascuache is the total antithesis of
Judd's minimalism. It is the altars, the ofrendas, the colors, the mixing
of high and low and the excess of making do with anything you have
that distinguished a lot of Chicanx popular culture and art. However,
because rascuachismo is never acknowledged or taught, it is almost
impossible to see, and much less able to be appreciated as an aesthetic
of its own (M. Anderson 2017). Franco's mission is to address this
problem; as he put it, "I want rascuachismo to be as available as mini-
malism or abstract expressionism as any other American artism." He
was especially proud of an oral history interview he did with Chicano
collector Cheech Marin for the National Archives. Marin was very fa-
miliar with the concept and had a lot to say during the interview. "His
eyes lit up when I brought up the term," he tells me. "I don't imagine
just any interviewer would have brought it up, though that's the goal
one day."

Then there are the many writers and digital archivists who are tak-
ing on roles as "arts equity advocates" and creating new platforms for
visibility in the digital world of social media. These include younger
generations to veteran writers, artists, and curators such as Kiara Ven-
tura (ArtsyWindow), Jasmin Hernandez (Gallery Gurls), Guadalupe Ro-
sales (Veteranas y Rucas), Djalí Brown-Cepeda (Nuevayorkinos), Karen
Vidángos (A Latina in Museums), and Rocio Alvarado (100Latinxartists),
most of them Latinas who find in the digital realm a freer space, at least
less encumbered by the institutional politics, requirements for degrees
or credentials, or the dominant formulas that plague institutional spaces
like academia, print journalism, and museums.

Naiomy Guerrero, the inaugural curatorial fellow of the Pérez Art
Museum Miami's Diversifying Art Museum Leadership Initiative, found
her voice and eventually this curatorial opportunity at the Pérez Mu-
seum through her blog posts and digital presence. Born and raised in
the Bronx to Dominican parents, Guerrero was moved to action by her
passion for art and her outrage at the stark segregation of New York
City's art world. As she shared in a blog post, "I was born and raised in
what many consider to be the art capital of the world, but didn't step
into a contemporary art gallery until the summer after my first year
in college" (Guerrero 2016). Before moving to Miami to work at the
Pérez, Guerrero was a tireless commentator of the exclusivity of New

York City's art world, and the invisibility of Latinx artist's presence at every panel and conversation whenever these issues were discussed and she was present (Guerrero 2017). But it is through her blogs and digital projects that she took charge of these issues by documenting the work of US Latinx artists, addressing their absence in permanent collections and arguing that they must be known and valued.[31] "I want to level the playing field," she says, explaining the impetus behind her US Latinx artists documentation project, where she specifically focuses on artists from nontraditional backgrounds, such as those who did not go to prestigious MFA programs that "everyone is looking at." Guerrero tells me she is especially interested in Black women artists of Latin American descent, who are among the most overlooked in the Latinx umbrella. Her first exhibition at the Pérez highlights her curatorial interest on overlooked artists—it will be a group show organized around the work of artists who are not formally trained.

Many more artists and curators are working off the grid, curating shows in pop-up spaces or in people's apartments. They all share the same passion for making Latinx artists' stories visible and exhibiting artists who are less known using Instagram as the forum to overcome their exclusion in galleries and museums. Kiara, a young Afro-Dominican from the Bronx, was only twenty-one when she curated *For Us*, one of the most highly attended and successful shows at the Bronx Arts space. "Community members first noticed the space after my opening," she tells me, proud that so many nearby residents visited the gallery for the first time to see her show. Kiara was paid two hundred dollars for the show, though she invested four hundred dollars from her own pocket to produce a glossy catalogue as part of ArtsyWindow, a virtual space she founded to amplify voices of diverse artists, or, as she put it, "to push artists and the public to see through another perspective, or shall we say, an 'artsy window.'"[32] We went through the catalogue, and she gave me the who's who: "Nicole Bellow, born in DR, raised in the Bronx; Rocio Marie Cabrera, Dominican, raised in the United States; Dana Davenport, Korean-Black; Monica Hernandez, Dominican, from the Bronx; Caseena Karim, Guyanese, Muslim, queer; Jheyda McGarrell, Black Mexican via Los Angeles; Solaris Sapiente, Dominican Ecuadorian." Most of them are also queer identified, she noted.

Ramirez, Franco, Guerrero, and Ventura are just a few of the variety of art workers across generations and media who are shaping and sharing the future of Latinx art. Some work in institutions, others

are making do with little, nonchalantly creating archives and producing interventions and diverse shows, blogs, zines, and more to insert Latinx voices and stories in all of the spaces these should be centered. They are doing so synergistically, fully aware that Latinx artists should never be a minority if you're really in tune with what is up. This is the ethos of "I show artists I know, I am from the Bronx" or "I wanted to show all the great artists I know but are never shown" that I heard from numerous curators of color, echoing the radicalism of the art workers of the past. What comes next must be transformative. I cannot wait to welcome the change.

CHAPTER

TWO

78

Nationalism and the Currency of Categories

To fully understand the exclusion and lack of legibility of Latinx artists in art history and in the commercial art circuits, we must delve into the rising infrastructure for Latin American art that has grown alongside the internationalization of art markets. For starters, let's remember that Art Basel Miami Beach (2002–), one of the most important international contemporary art market fairs, was always conceived as a gateway to Latin American art markets and collectors (Viveros-Fauné 2018). Since then, the influence of Art Basel Miami Beach is everywhere evident in the rise of multiple contemporary art fairs throughout the region, from Zona Maco in Mexico to ArtBo in Bogotá and Art Lima, among others. These fairs have become regular destinations for collectors, but in these spaces there are very few to no Latinx artists exhibited, and there is little discussion of Latinx artists that would call attention among collectors. In fact, I found that despite having worked and lived in the United States for years, many Latin American curators and dealers were as unaware of US Latinx artists as their white and mainstream counterparts are.

All of this shows how salient the ongoing segregation of Latinx and Latin American art worlds is in the realm of art markets. In fact, while

curatorial and scholarly efforts have tended to couple Latin American and Latinx art, markets have always been clear about the marketability of keeping these fields as separate as possible. Consider, for instance, the "Pacific Standard Time: LA/LA" (PST) exhibitions at museums in relation to the accompanying gallery program, where the separation of Latin American and Latinx artists in local galleries was in full display. The Getty had encouraged galleries to show Latin American and Latinx artists for the first time as they sought to participate in, and hopefully profit from, the global momentum of this megaprogram. One dealer remarked on the powerful influence of the Getty by joking, "If Getty had said find artists who made clown paintings, you'd have had a hundred galleries jumping and showing artists with clowns." However, many of the Latin American artists included in the PST exhibitions were simultaneously represented by satellites of Latin American galleries that have opened in Los Angeles or had pop-up shows during the event ensuring a seamless museum-to-gallery exposure that bolstered the market evaluation for these artists. Not so for most of the Latinx artists exhibited.

One example is Proyecto LA, a pop-up gallery in a downtown warehouse organized by some of LA's Latin American collectors, bringing

together major galleries from the United States and Latin America, where I saw many of the artists that were included in the major exhibitions of PST. From their website I learned that the glitzy converted space was put together by "distinguished Latin American curators" from Brazil and Colombia, in a space designed by a Mexican architect with offices in Mexico City, Los Angeles, and Milan, to boost the authenticity of the "Latin American" production.[1] The impressive showcase communicated to viewers the value of the Latin American artists shown in PST, and by association all the others showcased in their proximity.

I was uniquely interested in the PST gallery program because the first PST (2011–2012) had a huge impact on the market. Julia Halperin, executive director of *Artnet*, recalled during an Art Basel 2017 panel how the first PST, which focused on art in Los Angeles from 1945 to 1980, was described as a "shopping list for collectors seeking to build or strengthen their postwar California minimalism collections."[2] However, when asked whether the new Latin American–Latinx version will have the same impact on the market, Halperin was doubtful. In her view, the exhibitions were too spread out, and a lot of the

work was "ephemeral." Her loaded assessments made no mention of the difficulties of marketing Latin American and Latinx artists in Los Angeles, compared to the mostly white male postwar minimalist artists the first PST show helped to catapult into the market.

Overall, everyone I spoke to agreed that the PST shows provided additional visibility to many Latin American artists, especially those who had some degree of recognition in their home countries or gallery representation strengthening their status in the international markets. By contrast, Latinx artists were missing in action. They were exhibited in only a handful of area galleries. Most troubling, the few exhibited tended to be "nationalized"—that is, identified with a national country that allowed them to be represented as "Latin American" or whitewashed in other ways that I discuss in the next chapter. This is the case with Carmen Argote, the self-identified Chicana artist we met earlier, and the rare US Latinx artist picked up by a Latin American gallery (Bogotá-based Instituto de Visión); at Proyecto LA and other fairs, in both the literature produced by the gallery and the verbal presentation of her work, she was always called a "Mexican artist born in Guadalajara." This tendency to nationalize Latinx artists, especially those who were indeed born in Latin America, provides one of the clearest indication of the greater purchase of Latin American art in contemporary art markets.

This chapter delves into Latin American art market spaces to examine the "currency of categories" in the art market and why Latinx art must be delinked from Latin American art worlds in order to be appreciated and valued in all its complexity. Examining the Latin American art market also shows the importance of institutional validation and the role that identity categories continue to play in the art world.

I am fully aware that symbolic and commercial value is not always coterminous in the art world and that, touching only a minority of artists, the market is a poor barometer to assess the workings of all art worlds, especially those at the margins. However, I offer this analysis in a context when market logics are becoming such a dominant force in the international contemporary art world and at a moment when it is pressing that we do not underestimate, but instead fully understand, their influence and reach.

The Pull of the Nation

As new nations have entered the global art marketplace, much has been said about the globalization of the art world. Less discussed are the nation-centric dynamics that are fueled and strengthened by the globalization of the arts and the creativity hierarchies that they help maintain. Most specifically, the global art scene is fed by art fairs and biennials, and nation-centric policies and programs that benefit artists coming from nations with the strongest art infrastructures to ensure that their artists shine in the global art world. The field of art history, where geographical focuses such as "Latin America" or "Africa" are recognized specialties, also reinforces the penchant for nationalist references. Even the organization of art fairs anchors national references when galleries are identified by cities, which in contemporary art parlance become metonyms for nations. These dynamics are especially evident when one considers the rising popularity of Latin American art in the global scene.

As the product of US art institutions and geopolitical categories from the Cold War era, the category of Latin American art has been historically fed by a vibrant network of nation-centric stakeholders, collectors, institutions, national embassies, archives, curators, and galleries patronizing this art as a global category (Borea 2016). This network of nation/region/global linkages has historically favored countries like Mexico, Brazil, Argentina, Venezuela, and increasingly Colombia, and Peru, which have larger art establishments, over Central American countries and smaller nations, like Panama or the Dominican Republic. There is a history to the dominance of some countries (most of them the supposedly more "European" South American countries in the region) veiled and reinforced by notions of artistic quality (Dávila 2008; Traba 1994). For now, I focus on the nation-centric dynamics that continue despite the globalization of art markets. Even the definition of "Latin American artist" remains extremely nation-centric, especially around geographical boundaries, which seem to trump any other identifying variable. In auctions and collections, for instance, one may find European or North American artists who relocated to Latin America, such as the Belgian artist Francis Alys, who moved to Mexico in the 1980s and established a career there, before one sees a Mexican American artist or a US-born Latinx artist recognized in the category of Latin American art. The rare examples are Latinx artists who are born in Latin America and are often marketed as "Latin

American," because it is a more marketable category, even if they may have never even visited their countries of birth. Alternatively, when Latin American collections include Latinx artists, it is only those who have gained a measure of mainstream and commercial success, such as Teresita Fernández, though their backgrounds are never distinguished; rather, they are absorbed into the larger category of "Latin American art."

Key among these Latin American art stakeholders are collectors such as Patricia Phelps de Cisneros, who has spent decades amplifying the commercial value of Latin American art by patronizing research and curators. She has endowed a research institute and a position in Latin American art at New York City's MoMA and targeted gifts to major museums around the world. A recent example is her well-published and celebrated 2018 gift of over two hundred works by ninety-one contemporary Latin American artists, ninety of them to MoMA and the rest to other major contemporary art museums in the United States, Spain, and Latin America. While the acquisitions were supposedly arranged in consultation with curators from all the receiving institutions, it is obviously Phelps de Cisneros's collector eye, taste, and choice of works and institutions that is legitimized with the gifts and that remains dominant, shaping the collection policies of leading museums across the world. No wonder the curator critic Gerardo Mosquera ponders whether we are in the "private collector's age," with leading collectors beating curators as "legitimizers, promoters and gatekeepers" (2017: 61).[3]

This is a worrying trend affecting the acquisition of Latinx art and the work of any artists lacking the pull of patrons and collectors. Rita Gonzalez, the first Chicana curator of LACMA, explained how difficult it is for her to collect Chicanx art, especially the historical figures. She tells me it is almost impossible to fund-raise for these purchases because donors are most excited for the museum to collect artists they know or artists from their own collections. Add to this the reality that most museum boards are overwhelmingly white, even in cities like Los Angeles and New York City, where the overwhelming majority of the general population self-identify as people of color (Pogrebin 2017).[4] Additionally, until recently area museums were reticent to show Chicano artists. Armando Durón shared his open letter that in 2015 helped break the "no Chicano rule" at MOLAA to illustrate how the appreciation of Chicano art has been a slow process resulting from direct action and activism from locals (Miranda 2015). Rita Gonzalez

adds about LACMA, "Their Global Contemporary Acquisitions group wants to see what they saw at the Tate or the Venice biennale." In fact, she tells me that collecting Chicanx art has arguably become more difficult. In the 1980s and 1990s there were local collectors and galleries who focused on LA-area artists: "If you went to the house of Jack Nicholson and major collectors in Southern California in the late 1980s you'd see a Gronk or a Carlos Almaraz on the wall." But now it is very different: "The collectors that have emerged in the last decade want to compete with their peers in Miami and New York, so they are looking to Germany and Brazil and London. . . . They want to keep up and want that type of recognition as collectors, so they're less likely to be looking at Latinx art." Several dealers and gallerists give the same account about the new generation of Latin American collectors whether they are in Latin America, in New York, or Miami. As one explained, "The status thing is having international contemporary art in their homes. Their parents may have had great collections of national or Latin American artists, but their kids' homes look like any apartment in New York."

Not surprisingly, the trend toward exhibiting Latin American art within US museums has helped fuel public and philanthropic funds toward supporting the Latin American art market, even though it counts with more patrons and stakeholders that the Latinx artists who are in most dire need of institutional support. Being exhibited in the United States matters. It gives artists a stamp of approval, even when they may not have been initially supported in their respective countries. Unfortunately, the few Latinx artists represented by international art galleries do not seem to experience a transfer of value when they travel to Latin America. Some dealers are even discouraged to bring Latinx artists to Latin America art fairs, because, as one put it, "the white rich collectors there don't understand the issues and want to be associated with that sort of thing."

The point here is the need to recognize the growing influence of powerful collectors and stakeholders, and their taste for international and Eurocentric types of collecting. In fact, when I asked one gallerist at Art Basel what Latin American collectors are purchasing, she sent me to look at the Rosa and Carlos de la Cruz collection in Key Biscayne, Florida. This Cuban couple has amassed one of the most popular private collections from mostly commercially vetted contemporary international artists. "They are tastemakers," said the dealer; she added, "Being a part of and shown in the de la Cruz collection gives

validation." As a result, whereas at the height of the "Latin American art boom" in the 1980s it was magical realism that dominated curators, and collectors, imaginations of Latin American art, today it is geometric abstraction and conceptual art that dominate (Borea 2016). In all, the prevailing picture in "Latin American art" shaped by leading Latin American collectors favors art and artists inserted in Anglo and European art movements, over Afro-Latinx and Indigenous artists or those working in geometric abstraction over figuration, among other erasures that deserve more analysis of their own.[5]

Latin American nationalist elites have historically contributed to the strength and vitality of some of the most "mature" and developed Latin American markets, such as those of Mexico and Brazil. But now global networks and international art fairs are also trafficking in Latin American art across the region and the world, from Buenos Aires, Lima, Mexico, and Bogotá to Madrid, strengthening acquisitions in the category of Latin American art. Art VIP passes and programs specifically catered to collectors and museum directors are common at these fairs, which sustain a growing community of primarily elite Latin Americans and international collectors who either know each other or know about each other. These are the people whom one Latin American gallerist referred to as "los que mueven el caldero," the ones who stir the pot, and control what's in the soup.

The politics of "cheverismo," an economy of friendship where affective ties become a medium for establishing Latin American artistic collaborations and projects across the hemisphere, are relevant here.[6] Everyone I spoke to recognized the centrality of these affective bonds for bridging barriers and facilitating collaborations. These links were especially praised for helping people jump through bureaucratic and outmoded models favored by art elites and official cultural policies throughout the region. However, I immediately wondered about the exclusive implications of who is considered "chévere" to work with.

On this point, we must keep in mind the exclusivity and cliquishness of the art world everywhere, fined tuned by the highly racial and class-segregated reality of Latin American societies. Today more than ever, class intermingling in Latin American cities is rare. It is hindered by the segregated development and enclave lifestyles of contemporary cities.[7] I experienced a vivid example in the rising gallery circuit in Bogotá, Colombia. Like other cities in the region, Bogotá has developed contemporary art gallery clusters in gentrifying sectors of the city and has organized "gallery nights" to link the rising contemporary

art scene to their city's tourist branding. Yet when I visited the galleries clustered around Bogotá's barrio of San Felipe one afternoon, I found they were all closed and secured with chains and locks. No one could get in except by appointment, or at the whim of the person behind the lock. A student intern at one of the galleries well known by fellow gallerists gave me a tour, so locks and chains were opened for us. But signs of displacement and gentrification were evident in the abandoned buildings and streets, mostly empty except during "gallery nights."

I visited similar gallery districts in gentrifying sectors of Buenos Aires and began to appreciate how many of the Latin American galleries I had encountered in Art Basel or other international art fairs are best seen as makeshift spaces whose influence comes mostly through their Instagram and virtual footprint and their participation in international art fairs. Most of their sales take place during fairs abroad because the pool of clients is too small in their countries back home. It became obvious that these gallery districts are spaces geared not toward local communities, especially the ones they are displacing, but toward the type of global groups that attend art fairs, and toward the local elite collectors they are beginning to cultivate at home by cashing in on the "global" prestige they accumulate by participating in the international fair circuit.

This distance between local communities and new contemporary art infrastructures is especially evident in Buenos Aires, where the government-designated "Art District" is located in La Boca, one of the poorest and most gentrifying sectors of the city. Art studios, galleries, and arts residences—Proa 21, Arte Munar, Fundación Tres Pinos, and others—are popping up in the neighborhood, and all of them share a similar disposition to host international artists as a means of creating exchanges and inserting Argentinian artists into international art worlds. Yet up to my last visit on January 2019, no artists from La Boca had participated formally in any of the residencies, and there did not seem to be any plans to reach out to them. However, at least one of the residencies I visited drew from the neighborhood of La Boca as a resource in their call for artists to explore matters of marginality, space, borders, and community. I immediately thought of New York City's East Harlem and so many other Latinx barrios that are the subject of similar objectifying moves where artists, whether willingly or not, end up appropriating and consuming marginal neighborhoods as "inspiration" and influence for their work, while displacing residents from

these very communities.[8] The irony of seeing new glitzy artists' studios built a mere ten-minute walk from a Villa Miseria, from which residents were being relocated against their will, evinces the aggressive effects of this type of art-based urban planning. The entire sector was under development, yet arts and culture had been given a green light to build and occupy "empty" spaces, while the settlement of homes and people was entirely prohibited. In this way, Buenos Aires' La Boca arts district serves as an important reminder of the exclusive effects of many Latin American arts initiatives and of their differential impact on local artists and residents. For sure, it is a reminder that artists who live in marginal communities or beyond the perimeters of central cities, or who may lack the right education, class, race, or background (among other variables for exclusion), are not benefiting from the current Latin American boom in galleries and arts initiatives.

Latin American artists and curators may not share the exclusive backgrounds of Latin American collectors, yet in general, most of the artists I met in Latin America hailed from professional and intellectual backgrounds. Indeed, having the right background or patronage are prerequisites for participation in Latin American art networks, to the point that a Latin American art specialist I will call Laura, acknowledged the relatively homogenous scene with a familiar proverb for nepotism: "El que no tiene compadre no se bautiza" (Whoever lacks a godfather can't get baptized). Latin American artists, in particular, must have access to travel and mobility to make it, adding how rare it is for artists from an unprivileged background to access these spaces. Increasingly, artists must also speak English, the global language of contemporary art. Some Latin American artists of more modest means make do through the help of government fellowship and grants. But poor, Black, and Indigenous Latin American artists are rare in these networks: "You have exceptions like Oscar Murillo, but they are exceptions," Laura warned.

A series of panels on collecting Latin American art held at New York City's Americas Society in 2016 put in vivid display the hyperprivileged backgrounds of some of the key stakeholders making and branding Latin American art. Most in the "who's who" lineup had grown up among families who influenced their appreciation of art and taught them about its economic value. Augusto Uribe, deputy chairman of Phillips, recalled how his father, a diplomat who traveled throughout Latin America, introduced him to pre-Colombian art. Henrique Faria, a longtime veteran of Latin American art and owner of one of the most

important New York City Latin American art galleries, explained his preference for geometric abstraction as a reaction to his parents' penchant for landscapes painting "from the school of Caracas." For his part, the Chilean Latin American art mogul Juan Yarur recounted being a teen when he pressed his father to purchase him "a Marilyn" from Warhol, and twenty-three when he inherited the fortune to start Fundación AMA, a contemporary art foundation. Gina Diez Barroso, heir of one of Mexico's most important colleting families, even credited her grandmother with encouraging Diego Rivera to paint calla lilies. Because she did not like the "little Indians crying" that dominated his paintings, she insisted that if Indians were featured, they had to be looking at flowers, not at the viewer. Diez Barroso likened going to Sotheby's auction to shopping at Saks, except that at Sotheby's she did not spend, she *invested*. She had learned this lesson from her mother and passed it on to her daughter and also, that evening, to the panel's attendees.[9]

Most importantly, Latin American collectors function as key advocates for the value of Latin American art globally through their involvement in international museum boards such as the Latin American Acquisitions Committee at the Tate or MoMA's Latin American and Caribbean Fund. Through these involvements, Latin American art stakeholders are fostering the value of their own collections through donations of artwork to these institutions, and of Latin American collecting at a global scale. Estrellita B. Brodsky has endowed curatorial positions for Latin American art at London's Tate Modern and New York's Metropolitan Museum of Art and MoMA. For her part, megacollector Patricia Cisneros is known for having almost singlehandedly put Latin American geometric abstraction on the map, and having made the works of Venezuelan artist Jesús Rafael Soto a staple of any Latin American collector, through the sponsorship of her traveling collection in major museums, including the Reina Sofía in Madrid, El Palacio de Bellas Artes in Mexico, MALBA (Museo de Arte Latinoamericano de Buenos Aires), and Fogg Art Museum at Harvard, and her active patronage of Latin American museum acquisitions and curators.

These types of investments have shaped an exclusive yet fast-maturing segment for collecting that, since it is generally cheaper and less volatile than contemporary art, makes for a safer and fast-growing investment. This explanation was offered by Kaeli Deane, Director of Lisson Gallery in Los Angeles, who when we first met was head of sales for Latin American art at Philips in New York City. She tells me that

as contemporary art trends come and go, prices rise and fall: one can buy something one year that could be worth ten times more or nothing the following year. Yet with Latin American art there is always "more room for growth," and because there is less volatility in this market, it is a safer investment. "Prices don't rise at the same level, but you don't have to worry that (artists) will disappear," she tells me. This is another space where we see the politics of identity, value, and overcompensation, insofar as the lower volatility of Latin American art has a lot to do with the fact that these artists seldom come to auction without having well-established primary markets. As Deane notes: "With the contemporary art market, you might have artists showing up at auction who are still in their twenties and have only had one or two gallery shows and maybe no museum shows. . . . With the Latin American art market, if artists show up at auction, even if they are 'emerging' in the secondary market, they already typically have had many gallery shows and some museums shows solidifying their historical importance in some way." In fact, we can consider all Latin American contemporary artists "emergent artists," as this is the category used to describe artists who are "emerging" into the market anew and being rediscovered in new ways, irrespective of their trajectory. I heard this tagline used as a label for Carmen Herrera after she showed at the Whitney at age 101, or any artist who had "graduated" from Latin American art sales to contemporary art sales. This is what Wilson Valentin called the "Columbusing" effect when discussing the trend to hail the success of internationally known Latin American musicians, from Fonsi to Shakira, only after they are discovered by US audiences and tagged as "crossover artists," which becomes the "true" mark of success.[10] Similarly, artists only "internationalize" when they "graduate" from Latin American art sales into contemporary art sales, which is what commands the greatest price for any work.

The categorization of Latin American artists as "emergent artists" provides another instance of how globalization opens up avenues for participation, while reinforcing hierarchies of validation, through the categorization of some artists as eternally "emergent." However, while Latin American artists have structures of support to boost them from the eternally "emergent" category, this is not true for most artists of color in the United States. In fact, this category is most commonly applied to artists of color in the United States irrespective of their artistic trajectory. One example is African American artists Betye Saar and Emma Amos: though they are ninety-one and eighty years old,

respectively, and well recognized in African American art history, at the 2018 Frieze Art Fair they were exhibited in the "Spotlight" section, which features galleries showing artists unrecognized in the "Western" art tradition. This placement spoke volumes about the racialization of artists of color through their selective inclusion in art fairs. I cringed, during a tour of this section, when a guide called Saar and Amos "Black emergent artists who are finally being discovered," failing to make clear that both artists have recognized oeuvres and that they were invisible only to mainstream audiences. Similar blinders are regularly reproduced by the media when covering the supposed "coming of age" of artists of color, who are described as being "discovered" only after they are recognized by the mainstream art establishment, ignoring not only artists' previous trajectories, but also "the writers and scholars of color who know, and write about their work." As Steven Nelson, Professor of Art History at UCLA tweeted in response to the *New York Times* article focusing on the "discovery" of a number of senior Black artists such as McArthur Binion, Howardena Pindell and Melvin Edwards among others: "Some of us have been writing about these artists for decades. It's the mainstream art establishment that ignored them." (Nelson 2019a). This representation as unknown until the mainstream discovers them, and as separate and "almost" but never "there," even when they have long been recognized among critics, scholars, and many art historians, brings up a perceptive question by Jonathan Rosa (2018): "How are Latinxs to stake claims to rights in the present" when they are imagined as always emergent and of "future significance"? Following his reasoning we should ask, How will artists at the margins of a white-dominated art world be able to stake claim to equal representation when they are forever targeted as emergent or in the process of discovery?

That being said, clearly there are economic incentives involved in these categorizations. The branding of anything as "emergent" sustains the profitability of different sectors as affordable, smart, and poised-to-grow investments helping to attract new consumers wishing to cash in. In particular, Latin American art's systemically "emergent" status stimulates dealers and collectors to turn to the area in search of "their next investment." One dealer who is a frequent visitor to Latin American art fairs explained the draw this way: "You can get it in Colombia for $2,000 or wait for it to be discovered for $20,000. It's like a casino table, you win or lose. But you can get a lot more for your investment." This dealer was especially keen on discovering talent that is not rep-

resented in the United States and has not undergone the price evaluation that is common when galleries represent Latin American artists who are already located in New York City or Europe. The imperial logics involved in the process of validating artists echo the hierarchies at play in many other creative industries, where "developing" countries become the source of "extractive profit" to be fully maximized in the "developed" world. Accordingly, Latin America provides "authenticity," but validation and legitimacy come only from recognition by creatives located in "truly" global cities like New York. Catching up on these dynamics, many Latin American artists across the region are selling in dollars to control the speculation of their work, as well as the instability of prices due to inflation, which points to the dollarization of Latin American art markets, as these become more linked to international markets. This is another instance where we see how much the so-called globalization of contemporary art worlds becomes a veil for their Westernization with English-language fluency, dollars, and knowledge of international art currents becoming the dominant currency artists must manage to become both visible and legible.

Not surprisingly, I was often given noneconomic reasons for collectors' preference for Latin American art, over their investing in local US-based Latinx artists. For instance, while explaining his enthusiasm for the Latin American artists he encountered during his travels, one collector told me that Latin American artwork was more "political" and that artists there work with "an entropic purity" that contrasts with the "in your face" aesthetics of US-based artists. A dealer saw clearly through this fetish for "political work" coming from the South. "They like it when artists talk about colonialism, or politics from faraway countries that can be abstracted away," he told me, citing ironically how, in contrast, Latinx artists are often penalized by the market when their work is read as "political."

The fetish of traveling to Latin America to buy art was a special draw for Anglo-American clients and buyers of middle- and upper-class Latin American backgrounds who had not traveled to Latin America much but can now visit safely through the comfort of an art fair. "You are not selling art, but an entire experience," noted a gallery owner who encourages clients to attend art fairs and has even taken some of his clients to Latin America as pilgrimages of initiation into the field of colleting. Indeed, art fairs in megacities like Buenos Aires, Mexico City, and Bogotá provide increased opportunities for collectors to partake in the "exoticism" that Latin American art worlds represent,

through the glamourized and sanitized space of an art fair. The many times I heard Anglo-American and European collectors say "I love everything about Bogotá and Latin America" or "I've been to every city in Latin America" confirmed the types of "lifestyling" factors fueling their interest. For some, Latin American art worlds provide a way to easily consume and access exotic countries and authentic "multicultural" experiences of leisure and travel. For others, especially for the Latin American 1 percent, art fairs provide opportunities for being "in the know," lingering in trendy and artsy outfits in exclusive openings, sipping cocktails, connecting, networking, and showing off consumption habits and good taste. The "safe," elite, and high-end environment of art fairs has emerged as a key resource to navigate new cities and galleries, all with the promise of authenticity imbued with glamour.

Behind the Cuban Art Fetish

I don't know about Latinx artists, but I assure you that all galleries will have an artist from Cuba. Cuban always sells. / GALLERIST, ART BASEL

The growing popularity of Cuban art exemplifies the importance of structural investments through state funding and institutional infrastructures for artists from the public and private sectors that have helped bolster Latin American artists throughout the region. In the case of Cuba, the island's free education system, the celebration of Havana's biennial (1984), the patronage of wealthy Cuban collectors in exile, and US-based Cuban foundations such as CINTAS (1957–) were all attributed by colleagues as key factors providing consistent support for the category of Cuban art, elevating its popularity as a collecting category. Most defining, these factors are coupled with what the Cuban artist and curator Coco Fusco described as "an effective cultural bureaucracy that has grown over the last forty years." In her words: "The Ministry of Culture has contacts all over the world with biennials, museums, curators and galleries. Few other Latin American countries can boast such an effective promotional apparatus." Still the power of the market is paramount. As she added straightforwardly: "You want to know who plays a role? Kurimanzutto in Mexico City, Sean Kelly in New York. Those are both very powerful galleries representing Cubans."

Most significantly, the Cuban art market provides a good example of the currency of essentialist and nationalist posturing in Latin American art and in international art markets. In particular, interest in Cuban art has been fed by the exoticism of Cuba's reified "isolation": where the process of accessing works described to me as "prohibited," or "steeped in socialist culture," has historically played as a source of validation. In fact, most Cuban art stakeholders acknowledged the budding interest in Cuban art as voyeuristic, especially the favor for work "discovered" and purchased on the island. As a Cuban art dealer put it, "They think it's very sexy to go to Cuba, and they want to be seen as ahead of the curve." One effect is the rising popularity of young Cuban artists living on the island over Cuban American artists. As he explained, young Cuban artists can be branded more easily than those in the States, whose stories and trajectories are more accessible and easily read in terms that the market can recognize as more or less valuable. In other words, Cuban artists from the island are more conducive to speculation. One Cuban art dealer I met at Frieze 2017 angrily admitted that he had to bring artworks to Cuba to sell, either through the biennial or through local art entrepreneurs, because collectors won't buy Cuban art in the United States or Europe: "It's the same work, the same artists. Collectors won't buy it in the States, but they'll gobble it up in Cuba."

Rafael DiazCasas, a curator, art historian, and adviser focusing on Cuban art, had a lot to say about the rising popularity of Cuban art among international collectors. I met him at all of the 2017 fall auctions of Latin American art at Christie's and Sotheby's, observing the entire room from the back, as many art dealers do, so they can fully gauge the social drama of who buys and what is purchased or passed. Well dressed, elegant, and light skinned, DiazCasas fits in well with the Latin American global circles that patronize Cuban and Latin American art, many of whom, like him, grew up in homes where art was present. He was eighteen years old when he made his first art purchase—a work by Cuban abstract painter Sandu Darie, who is now considered to be among the highest-valued Cuban artists. He bought the piece for two dollars, he tells me, proud of his discerning eye and reputation for identifying artists on the upswing.

In particular, DiazCasas alerted me to the role of Cuban American expats, who built important collections in their effort to "reconstruct their country" through art and to the rise of Cuban art tours promising to expose visitors to Cuba's "thriving Contemporary art scene"[11]

delivering buyers and patrons to the very doors of artists in Cuba. In fact, at the very auction where I met DiazCasas, I sat next to a white female engineer from Houston, Texas, a collector of Cuban art who had attended and greatly enjoyed one of these Cuban art tours and turned out to be a board member of the Museum of Fine Arts, Houston, noted for its premier Latin American collection. I saw her sitting through all of the fall auctions studiously logging all the estimate and final sale prices of all the Cuban artworks auctioned. She tells me she is logging prices "for her own interest," though given her role as a museum board member and active collector, her studious notes on prices may well be put to other uses. It is noteworthy, too, that the US embargo has not affected Cuban art markets: artworks, which are classified as cultural assets, have always traveled freely to the United States and internationally.

For DiazCasas at the root of Cuban art's profitability are the colonialist frameworks at play in the art world, whereby a major international gallery's interest in a Cuban artist can help spill value over to the entire category of Cuban art. Hence Fusco's assertive statement about the determinant influence of international galleries like Kurimanzutto or Sean Kelly. For instance, exhibitions like *Concrete Cuba* (2016), by David Zwirner, or the representation of Carmen Herrera's Lisson Gallery in London, have contributed to the greater marketability and repute of many Cuban artists, including young artists, expediting their paths from their studios to galleries to markets. This was the case of Los Carpinteros, the arts collective founded in the 1990s, and of younger generations of artists like Yoan Capote, who have had consistent representation from US galleries from the start of their careers and are currently represented by key galleries such as Sean Kelly and Jack Shainman. These artists' Cubanness is always highlighted in press releases, testifying to its marketability. In fact, DiazCasas knew of at least one collector who, frustrated by the stagnant prices of Latin American art, had decided to sell off everything except the Cuban artists, focusing specifically on Wifredo Lam, Los Carpinteros, and Carmen Herrera, who had already proved their "commodity value."

Cuban American artists are very well aware of this trend, which has kept them at the margins of the growing popularity of Cuban art among international collectors. As Miami- and New York–based Afro-Cuban multidisciplinary artist Juana Valdes stated, "They want to buy that story; they don't want to buy the American story." As she saw it, part of what makes Cuban art marketable is the exoticness of collec-

tors being able to say they were at artists' studios and had this amazing experience in Cuba: "This is part of the value and the script and what gives it more value." In her view, the popularity of Cuban art has also helped reinforce nationalist boundaries. As she put it, "If you're in Cuba, you're *it*. If you're in Miami, then you're one of the many." She had seen many Cuban artists reinforce their links to Cuba, some even establishing projects or keeping residences on the island as a way to increase their value abroad. This is one of the reasons that so many Cuban artists, from Carmen Herrera to Tania Bruguera, are always labeled "Cuban-born" even when they live in or have spent most of their lives in the United States: their Cuban identity sells better.

Valdes regrets these trends, because the popularity of Cuban art has neither helped Caribbeanize Latin American art nor brought awareness of the Afro-diasporas in Latin America. In her own work, Valdes foregrounds race, color, and empire as the formative experiences to understand her Cuban identity off the island, and the reality of what it is to live as a Black person in America. For instance, her sculpture *Colored China Rags* features fabric rags commonly used for housework and domestic work made from bone china, a precious material the artist colors in shades of human skin to index matters of value and colorism. These topics find little room in the category of Latin American art, she tells me. For her, "Latin American art" equals a "white South American version," not one that highlights Latin America's African roots and welcomes work like hers and that of other Latinx artists who challenge Latin American nationalist ideologies denying the existence of racism. For this reason, the category of Latinx art seems somewhat promising as a space that could potentially value all that is central to her identity, and for it to be at least recognized and not seen as contradictory. As she put it, "I don't think the art world knows what Latinx art is. They just figured out what Latin American art is and what Mexican art is." But they're catching up, she says: "It brought something that is happening out in the street and in practice, out there into the institution, and said to people, you need to look at this."

Nationalism and the Globalization of Art Markets

So far I have described interest in Latin American art as in an upswing, at least relative to Latinx art. However, the value of Latin American art as a category is not without debate. To the awe of many, Phillips and

Sotheby's closed their Latin American art departments in 2018 to integrate some of its Latin American art sales into contemporary art sales. The move was advertised as a sign of success stemming from the growing prices commanded by selected Latin American artists and by the rising international appeal of this collecting category. At the same time, people wondered if this "success" would result in fewer Latin American artists reaching auctions altogether. After all, few Latin American artists command the prices that would grant Carmen Herrera and Brazilians Lygia Clark and Helio Oiticica inclusion in the contemporary art market sales.

Recall that Latin American art seldom commands the same prices of contemporary nonmarked art. This is why many Latin American art gallerists and collectors welcomed the move to merge Latin American auctions with contemporary art auctions as a necessary step toward raising the evaluation and global standing of this collecting category. Henrique Faria is one of the gallerists who supported this development. He has been working for years to obtain the same level of recognition and international standing as any other gallery, and to enable his artists to attain the proper prices and value. He spoke at length and passionately about the unrecognized originality of Latin American artists, telling me how, against the view that minimalist art was invented in the United States or Europe, artists in Argentina and Brazil were developing minimalists trends in the 1960s. But what most irks him is the art sales news reporting inflated prices that are out of reach for his artists. That day he was outraged to learn that a minimalist German artist had sold for $200,000, when many Latin American artists doing the same type of work, and years before, could never be sold at this price.

Many Latin American collectors and stakeholders are hopeful that placing Latin American artists in contemporary art sales will equalize prices and end the ghettoization that devalues their work. As Walter Otero, a gallerist from Puerto Rico, explained: "If I put a Tamayo in an auction with a Picasso, I am going to have the collector of a Picasso looking at a Tamayo as an equal." He experienced this firsthand with Puerto Rican artist Arnaldo Roche, whose paintings *La Ley: Sin paños ni lágrimas* and *The Pursuit of Happiness* sold in a contemporary art sale in Phillips, way over the estimated price and what they would have sold for in a Latin American auction.[12]

Already, many Latin American collectors have been internationalizing their collections in order to overcome price ceilings and join in

more profitable markets. Pedro Barbosa's collection move from collecting Brazilian artists to Latin American artists to global international artists, and his hiring of an Italian curator to maintain his collection—all well publicized in the *Wall Street Journal* and *ARTNews*—signal this growing pattern among many of the top Latin American collectors. The impulse to "globalize" (and hence validate) Latin American art is also evident in the trend for galleries from Latin America to represent and work with other Latin American artists across the region and with international artists. Thus, I was not surprised to see how the Guatemalan Gallery Proyectos Ultravioleta debuted in New York's Art Frieze in 2017 by showing Japanese artist Akira Ikezoe, and it would take another year, until Frieze 2018, for the gallery to introduce Guatemalan artist Jorge de León to New York audiences.

Notably, the participation of experimental galleries from countries like Guatemala is made possible only through by-invitation or competition programs that waive fees or charge considerably less to new galleries and that do not guarantee their continued participation when they are asked to pay full registration costs. Hence the inequality that exists between the greater number of Argentinian galleries in art fairs such as NADA and Independent and others during Art Basel, versus the very few galleries coming from Central American countries; and all of them, of course, are eclipsed by the overwhelming number of galleries hailing from the United States and Europe. In fact, most of the Buenos Aires galleries participating in Art Basel week in Miami in 2017 were subsidized at almost 90 percent through grants by the Argentinian government, providing another vivid example of how government infrastructure yields differential access to art markets.

This trend toward internationalizing Latin American art spaces is also evident in the push to bring international galleries to Latin American art fairs, and in the trend to open residencies and even offer their cities' walls and public spaces to international artists from the United States and Europe. Danny Báez, organizer of MECA Puerto Rico, echoed what other art fair organizers told me: the goal is to "bring the mountain to us" to ensure that, for once, people do not have to go to the United States to attend a "world-class" fair, and that international galleries are finally exposed to the local Caribbean and Latin American art scenes, and hopefully to local artists. Unfortunately, locals are often bypassed by these initiatives. We already saw how local Puerto Ricans artists benefited little from MECA, which involved minimal engagement with local and alternative spaces; and I witnessed the same

in Buenos Aires, where everywhere the trend was to open up calls to international artists, include international exhibitions in local museums, and make all types of outreach "global" by bringing the global home. However, the effects of these "cosmopolitan" strategies are up for grabs. We may ask whether they are challenging the Eurocentric profile of most North American and European museums, or providing local ways to strengthen it. Are they halting or reversing the continued marginalization of Latin American art in the global contemporary art stage? More specifically, are they creating complementary and greater opportunities for Latin American artists in the global art capitals of the world?

Buenos Aires, the first city to be selected to participate in the Art Basel Cities Initiative in 2018, provides some cautionary answers to these questions. It's a mirage, said artist/curator Santiago Villanueva, who marveled at the great divides between the Art Basel program and Buenos Aires' dire economic and social conditions. This was a city slashing budgets for museums and cutting funding for the arts but nevertheless investing $2 million to partake in the Art Basel brand. This is also a city with an excess of art scholars and artists, yet it was parachuting art stars in as speakers for a day or two, with little chance to make connections with locals. In his estimation, any gain was limited to the realm of perception and the ephemeral domain of what is to be seen in the future.

For now, the Art Basel Cities program in Buenos Aires leaves behind a city in a cultural trade deficit, importing more artists and traveling shows from European museums than the other way around. In fact, during my last visit in January 2019, the Museo Nacional de Bellas Artes was showing an exhibition of the English artist J. M. W. Turner, via the Tate Collection in London, while Fundación PROA was exhibiting a solo show of Alexander Calder, organized by the foundation staff in collaboration with the Calder Foundation in New York and Argentina's US embassy. In sum, it is obvious that Latin American art stakeholders' use of globalizing tactics to challenge their marginalization is contributing to more-exclusive art worlds throughout the region. As another Buenos Aires curator put it when describing the elite make-up of local art scenes: "They are marginalized in the global art stage, and they feel marginal. But at home, most of these artists belong to an elite."

With regard to the fetish over the global, the interest in going beyond the category of Latin American art toward the more profitable category of "contemporary markets" does not mean that Latin Ameri-

can art is slated to disappear as a collecting category. Far from it—this category continues to be reinforced by decades of purchase by curators, scholars, and national collectors, who are now intent on opening up spaces for Latin American art worldwide and turning it into a global brand to attract international stakeholders. In other words, even if nationalism may no longer be expressed through the practice of investing in "national artists," it still survives, in different guises. Now it is increasingly expressed in the impetus to validate and revalue local and national artists by collecting them, exhibiting them, and inserting them into the "global" (and more financially valuable) contemporary markets.

Nationalist prerogatives are also at play in the efforts by government and private sector stakeholders across the globe to build the most world-renowned collections and institutions (based on global Anglo- and Western-centric standards) and thereby position their cities and nations competitively as global art cities and players.[13] It is also evident in how governments and corporations sponsor selected national art galleries to participate in international art fairs to bolster their country's "art brand" at the international stage. In sum, we must be aware of the key role that art fairs play in building what Bandelj and Wherry (2011: 13–14) have termed the "cultural wealth of nations," by serving as instruments for cities and nations to navigate existing hierarchies of cultural wealth through the marketing of national reputations and "symbolic attributes." In these plays, nationalism and cosmopolitanism exist on a continuum where they mutually inform and transform each other, as Peggy Levitt notes for the world of contemporary art museums (Levitt 2015). Buenos Aires is a leader in this cosmopolitan type of nation-building and cultural policy initiatives. Recall their subsidy for art galleries to attend Art Basel week in Miami Beach. Nationalism is also visible in initiatives like the government–private sector grant program at Buenos Aires' ArteBA, where stipends are given to VIP guests from international museums to use toward the purchase of Argentinian artists at the fair (Boucher 2017). Most important, despite the turn to international contemporary art collections, the patronage of national artists continues apace. As an art consultant put it, "More and more they [young collectors] buy contemporary art from everywhere, but Brazilians always buy their artists and so do Mexicans, and so on."

A telling example is the inaugural debut of the Buenos Aires gallery Isla Flotante in Art Basel 2017 with the sale of the sculpture *Hanging*

Painting Pesos by Argentinian artist Mariela Scafati. The piece sold for $11,000, at the bottom of the sale price scales for sculpture, topped by the $9.5 million sale of white American artist Bruce Nauman's installation *Untitled (Two Wolves, Two Deer)* by Hauser & Wirth to an unnamed Asian collector (*Artnet News* 2017). Nevertheless, Isla Flotante's sale was featured in many of the postfair "What Sold and for How Much" reviews, a standard booster for artist and galleries, though who buys what is often intentionally kept private to intensify value and speculation. A little digging, however, revealed that the sculpture was purchased by the Argentinian collector Aldo Rubino for the Buenos Aires Museum of Contemporary Art, where it was scheduled to be shown in the exhibition *Latinoamérica: Volver al futuro* the following spring (Perez Diez 2018).

One could wonder why an Argentinian collector would wait to purchase a work of an Argentinian artist from a Buenos Aires gallery in Art Basel Miami Beach, when he could easily go to La Boca in Buenos Aires, or to the artist's studio, and purchase it far cheaper and with greater ease, but this question would be naive. I speculate that the collector was likely incentivized to purchase at Art Basel, as other VIP collectors are, or that the collector owned works by this artist and sought to boost her value though a high-visibility sale in Miami, or simply that being shown in Art Basel catapulted the artist's value. Its placement in *Volver al futuro*, a squarely Latin American art exhibition connecting modernizing projects from the 1940s and onward with contemporary practices and new acquisitions, is also a notable statement about the continued value of Latin American art in local cotemporary art worlds.

More locally, in New York City, Latin American galleries continue to develop vibrant Latin American art worlds for emerging Latin American artists. For instance, Proxyco, a gallery that opened in 2017 on New York City's Lower East Side, focuses on Peru, Mexico, and Colombia. It was founded by professional art stakeholders "Alexandra Morris (b. Mexico City) and Laura Saenz (b. Bogotá)," who openly identify their city of origin on their website, a common practice to index authenticity in Latin American art worlds. Proxyco's focus on Latin American art is not as "an essentializing classifier, but rather a fluid framework to value and engage with art that is informed by both a distinct cultural heritage and an ever-widening global perspective."[14] This qualification notwithstanding, the focus is squarely on Latin American art and also on using a New York City gallery platform

to boost the careers of emerging and midcareer Latin American artists who may be well known there but have no market in the United States. I attended one of Proxyco's first openings and spoke to the founder, who was excited about the thriving Latin American art scene in New York. She had worked in a Latin American modern art gallery before deciding to launch her own contemporary Latin American gallery, citing the *Radical Women* show traveling at the Brooklyn Museum as a testament to the renewed buoyancy for this collecting category. I left confident that she and her artists will do well. Not surprisingly, like other Latin American art stakeholders, she could not name a single Latinx artist she knew or would like to work with. When I probed, she responded, "Maybe in the future."

Into the Future

That the neoliberalization of art markets is not going to bring us a diverse art world, but instead will foster more exclusive spaces, should not surprise anyone who follows international art market news. The issue I want to highlight is the historical significance of nationalist prerogatives in creating categories such as "Latin American art," which have been and continue to be central to opening up spaces for scores of artists at a global scale. As we have already seen, this category fueled the growth of nation- and region-based infrastructures, museums, curators, and collectors, validating their work and providing key sources of institutional support—at least for the privileged artists who obtain recognition and patronage in Latin America. I say this because it is important that we do not homogenize Latin American art worlds. As I have shown, the Latin American spaces most often inserted in the market are also the least representative or accessible to the totality of "Latin American artists" who live and work throughout the region.

In particular, the trends I have discussed in this chapter mark a general divestment toward buying and strengthening the very markets that are in greatest need of evaluation, especially when art is increasingly treated as financial asset for profit and financial speculation. Articles like "Billionaire's Secret on How to Make a Bundle in Art" circulated by Bloomberg and other financial blogs promote this view by advising prospective collectors to focus on artists who "have been featured in reputable galleries or acquired by major museums," or who are "signed on" (Balfour 2018). As we will see in the next chapter,

though, it is extremely difficult for artists, especially artists of color, to attain gallery representation. Obviously, then, this type of thinking generates larger gaps between the few artists who reach commercially sanctioned sectors, whether "Latin American art" or "contemporary art," and the universe of US Latinx artists.

In turn, artists shunned by recognized art market categories face added hurdles to "compensate" and prove their worth. A collector from Los Angeles who started collecting Mexican artists and then quickly moved to Latin American art had a lot to say about this when I asked her what it would take for people like her to start collecting Latinx artists too. She was open to learning more about Latinx artists but admitted that it would be difficult to get her friends in Los Angeles to do the same. "A white and Latin American artist can be picked up if they have a gallery show, but a Latinx artist has to overcompensate," she tells me aware of the type of disparities in the art world that are regularly used to exclude artists of color. As she acknowledged, neither a museum show nor a gallery show is enough to validate Latinx artists—these artists must also have an art review in a major art publication, if not more, before they are considered valuable. Unfortunately, this is a difficult task for most artists, especially Latinx artists.

For one thing, Latinx artists lack infrastructures that could add value to the experience of purchasing and collecting their work. As US racial minorities, Latinx are nowhere to be found in US-based arts/culture institutions. They are marginalized by the US-dominant definition of nationalism that treats them as forever foreigner and foe. This positioning is ultimately what feeds into the view that, as another gallerist put it, "what smells like 'Latino/a' hints at narrowness, not market value." After all, he asked, "where would you take collectors to learn about Latinx artists in the United States?" Or, perhaps more to the point, what would audiences "get" from supporting these artists? These artists are missing from the whitewashed spaces that collectors and art audiences increasingly like to linger in, such as galleries and art fairs. Meeting them often demands visiting local, community, and grassroots arts organizations, or pop-up and living room galleries lacking the "right" cultural capital sought by neoliberal-minded upwardly mobile groups. Cecilia Fajardo-Hill explains: "They go to Brazil and see these Latin American artists in these massive and modern institutions that communicate value, but you never see Latinx artists displayed in any of the major museums or galleries in the United States. . . . You'd have to go off the grid to find them, and this does not communicate

value." She adds that if they do not see it in Chelsea, it might as well not exist.

I do not think that Latinx art, as a racial and diasporic identity, can follow the path that lent value to Latin American artists. But the case of Latin American art challenges the mantra that entry to contemporary art markets conveys an erasure of identity and specificity, as if whitening through the erasure of any ethnic, cultural, and even national specificity is the ultimate entry price. This does happen: as I discuss in the next chapter, names are regularly Anglicized, and backgrounds are erased or remarketed into whatever fashion make artists more marketable. Yet the currency of some categories, such as "Latin American art" and "Cuban art" and increasingly "Caribbean art" and "African art," reminds us that in the art world, identities have sold and continue to sell. The issue is that in contemporary art markets some backgrounds, especially national references and identifiers, are indeed more valuable and marketable than diasporic, ethnic, and racial ones.

Finally, the case of Latin American art provides valuable lessons about the need to create spaces of validation for Latinx art through institutions and investments in museums, schools, galleries, the media, and more. It also serves as a warning of the types of issues that must be addressed if we are to create expansive and inclusive spaces for Latinx artists and to avoid reproducing hierarchies among groups with greater institutional access while marginalizing those who lack it. Even more powerfully, thinking through Latin American art shows the need to overcome the pull of racism and its impacts on the categories used for branding and staking a claim in contemporary art worlds. As we saw, these issues make up the greatest obstacles to imagining Latinx artists as valuable and worthy of note and to achieving more equitable and diverse art worlds.

On Markets and the Need for Cheerleaders

I had a gallery for a brief period of time, . . . but I was not the right kind of artist. I think this may be true to another generation of Chicanos at least and some Latinxs that make work that lives in Nepantla, in the interstitial space in between the place of the market and the world of the community. / **AMALIA MESA-BAINS** at US Latinx Arts Futures Panel

The freshest thing in American art is that there are a lot of great nonwhite artists—the arrival of these communities is what you're seeing. / **GALLERY OWNER**, Los Angeles

What market? This is the single most common response I got from Latinx artists whenever I introduced my work on Latinx artists and contemporary art markets. Their response was a unanimous and unqualified testament to their exclusion, and a longing to access the space that they recognize has the most impact on their ability to make it in the art world. Harry Gamboa, one founder of the famous Chicano performance group ASCO, is a perfect example. Despite his legendary star status, when we met he had just closed an exhibit at Marlbor-

ough Contemporary, a flagship New York City gallery, without selling a piece. Glowing reviews in the *New Yorker* and *Flash Art* had created a lot of buzz, but no sales at the time we spoke. As he joked, "I've come out in so many magazines in the last few months that it's going to cost me $100."

We met by coincidence. Denise Sandoval, a friend, scholar, and curator of Chicanx art, had brought me to Los Angeles' Union Station to admire Barbara Carrasco's *L.A. History: A Mexican Perspective*, a mural critically dissecting Los Angeles history that had been warehoused for twenty-seven years. The work had come out from storage for PST, and Carrasco was there with her daughter and her husband Harry, greeting friends and recalling the censorship that had kept the work homeless for so many years. The work was still controversial. They told me that a few days earlier a group of Japanese tourists, offended by its depiction of Japanese internment camps, had requested that the mural be covered.

Harry and Barbara are a power art couple in the Chicano Los Angeles art scene, and I was starstruck at the happenstance meeting and his openness about the disappointing sales of his recent show. He was hopeful that the gallery might still sell some pieces, but as a veteran of the scene, Gamboa is well aware that success in the gallery world is having a show sold out before it actually opens. Gamboa is used to this type of dismissal. The important retroactive of ASCO's work from 1972 to 1987 in the Los Angeles County Museum of Art (LACMA) in 2011 was one of the most successful exhibitions at the museum. Gamboa tells me that the show traveled throughout Europe, without LACMA purchasing a single work by him for its collection. The exhibition marked a coming-of-age moment for the collective arts group. A LACMA curator had once told him that Chicanos don't make art, they join gangs; so the group had memorialized their names by spray-painting them on the museum. The closest he has come to being in their collection is through a postcard image sold in the gift shop. But that's it. Like most artists of his generation, Gamboa does not have gallery representation. The few colleges and museums that have purchased his work have done so primarily through him.

Some may ask why should we care whether Gamboa and other Latinx artists have little access to contemporary art markets. Most artists seldom sustain themselves through the sale of work, much less via gallery representation. We also know that the commercial gallery circuit is a white-dominated space that in recent years has become even more exclusive owing to a winner-take-all dynamic: a mere twenty-five artists,

most of them North American males, dominate nearly 50 percent of all contemporary art auction sales (Halperin and Kinsella 2017). This is also a market characterized by a shrinking gallery ecosystem where a few megagalleries dominate art sales. In this context, the closing of small and midsize galleries outnumber the opening of new ones, making it more difficult for smaller and alternative galleries to function, and for any gallery to show diverse and emerging artists (Reyburn 2018). The contemporary system is also highly dependent on art fairs, which are too pricey, unpredictable, and out of reach for most small galleries. In sum, I write at a moment of shrinking opportunities, when few galleries can afford showing artists who cannot guarantee sales. In this market, very few artists, especially Latinx artists, are gaining access to markets via gallery representation. And even fewer are poised to do so.

Entities in the noncommercial sector—museums and cultural institutions—have played greater roles than galleries in bringing attention to Latinx and POC artists and providing them with economic support. Most of the artists I interviewed for this book work as teachers or museum educators and in nonprofit arts and cultural institutions, as well as in various jobs in the commercial sector. This echoes research on the economic well-being of contemporary artists, which reveals that most artists, especially artists of color, depend on freelance work and don't find galleries helpful to their practice.[1] Additionally, as Amalia Mesa-Bains remarks in the epigraph above, Latinx artists are not always the "right kind" of artists for the market. Nor do they want to be. Many work around it intentionally for personal and political reasons or because they produce work that is linked to communities, or performance based, or not easily marketable.

At the same time, the nonprofit art sector is not intrinsically incompatible with the market. Instead, it represents a different positioning. In this sector, opportunities for artists to work with communities or in a socially engaged way also advance particular logics of what is more or less marketable, favoring products and artists that fit more closely with their multicultural initiatives. Community-based artistic work is also not intrinsically incompatible with commercial goals and initiatives.[2] The belief that it is stems from purist constructions of art and commerce as separate and opposite fields—constructions that tend to further advantage the most economically privileged. We must remember that equitable access to markets is also a key demand for achieving cultural equity. Artist Barbara Calderón is an artist and interdisciplin-

ary cultural producer concerned with opening up opportunities and markets for Latinx artists. She was straightforward in her response: "When Latinx artists are only asked to participate in socially engaged type of shows, that's akin to being called the maid—to having to clean up the mess the system has created. Community work is amazing and necessary, but we must also question why Latinx artists can't have a studio practice exclusively if white artists can."

In the current context, galleries and the commercial sector are central to the contemporary art ecosystem. Galleries channel artists' entry into primary markets and can make or break an artist by curating exhibitions, calling attention to the work, circulating it in art fairs, and establishing a trajectory of sales for pricing their work that can protect and determine their future marketability. Perhaps most important, only galleries have direct access to the application/invitation process to participate in most major and international art fairs, which are central to artists' gaining international reputations. Being included in a major museum exhibition does signal value and feeds an artist's career. But nothing like the endorsement of being picked up by a gallery, especially a "reputable" and "blue-chip" gallery, signals to collectors that artists and works are valuable and worthy of investment. Galleries are also the main conduit through which artists enter museum collections: galleries alert curators to certain works and market them directly to museums and other major collections. In turn, museums increasingly work in tandem with galleries and the commercial circuit, such as by sponsoring trips of patrons and "collectors' circle" visits to galleries.

Given this, it is fitting to inquire into the dynamics that make galleries so exclusive at the same moment they have become so influential within the larger contemporary art ecosystem, and to ask these questions while keeping in mind the questionable economic sustainability of the gallery model. Additionally, in light of the growing "global" pretenses and projections of the contemporary art world, it is also fitting to inquire into the dynamics that make the art world so exclusive exactly when it is supposedly more global, and just when the United States is demographically more diverse. Could it be that Latinx artists reveal this to be an exclusive system that is, in reality, a hindrance to most artists and in great need of reassessment? And what do we learn about contemporary art markets when we ponder why so few Latinx artists achieve commercial success?

Enter the "White Box"

I wanted to delve into this process of value creation shaping galleries' selection of what artist to work with, and soon learned that it was guided by a variety of hidden and less-discussed factors. And the number one factor was the most predictable. Everyone told me that decisions are guided by the "quality of the work," that "the work itself should do the work." But I quickly learned that the most powerful factor is the word of mouth circulated within a highly exclusive, cliquish, and segregated art world.[3] In fact, most gallerists I spoke to recalled selecting artists from contacts and references, never from unsolicited submissions sent by individual artists. "It's about making new friends," is how the owner of a small gallery in New York City's Lower East Side casually put it as she described selecting her initial roster of artists from friends she had met in art school, or artists recommended by former teachers and mentors. Yale, the Rhode Island School of Design, Columbia, the School of Visual Arts (New York), Bard, Cal Arts, and the School of the Art Institute of Chicago were some of the few arts schools everyone mentioned as key gatekeepers, places where students pay exorbitant prices for the chance to be exposed or meet international artists and curators. Among more established gallerists, the circle of reference was even more confined, though tales of artists introducing gallerists to other artists were common. And always, the pull of personal relationships was key. Most gallerists I spoke to insisted that they had to like an artist's work, but foremost they needed to like the artist "as a person." This response supports research showing that it is not creativity or the originality of the product but social networks, or the company one keeps, that most determine an artist's fame and success, starting with the type of attention that leads to gallery representation.[4]

Personal relationships are bolstered by the workings of an industry that is highly unregulated. As art critic Isabelle Graw puts it, "This market is a perfect example of an informal economy," given its reliance on personal agreements, unwritten laws, "idle talk," and casual conversations requiring a great amount of flexibility and trust among participants (Graw 2010: 63). In turn, the centrality of personal networks and relations in such a racially segregated world contributes to, and guarantees, its continued racial segregation. Whenever I visited galleries and art fairs, I came across mostly white gallery workers, especially women. Art professionals of color working as dealers are a rar-

ity, and those I met admitted entering the field when it was more open, or through the assistance of other arts professionals of color. Whenever I interviewed the few gallery workers and directors of color in the Chelsea gallery district, they were often the only person of color I saw among desks and work areas filled with primarily white women garbed in generic polished black outfits. I met a longtime dealer in a white office without windows, and she laughed when I joked it was the literal representation of "the white box." During our talk, she told me how her parents helped support her while she did all the necessary free internships at a time when she recalled there were not many galleries, and working in a gallery was not considered a profession. That was in the mid-1990s, but things have changed considerably. Today, entering the art world is extremely difficult and even more mired in nepotism. Insiders and children of collectors are more likely to get internships as a way of cultivating favor with collectors. Throughout my research I met less than a handful of dealers and gallerists of color, and even fewer with Latinx artists in their roster.

The lack of Latinx dealers and gallerists is a significant issue because without the relentless work of Black arts stakeholders who have been working for decades to create alternative galleries and to cultivate collectors and patrons, we would not have the current evaluation of African American artists. Thelma Golden at the Studio Museum is known to have single-handedly internationalized many African American artists and nurtured generations of collectors by creating programs such as its Artists-in-Residence and Studio Society programs. Many Latinx art stakeholders even asked, "Where is our Thelma Golden?," calling attention to the lack of counterparts doing the same thing for Latinx art. El Museo del Barrio, a contemporary of the Studio Museum, historically has not nurtured collectors; its expanded mission—to represent Latin American art, which for the last two decades has had a solid foot in the market—leaves little room to give Latinx art the necessary boost.[5] To appreciate the different approaches to nurturing collectors at these institutions, consider El Museo del Barrio's recently founded Contemporáneos Collectors Committee ($1,200), open "by invitation only," in relation to the Studio Museum's Studio Society ($1,500), one of a number of long-standing programs that introduce members to collecting and contemporary art events that have been operating for over a decade and that are accessible to anyone willing to pay and join in.

Black dealers are still a minority, to the point that a recent *New York Times* feature article on their work merited the headline "Why Have

There Been No Great Black Art Dealers?" (Zara 2018). But for Latinxs dealers the appropriate headline would be "Why Are They Missing in Action?" While browsing through major art fairs I met or learned about less than a handful of Latinx dealers, such as David Castillo in Miami Beach, Luis de Jesus in Los Angeles, James Fuentes in New York City, and Emanuel Aguilar (Patron) in Chicago. Despite being stylish, male, and light skinned and having a lot of experience in the arts, including art degrees, decades of experience working in galleries and museums, and, in one instance, a family background of involvement in the arts, these gallerists faced barriers in a mostly white gallery landscape. I heard tales of people assuming that they are "foreign" (because of their Spanish-sounding names) or that their focus was only on Latin American artists, all of which created additional barriers. On and on the only "legible" register for these gallerists were Latin American galleries. Emmanuel's gallery is named Patron, for arts patronage and support, but in art fairs it was commonly confused for a Latin American gallery and referred to as Patrón, a name that in Spanish conveys "employer" and "master" more than "arts patron."

Not surprisingly, Latinx dealers I spoke to prided themselves on representing diverse artists, such as women, Black artists, or self-taught artists, but Latinxs were mostly either missing or a minority in their roster. This void was unrelated to their professed interest in Latinx artists. Latinx artists are seldom exhibited in the spaces gallerists are tuned in to, and most just did not know where to find them. For instance, dealer James Fuentes only learned about artist Ronny Quevedo after his participation in the Whitney Museum's *Pacha, Llaqta, Wasichay* show through the introduction of one of the curators. The irony is that both Fuentes and Quevedo are among the few Latinxs from Ecuadorian parents via the Bronx who are working in the New York City contemporary art scene. Quevedo had previously exhibited in numerous group shows in Upper Manhattan and throughout the city, including at a solo show at the Queens Museum a year earlier. Still, only a group show at the Whitney made Quevedo visible to Fuentes and led him to host Quevedo's work at his Lower East Side gallery, making it the first time Fuentes had self- admittedly worked with a Latinx artist in his twenty-plus-year career as a dealer—ignoring his recent work with Haitian American artist Didier William—which makes up a total of two. Luckily, this would not be the last. A year later, Fuentes hosted a solo exhibition of Lee Quiñones, the graffiti artist who has had a recent upswing of interest following a show in Los Angeles. He marveled

at the reproduction of Lee's Lions Den mural outside the gallery, the same he had seen coming in and out of his home in the Lower East Side over thirty years ago, realizing he had come full circle by exhibiting artists so close to him for decades, though entirely off his radar. I heard similar stories of artists, who despite graduating from major art schools and having long trajectories, including exhibitions throughout New York City community arts and cultural organizations, were nevertheless "discovered" by dealers and gallerists only after encounters at "white airports" of mainstream recognition, including Latinx artists whose work was "discovered" only when it was exhibited outside the United States.

Yet the biggest challenge is the so-called unbankability or the idea that working with Latinx artists is inherently risky and unprofitable. Writing about the film industry, Maryann Erigha warns that the label "unbankable" functions as a racial code that is used to marginalize Black directors and their films, couching their exclusion on the idea that these films and products are not commercially viable as white films are, which results in Black films receiving lower production and marketing budgets vis-à-vis white directors and producers (Erigha 2019). And when Black films prove to be commercially successful, their success seldom carries on to a greater appreciation of the value of Black produced films. I found similar dynamics at play with Latinx artists in contemporary art markets, where the lack of patrons and institutional structures to support Latinx artist was seen as proof, rather than as the root cause of their so called "unbankability."

For instance, I was told that the lack of collectors patronizing Latinx artists makes doing business with them almost impossible. Luis explained: "As much as I would like to show more Latinx artists, the market is not there, the support system is not there, the collectors even for the couple we represent like Ken Gonzales-Day and Hugo Crosthwaite is very tough. It was like that with Black artists until they were able to be monetized, that's when collectors began buying their work." I heard a lot of reasons for collectors' turn to Black artists, including their wish to project liberal sensibilities or to seem trendy or multicultural. However, everyone concurred that the primary impetus was their monetization and that unless Latinx art is similarly monetized people will continue to reject it and find reasons to not identify with the work.

Dealers representing Latinx artists also regretted with frustration that even artists whose work is shown consistently in museums and

biennials lack collectors and a commercial support system. This is one of the most powerful reminders of racism's role in the interplay between legitimating institutions and commercial success. After all, galleries are a central link in the creation of value, but they do not create it on their own. They traffic in careers, reputations, trends, and fashions created by critics, writers, curators, and collections, among other meaning-making agents who most affect cultural value. And as we have seen, there is a lack of "legitimating" institutions for Latinx artists. The irony is that even when Latinx artists get symbolic recognition for their work, it seldom translates into commercial value as easily as it does for white artists and artists with institutional supporters and collectors. Remember that I was told by the Latin American collector, "Latinx artists have to overcompensate" because exhibitions, even with reviews, are not enough to make them marketable. This need to overcompensate also plays out in galleries' selection of the few Latinx artists in their roster. One gallerist made this clear when describing his selection of the only Latina artist he represented as someone he felt safe to represent because she taught at a major arts program, is well known and connected, and will surely bring an entire network to the gallery with her.

Most major gallerists I met reported not knowing any Latinx artists or where to find them. At NYC Frieze Fair, one told me she learned about the first and sole Latinx artist represented in their program via a referral from a gallerist friend who also represents him in Los Angeles. She lives and works in New York City, where Latinx artists are practically everywhere, but like everyone I met in these spaces, she seemed clueless of this artistic demographic. On and on, when I asked galleries if they knew or had worked with Latinx artists, the response was always the same: silence, followed by vague mentions of this or that Cuban or Brazilian artist they may have worked with, among other responses that confirmed their obliviousness and inability to even distinguish between Latinx and Latin American artists. This lack of knowledge was a key indicator of how removed galleries remain from the city's diverse Latinx arts communities. I laughed internally when a dealer told me she should go to Los Angeles more to learn about Latinx artists, as if there were no Latinx artists to learn about in New York City. It was obvious that, to her, "Latinx" signaled Chicanx or Mexican Americans in Los Angeles, not the diversity of Latinx groups in New York, among whom there are also many Mexican Americans and Chicanx-identified artists. The local arts media feeds into this bias

in its sparse coverage of Latinx artists in its penchant for stories of national interest, which tend to look toward Los Angeles bypassing Afro-Latinx and Caribbean Latinx artists living within New York City, or anywhere else in the United States. [6]

This lack of diversity in the gallery world is especially concerning in today's highly competitive market. More than ever, galleries must command fervor, excitement, understanding, and commitment to artists' visions to market an artist's work. They should have clients in their roster who are interested in the category of work that the artist represents, or who are at least interested in learning about new artists. However, when a whole category of artists is not known, and when these artists lack the type of references and bars used to gauge value like museum shows or reviews, the chances of any gallery betting on them is almost inexistent.

Moreover, artists cannot individually break into this system. Artists are told that networking is key to commercial success, but the exclusivity of the art world renders this recommendation useless where artists of color are concerned (Nieves 2011). First, artists unable (or unwilling to become indebted) to pay for expensive BFA and MFA programs are essentially barred from the system altogether. And among those who get to art schools and acquire contacts, few have the time to make openings and events or are blessed with the people skills, patience, and social tolerance or familial economic support to subsidize their ability to network and make themselves noted and visible. I will never forget meeting Wilfredo Ortega, a Dominican/Nuyorican Afro-Latinx artist from the New York City's Lower East Side at a show curated by Rocío Aranda-Alvarado on contemporary artists working in pattern and decoration at the Longwood Art Gallery show. Ortega, a Yale MFA graduate working in abstract installations and site-specific works, has been working too many evening teaching jobs to make any openings. This was the first time in a while he had been able to come out to his own opening, and he came alone. That evening, I learned that three of the Latinx artists at the same exhibition had never even met each other before their inclusion in this show, even though they all were born, raised, and currently live in New York City and a couple had even attended similar art schools. In other words, attending a prestigious art school had obviously done little for artists lacking the financial means to maximize their contacts and experiences.

This lack of connectivity and community among Latinx artists and stakeholders in the so-called global capital of both Latinx culture and

the arts is one of the most worrying outcomes of the lack of spaces for Latinx artists to be exhibited, to create networks, and for people to learn about their work, and for them to know about each other. In the rare instances where Latinx artists were shown in mainstream spaces and galleries at the time of writing, I saw these spaces become Latinized with Latinx artists and art stakeholders turning up for each other in support. However, these momentary Latinx events don't guarantee lasting or sustainable networks. Hence, while writing this book and whenever the opportunity presented itself, I found myself playing the role of matchmaker and facilitator of introductions among artists and art stakeholders I interviewed. Each time I was surprised about how many had never met in person. Whenever I found myself in mostly "white airport" art spaces, I did the same, sharing suggestions about Latinx artists and curators and where to find them. In other words, I tried to be a cheerleader—what everyone told me was most missing and needed.

Not surprisingly, when I inquired why Latinx artists are so absent from commercial galleries, the exclusive nature of the gallery system was seldom mentioned. One dealer even blamed artists themselves for their own lack of marketability, dismissing Latinx artists as "too difficult to work with," or too ambivalent toward the market or commodifying their work. Yet when considering that the art market is among the least transparent and most manipulated markets, I am certain Latinx artists are no more ambivalent, resistant, and difficult than any other artists when figuring out its operations, and that other factors play greater roles in their exclusion.

To be sure, many artists—especially those with a history of work and engagement with local arts communities and social movements—have been resistant to the commodification of their work.[7] Hiram Maristany, one of the most important Nuyorican photographers, best known for his photographic archive of the Young Lords, is a canonical example. For decades, he refused to talk to curators or be interviewed or exhibited because of his general mistrust that any museum would be able to contextualize his work and guarantee the respect and assurances he demanded for the subjects he had photographed. For him, a key issue was ensuring that the people who trusted him to take their pictures would not feel dishonored by the treatment of his work. As he put it: "I've been given enormous confidence by the poorest of people. These are people who are disrespected, ignored and violated and I take this trust very seriously." Maristany's political commitment

to his work and his doubt that any museum or curator would be able to appropriately honor his subjects kept his work from circulation, much less from being marketed, for decades. Yet he speaks to a sentiment shared by other Latinx artists, many of whom view their artistic work as a public trust connected to social and artistic interventions around everyday issues and activism not meant to be hidden in any individual's collection. This position also represents a larger critique of mainstream museums' practice of collecting works only to store them away and rarely exhibit them, and of collectors' sequestering and treating art purely as an "investment."

More commonly, I found Latinx artists had mixed responses to and ambivalence about a market that they felt was not poised to understand their work, but that they still tried to enter and manage to the best of their ability. Some who worked with galleries felt it was difficult to find galleries that fully understood the work and could market it appropriately without reducing it to clichés or stereotypes (as I will discuss in the next chapter). Others had given up from breaking into a system they found unwelcoming or exploitative.

Two senior artists who preferred not to be identified were especially critical of galleries poaching, branding, and dumping young artists of color from major MFA programs. "Galleries like to brand artists before they manage to develop their own aesthetics and voice," one warns me. "But just as quickly they tire of them." They asked me to think about James Luna or Rafael Ferrer, among other artists who got recognition from mainstream museum and galleries in the 1970s and 1980s, as well about the furor when galleries embraced graffiti artists such as LA II (Angel Ortiz) and Lee Quiñones, but then quickly dropped them (by the late 1980s).[8] "Among graffiti artists, the only ones they kept are Keith Haring and Kenny Scharf, who went to art schools who were validated by institutions," he tells me, insisting on the cyclical pattern that has historically elevated some artists without changing the system. "You get into the gallery, but when you sell, the gallery wants you to do the same thing over and over, and if you do it, then you can't evolve and collectors will tire of the same thing. But if you change, they'll say your work is not consistent."

The second senior artist was even more critical of galleries, insisting that artists of color should develop alternative systems, away from the commercial sector altogether. However, he continues to have gallery representation out of "tradition" because his work is not very commercial and hardly sells. Contrary to the idea that gallerists only show

work that sells, galleries also keep artists with "symbolic" capital or artists who "round out their roster," whether in terms of genre or to project diversity along the lines of gender, race, and ethnicity. All galleries have their "darkies," is how someone else put it. The problem is that the inclusion of some "consecrated" Latinx artists did not seem to translate into their welcoming more Latinx artists into their rosters, on the idea that "one is enough." Most important, the senior Latinx artist who shunned the commercial sector has a permanent full-time job at a major university and receives regular commissions from arts/culture nonprofits. These nonprofit opportunities secure his position but are increasingly unavailable to younger generations of artists, who face a shrinking nonprofit sector and diminished state funding for the arts. In sum, more and more POC artists must depend on galleries and markets to also validate their work, rather than the nonprofit institutions and museums that have historically opened the door for many such artists.

William Cordova, a Peru-born, Miami- and New York–based interdisciplinary artist known for his installations, is aware of these trends. He is represented by Sikkema Jenkins, which he attributed to the mentorship of Franklin Sirmans's patronage, another example of the key role African American art stakeholders have played in brokering Latinx artists access to mainstream recognition. Cordova is a big proponent of art residencies and of artists working with alternative or nonprofit venues, which allow them to take more risks with their work, before delving into commercial galleries. In a way, he was repeating the well-known "economic versus symbolic value" formula that most artists must negotiate. Yet economic obligations, dependents, and debts make waiting for "the right gallery" a difficult task. Women artists, who often have primary responsibilities for family or childcare, are especially penalized because they cannot so easily travel for long-term artist residencies. I marveled at the class privilege demanded from galleries when a dealer admitted passing on a Latina artist she was considering for her gallery because the artist had not done work in years. "Our artists are people working [on their art] all the time," she said.

The commercial gallery system is also known for selecting work that "fits into their DNA," as one artist described work that sells and is on trend, placing enormous pressure for artists to fit into commercial trends. As one artist joked, art has to "fit and look good on top of a Manhattan sofa." Yet few artists I meet in New York City even have the studio space to produce work, much less "commercially scalable" work

to fill gallery walls, echoing how even the materiality of artists' work was directly impacted by processes of gentrification and their experiences of spatial precariousness.

Dealers never discuss how commercial motivations guide their selection of artists. This topic compromises the purely artistic and quality positioning on which the business of art is most predicated (see Bourdieu 1993; Graw 2010). "It comes down to the work itself and my personal response to it" was the mantra most mentioned by dealers who were especially keen on downplaying any other reason for selecting works, especially if they hinted at matters of identity, gender, race, or even age. This was so notwithstanding the growing interest in senior women artists becoming the new "art world darlings," or news about African American artists' breaking record sale prices in auctions (Sussman 2017). A dealer at Sikkema Jenkins and Co. explains: "It's not like we don't think of commercial appeal, but we would not say that. You want to have a reputation for having picked something with lasting value." If anything, dealers blamed collectors for wanting to "check boxes" and looking at art more commercially, bemoaning how they often have to "educate" collectors to appreciate all types of art.

Still the centrality of commercial determinations among dealers was evident whenever they talked about taking more "commercial" work to fairs, or favoring work that was "technically rigorous" or "beautiful and aesthetically attractive," or remarked on works that are "perfectly sized" or "crate ready" to be shipped from a fair. Moreover, at least to my eye, it was evident from comparing art exhibited at galleries and at artists' studios that commercial art "looks" a particular way. The style of the artist is often recognizable. It often "looks" expensive, lavish, and even, at least in my view, overproduced. One dealer was very honest when admitting, "The issue is, will white people buy this?" I was told that collectors like to be entertained or amused, and preferred work that they can recognize and talk about and make them sound smart, edgy, or multicultural. But foremost, the work needs to be accessible, especially when artists of color are concerned. As one put it: "It should allow a certain degree of empathy but not fully," unless of course, the artist is well valorized, though he quickly clarified this seldom happens with Latinx artists.

Then there is the issue of access presented by the required hike in prices to meet the customary 50/50 distributions of gains between gallery and artists, and the demands for exclusive access to artists' production and how it limits their ability to market and circulate their work.

Galleries create value through the types of collectors they nurture and their positioning of works, such as in museums and with "reputable collectors," who are always favored over new and unknown ones (Velthuis 2005). However, this value-creating strategy of prioritizing the exclusivist cultivation of selected buyers, collectors, and consumers is often at odds with artists' desire to maximize audiences.

Chicano artist Ramiro Gomez, one of the most commercially popular Latinx artists I met during my research, provides an example. Gomez's paintings of migrant workers in luxurious spoofs of David Hockney's Los Angeles backgrounds have captured the imagination of writers and critics, providing a level of exposure that is uncommon for most Latinx artists of similar working-class backgrounds without an MFA. Yet he was surprised to learn that when the owner of the Yankee Linen Company, which was featured in one of his works, recognized his company in an Instagram post and reached out to him to purchase the work, his gallery was unimpressed by the potential buyer and ignored the query: "I have to push them to understand that this creates value for me because I connected to him," he tells me. He says, in a regretful tone, "The more my work develops, the less accessible it is for the people I want to connect with."

Interestingly, it was networks of support from curatorial, criticism, and scholarship communities who assisted Ramiro Gomez's commercial "discovery," just as I was repeatedly told is the case with most artists. However, this support came not from the mainstream Los Angeles arts establishment, but from Chicanx and ethnic studies advocates such as George Lipsitz and Chon Noriega. In fact, it was Chicanx-centered spaces such as UCLA's Chicano Studies Research Center Library that hosted his first exhibition, the 2013 show *Ramiro Gomez: Luxury Interrupted*, which helped launch Gomez's career. It was there, after media coverage of his "Hockney" painting appropriations, that Los Angeles gallerist Charlie James made the trip to UCLA library to "discover" him, eventually hosting several solo shows of Gomez's work at his gallery and introducing him to a New York City gallery.[9]

Ramiro Gomez's career trajectory makes up a telling exception. Chicanx- and Latinx-focused arts and culture spaces have historically nurtured Latinx artists, but being among the least valued legitimating institutions in the contemporary art world, they rarely help launch artists to mainstream recognition. A well-wishing curator even warned me, "If you want to legitimate Latinx artists, the worst thing you could do is discuss them in ethnic and cultural studies." This

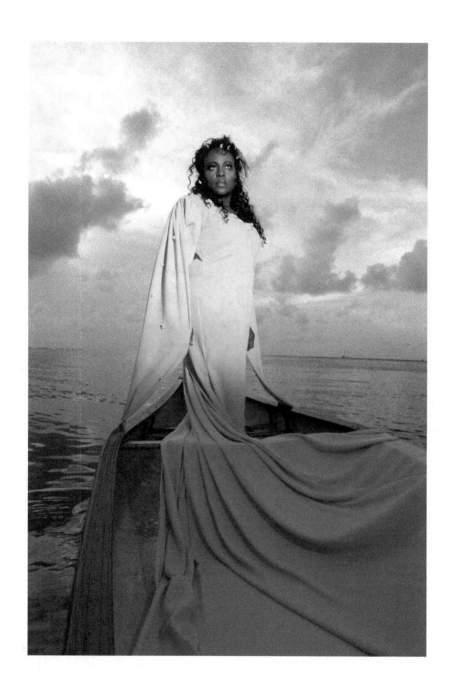

PLATE 1 ⁄ Elia Alba, *The Orisha (Juana Valdes)*, 2014. Archival pigment print. Photographed in Key Largo, Florida. Costume designed by Elia Alba.

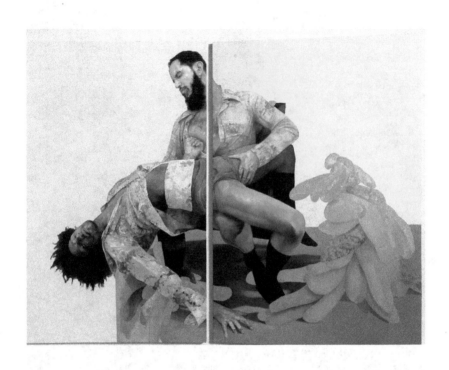

PLATE 2 / David Antonio Cruz, *SOLETTHEMEATASYLUMPINK*, 2016.
Oil and enamel on birch, 72 × 96 × 10 inches.

PLATE 3 / Carmen Argote, *720 Sq. Ft.: Household Mutations—Part B*, 2010.
Carpet and paint.

PLATE 4 / Melissa Calderón, *The Bronx Housing Court Monster*, 2018. Embroidery on linen, 16 × 20 inches.

PLATE 5 / William Cordova, *Huaca (Sacred Geometries)*, 2018. Image courtesy of Argenis Apolinario.

PLATE 6 / Beatriz Cortez, *Memory Insertion Capsule*, 2017. Steel, archival materials on video loop. Photo by Nikolay Maslov.

PLATE 7 / Scherezade Garcia, *Super Tropics: La Mulata Blond*, 2015. Acrylic, pigment, mirrors on linen, 72 × 48 inches.

PLATE 8 / Ramiro Gomez, *Portrait of a Pool Cleaner (after David Hockney's Portrait of Nick Wilder, 1966)*, 2014. Acrylic on canvas, 72×72 inches.

PLATE 9 ∕ Alicia Grullón, *Female with Mulehip*, 2005, part of *Becoming Myth: An Auto-ethnographic Study*. Archival digital print from celluloid, 6 × 8 inches.

PLATE 10 / Lucia Hierro, *Breakfast Still-Life with Greca*, 2018. Digital print on brushed nylon, felt, foam, 22 × 25.75 inches framed.

PLATE 11 / Ronny Quevedo, *ULAMA—ULE—ALLEY OOP*, 2017. Enamel, silver leaf, vinyl, and pencil on Mylar, 84 × 42 inches. Collection of Jonathan Goldberg, New York. Photo by Argenis Apolinario.

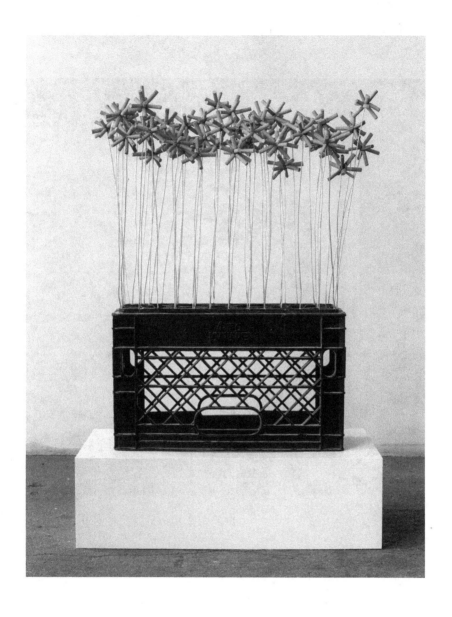

PLATE 12 / Shellyne Rodriquez, *Orthography of the Wake*, 2018. Assemblage of cigarette butts, bronze wire, crate, wood pedestal, 34 × 27 × 13 inches.

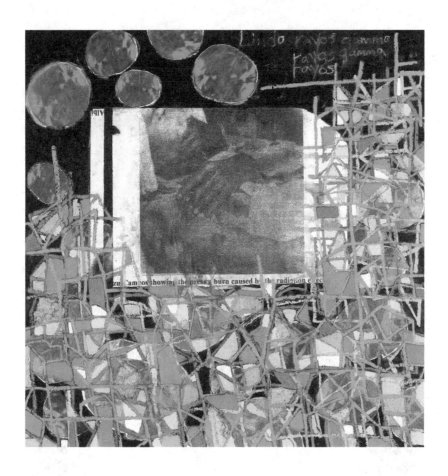

PLATE 13 / Juan Sánchez, *Lindo colores (Rayos gamma)*, 2002. Oil and mixed media on wood, 74 × 72 × 2 inches, courtesy of Guarinken Arts, Inc.

PLATE 14 / Juana Valdes, *Redbone Colored China Rags*, 2017. Bone china porcelain, each 12 × 3 × 4 inches. Photo by Diana Larrea.

PLATE 15 / Vincent Valdez, METANOIA, 2017. Oil on canvas, 84 × 134 inches.

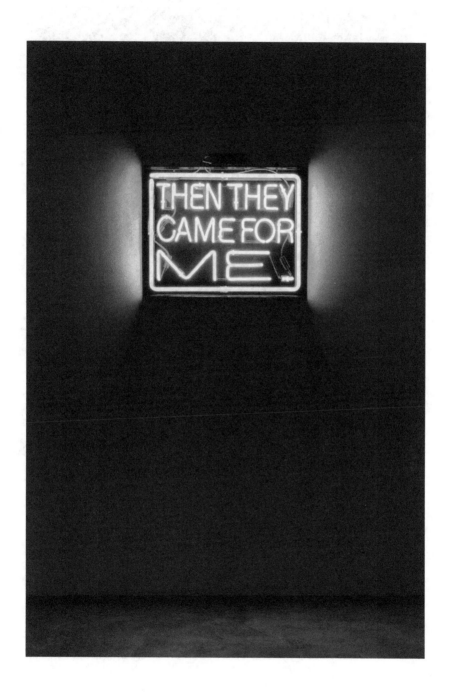

PLATE 16 / Patrick Martinez, *Then They Came for Me*, 2016. Neon. Courtesy of the artist and Charlie James Gallery. Photography: Michael Underwood.

PLATE 17 / Mary Valverde, *Curves and Points*, 2018. Bamboo, acrylic, and cotton string. Image courtesy of the artist and the Queens Museum of Art.

is where Gomez's story is also instructive, in that without the bro-
kering of Charlie James, a well-known white male LA gallerist with
connections in New York City, his story would have likely been very
different. The influence of Lawrence Weschler, a longtime writer at
the *New Yorker*, was also at play. Weschler, who authored a mono-
graph on David Hockney, took an interest in Gomez's reiterations of
Hockney's work and wrote both a *New York Times Magazine* article fea-
turing Gomez's work on the cover and a full-length monograph on the
artist's work. In sum, Gomez's success was undoubtedly expedited by
the assistance of white art stakeholders, confirming the warning by the
Cuban art dealer we met earlier that having a Latinx writer or curator
write about a Latinx artist—or, as he put it, having "Latinx on top of
Latinx"—was the worst thing for branding an artist.

The result is a well-honed "ethnic division" of cultural labor at play
in the art world, where marketing Latinx artists is most facilitated by
the brokering of white interlocutors (critics, curators, dealers, etc.)
who stand as the most-recognized arbiters of value. On this point, I
heard of at least one male dealer of color who had "partnered" with
another white male dealer exactly to reach audiences he would other-
wise not be able to reach. He tells me that, unlike him, his white friend
is able to project the "Sotheby's preppy look people like" despite both
of them having gone to the same art school and sharing a more modest
class background. In fact, to date, the most commercially successful
Black artists, such as Kehinde Wiley and Kerry James Marshall, are
represented by white-owned galleries such as Sean Kelley and Jack
Shainman. The same is true for the few Latinx artist with commercial
markets, such as Teresita Fernández and Angel Otero, who are repre-
sented by Lehmann Maupin.

This was a repeated concern of many artists who were tired of hav-
ing to be "found" and represented by white interlocutors to become
really legible. For instance, LA-based artist, educator, and activist
Mario Ybarra Jr., who in 2001 became the first working-class Chicano
student to graduate from the UC Irvine MFA program, admitted he
would have never gotten the recognition of galleries and museums in
the United States if not for the international positioning he gained
when Jens Hoffman, a German curator he met via his mentor, Daniel J.
Martinez, took him all over Europe. Ybarra's work and practice have
always drawn from the Chicanx experience and urban milieu of LA, yet
the international positioning of his work opened up doors that would
have remained closed to him otherwise, from having exhibitions in

major museums all over the United States and Europe to working with multiple galleries, including international ones. Like other artists I spoke to, Ybarra wants to see more Latinx art stakeholders generating value on our own terms, rather than relying on the rare international curator who sees value in the work. As he said, "We need more people to recognize what is possible. We need to occupy more spaces and go into them with fearlessness."

The Economy of Exclusive Spaces

The exclusivity of the contemporary art world is most puzzling when we consider the current crisis over the sustainability of galleries and art fairs. Everyone worries about the need to cultivate new audiences and collectors to halt the growingly exclusive landscape of the arts and to weather the cycle of gallery closings. At the national level, discussions revolved around the need to regulate art markets, including imposing taxes on large galleries at art fairs to subsidize smaller galleries, among other strategies to ensure a more diversified representation in art fairs. More locally, artists and cultural activists worry about the economic inequalities underlying the inaccessibility of art markets. Many had been involved in developing the People's Cultural Plan for Working Artists and Communities, a grassroots response to New York City Mayor's Create NYC plan that ignored matters of equity in housing, land development, labor, and public funding. For instance, in contrast to the mayor's official plan, the People's Cultural Plan addressed dispossession in all sectors, including the commercial sector affected by the lack of affordable commercial rents and the spike in rent speculation.[10] Artist activists pushed for galleries to become part of the plan's call for commercial rent controls, since they too, like other independent commercial stores, are affected by the rise in rents. But not all galleries were on board with a claim that compromised their arts/ position and linked them to any commercial establishment, even at the cost of their own economic interest.

At Lichtundfire on the Lower East Side, I attended a panel on these issues perceptively titled "Beyond Price and Prejudice, Ideas about the Future of Art," where these and other ideas were discussed (Becker et al. 2018). If the market can't absorb all artists produced by MFA programs, one speaker urged, why not adopt a universal income to ensure everyone can be creative in all regions of the country, not only urban

capitals? If there are not enough collectors to sustain our galleries, asked another, how can we democratize the arts and make them more accessible akin to other culture industries, such as gastronomy? The panel featured Cecilia Jurado Chueca, artist and founder/ partner of Y Gallery, recognized for its eclectic roster of mostly politically engaged Latin American artists and for her performances and public events, which attract diverse communities. The gallery started in Jackson Heights, Queens, then operated on the Lower East Side, and had moved to an on-and-off virtual platform to weather rising rents. Addressing whether it is possible for "mainstream" art to become appealing to wider audiences, one speaker insisted that this was impossible: the arts depended on exclusivity to garner value. However, Cecilia recalled selling a piece to a bodega owner when her gallery operated in Jackson Heights. The bodega owner was moved by a painting of the Virgin in the Peruvian Cusqueño School painting style and purchased the piece in installments. Additionally, she recalled urging artists to make work that communicates and is accessible to wider audiences, especially in regard to price. Even listing prices in the open would communicate that not all work is inaccessibly priced. Pointing to the packed, primarily white gathering, where less than a handful of audience members were people of color, I also added that maybe more audiences would visit galleries if the artists shown reflected the real demographics of a city that is primarily made up of people of color.

Unfortunately, there are big and growing gaps between artists of color and collectors. Larry Ossei-Mensah is a Ghanaian American independent curator who has been cultivating collectors for artists of color, including many Latinx artists with whom he is familiar with having grown up among Latinx and Caribbean communities in the Bronx. He explains, "Whenever you see an artist of color doing well, you'll look at the collectors and the majority of them are white. So the work is produced by diverse artists, but it is consumed by people who don't look like the artists." The question, then, is, how can we increase the number of collectors of color that actively collect and support artists of color? For their part, many artists seek to cultivate diverse collectors by producing prints and works that are more accessibly priced. Vincent Valdez is a Chicano artist from Texas whose paintings in the *Strangest Fruit* series (2013) and *The City I* (2016), which examine continuities in the US history of racism, have gained him accolades as an artist who "mirrors and chronicles our times" (Anspon 2016). David

Shelton Gallery in Houston represents him. However, to ensure that his friends, family, and community members are not priced out of his work, he sustains an active printmaking practice, producing prints that range from $250 to $1,000, and he regularly donates these prints to community programs. Valdez also underscores that commercial galleries are not a panacea or a guarantee of success. In fact, when I asked him how he survives as a full-time artist, what he mentioned was not solely sales through his gallery. Rather, he emphasized the "hustle" that no one teaches you at school—in particular, learning to barter. In the past he had taken care of dental and medical exams procedures and treatments, car maintenance, even six months of mortgage payments, by bartering artworks.

However, artists' generosity and public outreach can also backfire and contribute to exploitative practices. In the United States, visual artists can't claim a royalty right from the sale and resale of their work when they donate works for charity auctions. Neither can they deduct taxes when they donate works, beyond the expenses they paid for materials. By contrast, buyers at a charity auction, in addition to getting works below market prices, can deduct taxes from their purchase, and accrue gains if the piece appreciates in value when sold. Latinx artists are often bombarded with requests for donations from people unfamiliar with the working of the art market, and this also adds to the strain of protecting the value of their work while managing the expectations and demands of the market and their immediate communities. Hence the decision by artist Kerry James Marshall to stop producing public art after the city of Chicago sought to sell work the artist had intended for public display (Cascone 2018).

Artists' inability to accrue value from future sales of their work is another reason why it is so exploitative when dealers poach the work of artists of color at major MFA programs, speculating that at least one of them will become commercially valuable. Most artists who attended MFA programs recalled witnessing this type of predatory buyout, which can be devastating to artists' careers by limiting their ability to control the price of their work. The story of Oscar Murillo, the London-based Afro-Colombian artist, surfaced often in my talks as an example of the manufactured rise and fall that artists can experience at the hands of powerful gallerists and collectors.

Finally, artists are being confronted head-on with the role art galleries play in gentrification in the search for cheaper rents, and this too impacts their relationships with galleries. The past decades have seen

the growth of galleries, art fairs, and other types of pop-up mega–art events in spaces primed for gentrification. The best example is Art Basel Miami, which led to the rapid transformation of the formerly Puerto Rican and Latinx district of Wynwood into an Arts District, turning Miami into a destination city, to the awe of development enthusiasts. But this struggle is evident everywhere, from New York City to Buenos Aires. This is the key reason that Los Angeles' Boyle Heights antigentrification groups, such as Defend Boyle Heights and Boyle Heights Alliance against Art Washing and Displacement, focused their efforts on pushing art galleries out of the area, including nonprofits and longtime Chicano spaces like Self Help Graphics (Wagley 2018). Activists' intolerance against all art, pitting communities against artists and artists of color against each other, is a key symptom of the effects of neoliberal urban policies.[11] In the past decades these have become very adept at branding and using arts and culture strategies to divide and conquer constituents while keeping their predatory effects away from scrutiny, and leaving artists and communities of color to bear the greatest burden.

Against this context I noticed interesting trends of pacification by mainstream galleries organizing temporary exhibitions with diverse artists, contracting independent curators of color to bring them in. These shows provide galleries with a much-needed veneer of diversity and outreach, but they do little for launching artistic careers, as the exhibited artists are seldom picked up for formal representation. It was interesting to learn that many of the Latinx artists I interviewed had exhibited in these types of gallery group shows, especially right after graduating from major MFA programs. At Elizabeth Dee's short-lived Harlem gallery, in the same building that was once the Studio Museum's original location, I saw Latinx artists Lucia Hierro, Ronny Quevedo, Leslie Jiménez, and other Bronx-based artists in *Selections* (2017), curated by Larry Ossei-Mensah right before the developer decided to push the gallery out and demolish the historic site. None of these artists was picked up for formal representation by the gallery, though it received a lot of goodwill through filled-to-capacity openings and programs. Larry admitted, "We celebrate having the opportunity to be in these shows, we high-five about the show, but no one is asking what's next. We all need to start asking more questions. . . . The issue is, How do we ensure these type of opportunities are not 'one and done'?"

Shellyne Rodriguez is sensitized to the problems of art galleries and space coming to communities of color through her antigentrification

activism in the Bronx. Thus, when invited to participate in an exhibition by We Buy Gold, a "roving space" gallery organized by gallerist Joeonna Bellorado-Samuels in Bedford-Stuyvesant, Brooklyn, she emailed the dealer a long list of questions to ensure that the gallerist was not involved in the displacement of locals. Bellorado-Samuels, one of the rare African American dealers in the business, is a long-time dealer at Jack Shainman Gallery, one of the few major galleries in New York City that has a strong roster of African American and international Black artists. This new space was her initiative to show more off-the-grid artists, and she was able to answer the questionnaire to Rodriguez's satisfaction. Both Rodriguez and Bellorado-Samuels agreed to share their email exchange dating January 2017.

RODRIGUEZ: Where in Bed-Stuy? Is this a new construction? If not, do you know how long it's been empty or who was there before? Who is the owner? What is their relationship to the neighborhood? You can probably tell from my line of questioning that my concerns might have to do with the entanglements that real estate has with the arts and how it contributes to displacement. As an artist caught in the crosshairs of this mess, it's become standard for me to ask these questions, I think we all should in an effort to push back against predatory speculators feasting off of our creative labor at the expense of poor and working-class communities of color.

BELLORADO-SAMUELS: Completely understand your curiosity about the space and the nature of the project . . . and the complexities of opening this kind of space in Bed-Stuy.

Bellorado-Samuels goes on to share the story she was told of a building—a former single-room occupancy site, empty and abandoned for years by multiple descendants, and now partly occupied by the new owners, a Brooklynite couple who had been living "for some time" in the area—to establish that there was no immediate displacement of locals. The new owners are an artist and an independent art book publishing couple, she explains, adding: "They have turned down a few offers for chain restaurants or larger corporate entities and they do not want to bring another bar onto the block. Who knows what they will do later, but I appreciated their enthusiasm for what I want to do and even negotiated down to something more manageable in price for me so that we could make this all happen." Bellorado-Samuels concludes

by sharing her vision for a space that addresses issues of cultural production, ownership, and access and explains her interest in including Rodriguez's zines exactly to ensure that there are more accessible artworks available for purchase.

Some of Rodriguez's friends were appalled that she had even asked questions and presented any hurdle before working with a dealer of such repute. Many would have been too intimidated to put any conditions or ask any questions from her or any other dealer. In situations like these, artists are confronted with determinant questions about whether to jump uncritically to any opportunity that is presented to them or whether instead to attempt to demand accountability, in order to build and imagine new types of art worlds. These decisions are tense and often divide artists of color along the lines of class, race, and educational privilege, presenting additional hurdles to developing the type of coalitions needed to fight all the different fronts of capital presented by the mainstream art world, and by processes of gentrification and displacement. But Rodriguez's unwavering response reminds us that artists always have some agency, and it can be put to powerful use. In this case, Rodriguez modeled ways to demand accountability from galleries and any arts-based development initiative about their role in gentrification and to ensure that their invitations and outreach to artists of color are not tokenistic or public relations driven, but transformational. In fact, Rodriguez did not know anything about Bellorado-Samuels when she was approached by her, and she asked her what she would have asked any other dealer. Bellorado-Samuels is also very aware of these issues. She cannot open a gallery of her own because of the same concerns. She responds: "Don't get me started on the need for major financial backing when it comes to galleries and why gallery owners generally come from a lot of money or have access to a lot of money and what that means for artists of color, cultural production, ownership, and access."

The Perennial Problem of "Identity"

> There is always race and identity in art. It's just that people don't want to talk about whiteness. / **DEALER, ART BASEL**

The greatest obstacles to Latinx artists' insertion into contemporary art markets are more pernicious and difficult to tackle. I'm thinking

here of the "identity work," what Minh-Ha T. Pham (2015) calls the additional work that racial minoritized populations must do to strive in creative contexts where they are seen as out of place, because their identities are regarded as problems to be hidden or highlighted.

I write at a time when identity is supposedly fashionable, as are artists of color, yet although scholarship on race and creative sectors shows that identity may be celebrated or fashionable in some contexts, identity is exactly what must be erased or managed to make artists more acceptable and marketable in larger society. Let's remember the many cycles of boom and bust over Latinx culture throughout the decades, and that identity has been *in* before—most recently during the late 1980s and 1990s—but artists of color have benefited little in return.[12] After all, in the mainstream contemporary art world, cultural identities and artistry have been historically inversely correlated. The more "cultural difference" one is recognized to have, the less unqualified artistry one is given.[13] This is how whiteness in the art world comes most forcefully to the forefront: by promoting the idea that value is purely the product of aesthetic merit that should be "universally" recognized and that this merit is always compromised when artists are marked and "identified" as racial others.

Hence the anxiety voiced by artists about whether they or their work was "read" as having too much or too little identity. This was one of the most common causes of insecurities among artists who felt they always came up short in terms of what was most valued, whether it was in relation to formats or the colors they used, among other issues triggered by the range of stereotypes and contradictory messages art teachers, curators, and peers, continually direct at them. In fact, talk about identity triggered a lot of discomfort, anxiety, and pain among many of the artists I talked to, especially the older artists, who have faced decades of direct racism shaping who they are, how they are identified, and how they are "positioned" by others. A couple of artists and curators even refused to talk to me, afraid that it would "not do anything for me professionally" to be talked about in a book discussing identity and racism in the arts. Yet the issue came up repeatedly. At artists' talks, I even saw white audience members ask artists of color outright to discuss their identities, including whether and how their race and identities presented a limitation for maneuvering the art world. When Afro-Dominican artist Leonardo Benzant was asked this question during the artists' closing panel for *Visionary Aponte: Art and Black Freedom* at NYU's King Juan Carlos Center, many eyes rolled in

frustration in the back of an audience filled to capacity with people of color. This is a common question Afro-Latinx artists face from people who still can't reconcile their "Blackness" and "Latinness." Yet the artist was extremely patient. "I treat them as little children when I get questions like this," he tells me after the panel. "We have to know their world to survive, but they don't need to know ours."

Foremost, artists get mixed messages about whether and how they should address matters of identity in their work. For instance, LA-based artist, educator, and activist Mario Ybarra Jr. is part of a generation coming of age in the early 2000s alongside the exhibition *Phantom Sightings: Art after the Chicano Movement*, who saw a strong push to deny their Mexican identity and position themselves as "post-Chicano" to fit into "larger art rubrics." This lesson was driven home by his teacher and mentor, conceptual artist Daniel J. Martinez, the first Chicano to gain international recognition, who is renown for disavowing any "identity" categories to avoid ghettoization and for encouraging his students to do so too. Since then, he has seen newer generations of artists embracing their identities more freely, pushing on the canon, and arguing that recognition of their Chicanx and Latinx identities does not compromise their inclusion and participation in the art world.

Nonetheless, contemporary generations still feel similar pushbacks. Arts programs are especially known for discouraging artists of color from doing work delving into their background and identity. José Delgado Zúñiga, a Chicano painter from Ventura, California, living in New York City, recalls his BFA experience in Los Angeles as an "indoctrination in self-hate." He was chastised for doing anything that evoked Mexican and Chicano or social realism and quickly learned to strategize. "I had to learn the language of contemporary art and abstraction to talk about identity so I can exist in the white cube." He had to learn about Rauschenberg, Pollock, all of these Anglo-American artists, to survive but wondered, Why don't *they* learn about *Chicano* art, which is also American art? To his surprise, he was told he "had evolved" when he began to move away from social realist image and adopt more abstraction—a diss of his Mexican background that was not lost on him. Yet while attending Columbia MFA's program in New York City, he encountered a different message. In New York City, where Mexicans are a newer immigrant community relative to the West, he felt encouraged to be proud of his identity, finding inspiration in the work of Black artists and the Black community in New York City. "Here

people were celebrating Asianness and Blackness and queer bodies," freeing him to explore his Mexicanness in New York City.

Similarly, when Vincent Valdez painted *Kill the Pachuco Bastard!* (2001) during his last semester at Rhode Island School of Design, he was told by a professor he'd never make it in the art world, that no one cared about the subjects of his paintings, and that he would have to change the course of his work, if he hoped ever to sell it. There he quickly learned he faced three obstacles: he was an artist of color, he was painting figuratively and narratively, and he was creating paintings addressing sociopolitical work. Yet it was exactly the Chicano content of Valdez's painting that first called the attention of commercial collectors after Cheech Marin purchased the painting and used it to headline the 2001 traveling exhibition *Chicano Visions: American Painters on the Verge*. The exhibition placed Valdez's work alongside pioneers of the likes of Carlos Almaraz, Frank Romero, and Patssi Valdez, but it also "pigeonholed" him as the archetypical Chicano artist.

In Valdez's view, this positioning *denied* the complexity of his work and its commentary and engagement with the American story. He asked me, Why can't we recognize that artists are simultaneously influenced by a variety of sources, without chipping away their recognition as "American" artists?

Finally, artists get mixed messages in simultaneity and from different art stakeholders. For instance, minoritized artists are often discouraged to explore their identity at school, only to be expected to "wear their identity on their sleeve" by dealers and curators, or vice versa. Wilfredo Ortega recalls being told by a curator that he made "white people's work" because he worked in abstraction. As he put it, "It's schizophrenic how people treat identity in this country." In sum, complexity is never given to Latinx artists; instead they have to assert it consciously and with great effort.

Interdisciplinary Cuban American artist, curator, and writer Coco Fusco has been teaching art for twenty-five years. She had a lot to say about the mixed messages regarding identity that art students are exposed to. She authored one of the first articles on the politics of what was then called "Hispanic" art and its reception, "Hispanic Art and Other Slurs," in the *Village Voice* in 1988, which chillingly reads as a déjà-vu of the decade-long issues that have plagued the homogenization of Latin American and Latinx art. As someone who has been challenging essentialist and reductive formulations of identity in the art world for decades, Fusco feels that a key problem is the lack of educa-

tion about Latinx art in this country. "In art school next to nothing is taught about Latin American art, even less about Latinx art. On top of that, it is unlikely that art students will learn about the civil rights movement and the impact it had on culture and education. . . . So how then can we expect kids to demonstrate a complex understanding of their cultural heritage?" she asked.

Unfortunately, she tells me, many white instructors and peers automatically expect Latinx students to possess knowledge based on a surname. Fusco has seen students break down as they maneuver expectations that they will know their "culture" because of their "background," assumptions that reproduce packaged and essentialized notions of culture as "facts," or materialized embodiments that can be reproduced and represented rather than as something that is intangible and ever-changing. In other words, culture treated as something some students know and can access rather than as something that everyone has but that is not easily materialized. Not surprisingly, this treatment of culture also leads to inequalities between racial minoritized students and international students in US art schools. As she explained: "This is the situation that leads to Latin American artists beating them at their game. Immigrant students have an education and knowledge of cultural references that makes it easy for them to play creatively with Latino symbology. If you grow up in Mexico, for example, you learn about your culture and history in school, on TV and at home. You have Sor Juana (Ines de la Cruz) on a peso bill! The culture is everywhere." Fusco shared the example of Guillermo Gómez-Peña, the Mexican artist who in the 1980s translated the border and transnationalism and pitched the phenomenon to mainstream audiences, becoming the embodiment of border Chicano culture for US and international audiences. "Americans are very literal minded in how they understand identity and culture, and it drives me insane!" In other words, growing up as national citizens in their own countries vests Latin American art students with an advantage over US minoritized Latinx students whenever the art world traffics in "culture" and identity. This advantage is not only an issue of class and privilege or whether Latin American and foreign students come via fellowships or wealthy families and supporters. Instead, it is part of what I've been calling national privilege, reinforced by the narrow confines of how identity and nationality are objectified and consumed in the art world and in North American art schools. In these contexts, Latinxs who grow up being racialized in the United States cannot draw so easily

from "veritable" culture, narrowly recognized as "objectified culture."
Nor do they have the privilege of being able to distance themselves
from the anti-Latinx racism they live and breathe, to freely "play" with
their backgrounds and identities.

As a global city, New York City is a hub for many Latin American
transnational and immigrant artists who also identify, in the United
States, as Latinx and racial minorities, in direct challenge to how they
are positioned and marketed by dealers and stakeholders at home.
However, many of them experience pressure to disidentify with their
Latinx identities to become more commercially viable. Multidisci-
plinary Dominican York artist Scherezade Garcia is one of the few
Latinx artists who has gallery representation in the Dominican Re-
public and in New York. Lyle O. Reitzel Gallery, owned by a veteran
Dominican gallerist focusing on Latin American art, represents her
and most recently, the Argentinian gallery Praxis art in Chelsea. Yet
Garcia has faced resistance to her identification as a proud Domini-
canyorker whenever she has tried to vindicate this identity in the Do-
minican Republic, where art circles look down on it. "I come from
upper middle class in the DR and people feel I debase myself when I
identify with my New York Latinx identity," she tells me. Her paint-
ings dealing with migration and colorism in the Caribbean are always
an issue on the island. "People want to know why I paint so many
Black people." Artists like her are confronted with a divergence be-
tween how they see themselves and their work, and how it is talked
about and is sold in their home countries and internationally. In par-
ticular, as a woman, Garcia has experienced pushback whenever she
addresses topics of race, history, and colonialism. As she explains:
"There is an incredible sexism about what women artists can do. . . .
They want me to work on the body, or on more 'domestic' topics, not
on issues like colonialism."

Mary Valverde, a Queens-based artist of Ecuadorian background,
has experienced similar sexist bias in the understanding of her non-
representational work. Most often it is approached aesthetically, in
ways that miss out on how much it is informed by her knowledge of
math and geometry as well as its political significance. In particular,
Valverde uses abstract language as part of a larger claim that artists,
especially women, can have access to math, science, and any other
realm for artistic inspiration. She tells me, "Math is very political, the
way the pyramids are built, how math and form relate to textile and
pattern work and our understanding of land and the stars. All of this

is math. To be aware of all the knowledge that was taken away from us and the fact that we can't empower ourselves with this knowledge today is very political." As an arts teacher and advocate for artists on the New York City Public Design Commission, Valverde is also very sensitized to how much the creativity of Latina artists is believed to be tempered by their age, gender, and even their choice to have children. On this point, the expectation is that women need to be either young and single or senior citizens, as the mere fact of having children or just being a women of reproductive age was seen as compromising their productivity and "seriousness."

The turn to discovering older female artists while I was researching this book speaks to this trend. This tendency is the outcome of a system that shuns women artists but then reevaluates them when their older bodies are deemed less "risky" for profiting from long artistic trajectories and achievements over and above what is demanded from male artists. Carmen Herrera is the primary example here, but there are others as well. Cecilia Vicuña (b.1948), a Chilean artist based in Santiago and New York, finally got a major New York City gallery to exhibit and represent her work after her inclusion in the *Radical Women* show. Yet Vicuña has been in New York City for decades. She was even one of the artists in the important *Decade Show: Frameworks of Identity in the 1980s* (1990), a collaborative between the New Museum, the Museum of Contemporary Hispanic Art, and the Studio Museum that brought together ninety-four artists, mostly artists exploring identity in relation to wider themes, from sexuality, politics, and religion to the environment. In sum, she's been part of the New York City arts scene for decades, but only now is getting a market, and, not unsurprisingly, she is positioned squarely as a "Latin American artist."[14]

Artists involved in activism recognized their politics could mark them and jeopardize their chance of success. This seemed to be in contradiction with the supposedly marked popularity of arts activism generated by exhibitions like *Radical Women* (Hammer), *We Wanted a Revolution* (Brooklyn Museum), or *An Incomplete History of Protest* (Whitney), which were on view at museums at time of writing. An artist explained: "Activism is in, but only if it's the type that is done in a museum." However, activism in museums can also be a double-edged sword when artists of color are concerned. A classic example is the backlash after the exhibition of Daniel J. Martinez's *Museum Tags*, which read "I Can't. Imagine. Ever Wanting. To Be. White," in the 1993 Whitney Biennial. According to the artist, the reception of this work

was akin to "an atom bomb that went off in the museum"—one that blacklisted him for years.[15] By Martinez's own account, his career was in an upswing prior to the biennial, but afterward he could not get a show in New York City for five years (M. Durón 2018). To date, *Museum Tags* remains a powerful and timely intervention, especially in light of today's resurgent white supremacy. Similarly, after touring her celebrated *Two Undiscovered Amerindians Visit the West* (1992–1993) performance piece with Guillermo Gómez-Peña, Fusco recalls that it took eight years before she got an invitation to present her work again in New York. "No one would touch me here, so I worked abroad a lot during that time." During this time, she received support from scholars in cultural studies, ethnic studies, anthropology, and performance studies—but it was not until much later that a younger generation of art historians expressed interest in her work.

The fear of being "blacklisted" was often expressed in my interviews: people were wary of being outspokenly critical or tried to refrain from criticism altogether, claiming that the best strategy was simply to "focus on your work." However, for many artists of color, this is not an option. Alicia Grullón, a Dominican artist from the Bronx, explains, "By my entering a space I am politicized. I am a woman of color, I do not have a choice that my work will be political." Grullón's video, photography, and performance work delves into the anthropological practices of othering involved in documentation, and she is very sensitive to the politics of representation and what the mere presence of her body in museum space can signal. At the same time, she was careful to distinguish activism in these spaces and outside them. The week we met to talk about her work, she had just participated in a demonstration for #decolonizethisplace #decolonizetheBrooklynMuseum at the Brooklyn Museum, where she was also due to perform as part of the *Radical Women* show, and the stakes of choosing to be political were very present in her mind. She survives off "gigs like this," she said at the demonstration, "but please do not mistake my risk for that taken by undocumented workers currently in sanctuary in churches in NYC."

Alternative Markets

"Won't galleries still be white even if they showed Latinx artists?" asked interdisciplinary artist CarlosJesúsMartínezDomínguez during a studio visit in Washington Heights. The Dominican-Rican artist for-

merly known as FEEGZ uses this elongated name purposefully as a sarcastic pun on the illegibility of his Latinx hip-hop / graffiti background at El Museo del Barrio, where he works as a part-time educator: he felt a high-class-sounding name, like that of a Spanish-language telenovela character, would be most rewarded. The artist has been mulling over this question of markets and access with other artists who argue for the need to open up gallery spaces by and for communities of color. But he has always been on the skeptical side of this debate, raising a question that hits at the root of the issue, of whether Latinx artist entry into art markets conveys a transformation of that market or, rather, more complicity.

More and more, artists clamor to enter galleries, especially the younger generations. And they claim entrance as full partners, not through temporary exhibitions or pop-ups but in fair and equitable ways. However, galleries are far behind in terms of creating spaces for them, and Latinx artists and stakeholders are not simply waiting. They are also self-organizing. Thus, I conclude this chapter with lessons gleaned from examining some of the multiple art worlds that exist in simultaneity to the formal gallery system and that have historically helped nourish any diversity in the art world. I turn to local, culturally specific, and alternative spaces and to some imagined spaces that are still to come, spaces where boundaries and categories are blurred and artists function as curators, entrepreneurs, and all of this out of necessity but also as an assertive act of empowerment. Below are three lessons gleaned from talks with some artivist-entrepreneurs who are carving out spaces to support Latinx art and artists.

First, access to art markets is a key demand for cultural equity. The art world is exclusive because our society and economy are exclusive, hence art markets can't be transformed until the economy is transformed. However, while achieving income redistribution and economic equity may be daunting tasks, we could start by centering issues of class and wealth and addressing the structural barriers that limit who has access to creating and working in art markets. César García, founding director of the LA-based exhibition space the Mistake Room, is a Mexican American from a working-class background committed to diversifying art markets. He talked openly about how even people of color in the art world hail from primarily middle- and upper middle-class backgrounds. As he observed, it is their views and tastes that talk loudest, pushing institutions to do exhibitions and developing collections that become tastemakers. In his words, "An inordinate amount of

cultural capital is needed to navigate spaces of wealth and capital with comfort, but we don't have financial literacy at home, and this is not taught in MFA programs. Dealing with money feels like taboo."

For García, getting more Latinx dealers and collectors to understand the political power of bolstering the value of our own market is key. And one way out of this impasse is to challenge the purist constructions of art and commerce as separate and opposite fields. These distinctions have historically kept many Latinx stakeholders from even considering the economic aspects of their work for fear of tainting their status, or whatever status they could claim; instead they have tried to maintain a strict artistic, scholarly, or political position (see Davalos 2017). However, these distinctions are neither sustainable nor productive. They are also the product of politics. As I have argued throughout this book, strict separations between art and economics are informed both by dominant Western-based definitions that prioritize disinterested, noneconomic definitions of art that are the product of privileged positions, as they are by historically and socially specific determinations such as those made in the realm of cultural policy (see, e.g., Bourdieu 1993; Dávila 2012; Zelizer 2013).

In fact, playing by the strict rules of the privileged and adopting "disinterested" economic positions is a sure way to produce more inequality in art markets by diverting attention from the policy decisions that fuel inequality. For instance, artists' ability to accrue resale royalties for their work could help deter speculation and benefit artists. When we spoke, García was grappling with these issues while deliberating moving away from curatorial work to work as a dealer. "I keep thinking about what is the responsibility of Brown people in the art world right now, and what I think the most potent and fertile ground for impact right now may be the commercial sphere." This was a common realization of many of my interviewees, and it will be interesting to see what types of initiatives are born from these efforts.

Second, there needs to be a spectrum; or, as Larry Ossei-Mensah puts it, "If we focus on artists that make it to Gagosian, we lose what we do that makes us so special." This lesson is important because the quest to seek validation in "formal" commercial spaces has historically deterred many artists from participating in, fostering, and nourishing the few alternative commercial spaces that do exist. One such space that was beginning to get national and international exposure is Commonwealth and Council, founded by Young Chung, "the Unofficial Leader of L.A.'s Underground Art Scene" (Messinger 2016) in his apartment

in Koreatown, the neighborhood where he grew up. Chung started in 2010 showing with Gala Porras-Kim, and he has been consistently showing Latinx artists such as Carmen Argote, Carolina Caycedo, Jessica Kairé, and more recently Eddie Ruvalcaba, Clarissa Tossin, Beatriz Cortez, and rafa esparza, in a roster focusing on "women, queer, POC, and ally artists." Among them are some of the few emerging Latinx artists shown in the Getty's PST shows, who have gotten considerable attention and offers to work with other spaces but, at the time of writing, continue to work with him. In fact he attributed his success to the support of his artists in contrast to the view that artists are always vulnerable and dependent on dealers: As he said: "Artists have the power. We're staying in business because they choose us. . . . We don't sell as much, but they want to support other artists." Nurturing the idea of a space where artists can support other artists has paid off for the gallery and for a community of artists favoring a diverse multicultural space where everyone intuitively understands each other's and LA's multicultural diversity. As Chung put it, "I grew up in this. This is part of my life. We're spotlighting what is part of our cultural landscape."

Across the United States, print studios from the pioneering Self Help Graphics (1973–) to newer studios like Pepe Coronado Studio (2006– in New York and Austin) have been foundational to opening up markets for Latinx artists, and to introducing them to the commercial aspects of selling their work. Because prints have always been the most accessible artworks circulating in communities, they have also played a key role fostering interest and knowledge about Latinx art and artists among larger communities, as well as new collectors. In New York City, José Vidal, one of the few active collectors of Nuyorican art, has been organizing the only Latinx Art Sale since 2016 (rebranded as a Latinx Art Fair in 2018) at the social hall in the Church of Saint Mary the Virgin in Times Square, where Vidal has been hosting exhibitions of Latinx artists for almost ten years. The fair grew out of artists' need to reach markets and take control of their art production, and in it some artists sell to audiences either directly or through Vidal and other artists and curators, who serve as temporary dealers. Spaces like these are exciting because they bring together artists from different backgrounds and working in different genres, into the same space to imagine what Latinx commercial spaces could look like. Initiatives like these also help challenge the old-fashioned view that artists taint their reputations if they become involved in selling and marketing their work, eroding the strict divide between artists as creators or as eco-

nomic beneficiaries of their work. Empowered artists who are more involved in making commercial choices about where and how to sell can challenge the dominance of the traditional gallery system and help curb the art market's most predatory practices.

A final example is Prizm Art Fair—a nonprofit African diaspora fair founded by Mikhaile Solomon, a Miami-based Black designer and arts advocate of Caribbean background during Art Basel week, organized "with the needs of Black and Brown communities in mind." I talked to Mikhaile right after a panel in New York City where she was the only person of color in a conference on the Business of Art, where art fair organizers bemoaned not casting a wide net and the need to retool to reach wider markets, though no one at the panel seemed to know exactly how to do this. Whereas for her, the intention was always to be inclusive and diverse. She tells me, "I was going to art fairs as a younger person while I was in college and I could not see how this could be accessible to me. I wanted to purchase artwork I loved and could afford." Solomon's partnership with social justice organizations Like Black Lives Matter, the Africa Center, and the Laundromat Art Space brings wider publics to the fair, while funds from philanthropic partners like The Knight Foundation allow the fair to keep prices low and offer free admission on selected days. At Prizm people can find works at different price points, from a few hundred dollars to lower thousands and more, and most important, artists can participate without a gallery intermediary. For the 2019 fair she described selecting 39 artists from 250 artists who applied to their open call, to present alongside a roster of galleries owned by Black and Brown proprietaries, and other mostly emerging galleries. Prizm was the only fair where I recurrently saw Latinx artists, from artists working at Pepe Coronado Studio, to those participating in the curatorial interventions of William Cordova and Naiomy Guerrero. As she notes, "Someone who is young and loves art, why should not they be able to buy art from an artist they love? And why can't they purchase art when they get their first job, and why does anyone have to wait until they are wealthy to do that?"

Finally, artistic community linkages and collaborations are key. This can be in the form of artists writing about the work of other artists or curating exhibitions in galleries, art fairs, and nonprofit spaces to open opportunities up for others. This represents another important challenge to the idea that there are strict roles in the art world, each demanding unique and narrow types of expertise. Artists are also

sharing exhibition opportunities with their peers. During the 2017 Whitney Biennial, rafa esparza invited five other artists to exhibit their work around his adobe brick installation *Figure/Ground: Beyond the White Field*, including Dorian Ulises López Macías, Beatriz Cortez, Gala Porras-Kim, Eamon Ore-Girón, and Ramiro Gomez. Puerto Rican artist Jorge González did the same when he was invited to be part of the Whitney's first Latinx art show, *Pacha, Llaqta, Wasichay: Indigenous Space, Modern Architecture*, inviting Francisca Benítez and Mónica Rodriguez to participate in the programming.

Moves like this expand audiences' exposure to other Latinx artists and artists' entrance to all types of spaces in ways that have important repercussions in art markets. But even more important, these moves strengthen the sense of community and collaboration that exists among many Latinx artists, and the value of these relationships as a contrast to the dominant market-focused art ecosystem. In a neoliberal art world that seeks to pit artists against each other in the quest for recognition and confronts them with decisions that promote gentrification, classism, and exclusions, these communal strategies provide a compelling reminder that artists have at least some power to make choices that can empower other artists and larger communities. In sum, these strategies are all the stronger for the communities they create, the values they nourish, and the tensions produced in the white box, and beyond, by imagining Latinx art as thriving and valuable.

Whitewashing at Work, and Some Ways Out

The more successful I became, the less I was perceived as a Latina or as a Cuban-American. It started to bother me because, inside, I knew that I was making the work that I was making not in spite of who I am, but precisely because of who I am.

/ **TERESITA FERNÁNDEZ** in conversation with Ana Dopico, at the Perez Art Museum Miami, November 9, 2019

In the midst of the supposedly current turn to identity, I was intrigued to learn how when Latinx artists "make it" in mainstream spaces, their backgrounds are often diminished, denied, or explained away. The example that most often came up is that of Félix González-Torres, one of the most commercially successful and recognized Latinx artists. At the hands of Andrea Rosen Gallery, the Cuban American artist is most known as a "gay white man," more conceptual and international than Brown and immigrant. Multiple curators told tales about how the gallery that served as keeper of his estate emphatically insisted that his work be framed in relation to international art currents, never too closely associated with other Latinx artists or in Latinx art theme shows. Accents are altogether eliminated from his name, as are his

involvement in AIDS activism and formative years in Puerto Rico missing from his bio.[1]

González-Torres may be the clearest example of how Latinidad is whitewashed when Latinx artists are inserted in the commercial art world. But he is not the only one. This was a recurrent concern of Teresita Fernández, who insisted in all her public presentations, "I don't want my identity to be whitewashed."[2] Fernández has personally experienced this trend, first in the growing isolation of finding herself as the only Latina in whatever mainstream spaces of the art world she was entering, and then in the greater distance she felt being drawn between her conceptual and abstract work and her Cuban American and Latinx background. When Fernández's work was included in *Our America*, she was astonished that a critic raised questions about the appropriateness of including her work in the exhibition. According to the critic, an artist who "does not link her artistic practice to her Latino origins" did not belong in a Latinx-themed exhibition; the critic reproached the show for "appropriating a successful artist, whose Latino credentials are unclear" (S. R. Davis 2014). The loaded review embodies key stereotypes plaguing the appreciation and evaluation of artists of color and their work, including the idea that there is direct relationship between their identity, and their work, which assumes that Latinx identity must be easily read in an artwork. Accordingly, artists whose work is less clearly seen as "Latinx"—based on whatever definition is used to define how ethnicity is read in an artwork—must be less "authentically" Latinx. Fernández was most appalled by the assumption that including a successful artist in a "Latino show" constituted an "appropriation." For her, this line of thinking represented a doubt about the very possibility that a Latinx artist could be great and successful—a questioning of their "authenticity" once they have achieved a measure of mainstream recognition or commercial success.

Fernández has responded to the market's penchant for changing narratives about artists of color by becoming her own archivist of her work. She keeps careful records and archives of all her projects and insists that any public presentation of her work is filmed and recorded. She explains, "I always feel like we have to start from the beginning, because there are no archives and if you do make it and pass away like Félix, the whole thing can be changed, like a Wikipedia entry. So I have been deliberately videotaping explanations of my work in my own words, with my own face, so that the fact is there, instead of letting the success of the market control how you are perceived."

This tendency to take Latinx artists out of their context, sanitize their backgrounds, and keep their identities invisible or safely packaged did not come as a surprise. Marketing Latinidad always involves similar processes of commodification and transformation to make Latinxs more easily consumable, and in the past I have documented how these processes reduce Latinidad to essentialist tropes and stereotypes. The surprise was learning how in the context of contemporary art markets, marketing Latinx artists seems to work in direct opposition to how Latinidad is commercialized in other sectors of the public sphere. Instead of being marked and made highly visible—as is done regularly by television and other mass media, for instance—Latinx artists are marketed through processes of erasure and whitewashing. By the same measure, when Latinidad is purposefully marked, it often comes at great commercial cost to the value of the artist and their work, in comparison to when it is positioned in the more profitable "nonmarked" domain of "contemporary art." This explains why scores of Latinx artists have purposefully disavowed identity and identification to gain status through white association, whether purposefully or not. After all, the mainstream art ecosystem, from the MFA educational system to art criticism, teaches artists to adopt this seeming "universal" stance as the norm.

Yet in a context where there is supposedly a marked interest in diversity and diverse artists, we must ask why Latinx artists are asked to remain so invisible. In fact, on closer examination, the idea that "identity is in" in the contemporary art market has been generalized from the experience of selected Black artists who gained unprecedented recognition and commercial success, including artists whose work depicts Black bodies figuratively and proudly or examines themes from the African American identity and experience. Think here of Kehinde Wiley, who painted Barack Obama's official portrait, or of Kerry James Marshall's record-breaking auction sales. Some of this interest has spilled over onto selected Afro-Latinx artists, especially those who work with themes of Black subjectivity and Afro-Caribbean/diaspora, but on a limited basis. Currently, the category of "Black artist" is mostly used as synonym for "African American artists," rather than encompassing the universe of Black artists who are Afro-Latinx or Caribbean, although the category is also undergoing expansion and reassessment.[3]

Dealers commented that Latinx artists are often accommodated in the market in ways directly opposite to how many Black artists are

branded and positioned. As a gallerist Lehmann Maupin put it, "With African Americans it's different—every single African American artist we represent, their being African American is a huge part of their work." She was drawing a contrast between the African American artists represented by the gallery and the work of Teresita Fernández and Angel Otero, the two Latinx artists represented by the gallery, whose works were primarily abstract or conceptual and could not be identified as easily in terms of identity beyond the artists' Spanish-sounding names. Another gallerist put it in simpler terms: "There's currency in African American art but none for Latinx art." Once again the question is, What will it take to change this?

At the same time, the putative commercial success of selected Black artists needs some unpacking. Despite headlines like "Black Art Spurs Gold Rush as Collector Stampede Drives Up Prices" (Kazakina 2018), questions remain about the lack of structural changes to ensure Black artists won't have to be rediscovered again in the future. Recall how artists of color have long been stuck in the "emergent" category within mainstream art worlds, even when they have historically important trajectories of their own. Moreover, the current "discovery" is part of a larger corrective trend in the art world that some believed to be temporary and highly speculative.

One dealer acknowledged the growing interest in discovering artists "missing" from the art historical record on account of their race, gender, or age. But she skeptically dismissed the trend by reminding me this is happening at a time when the art market is in a "correction" mode after years of elevated prices and boom, drawing on financial metaphors as if she were talking of shares in the stock market. For her, identifying great but previously ignored artists is all about searching for a more secure type of investment: she explained that great and renowned artists who have been bypassed because of social prejudices make for a "safer" investment than betting on new artists, including new artists of color. In her view, this was leading collectors to "check boxes," and in particular to seek women and Black artists, as "a good place to put money now."

A dealer from Sikkema Jenkins & Co. was very critical of all the ensuing art grabbing and speculation over Black artists. She offered the example of a collector who approached her during Art Basel Miami looking specifically at Black artists because they knew Sikkema Jenkins & Co. was the gallery that pushed Mark Bradford's career before he moved to Hauser and Wirth, a gallery well known

for its market-approved art stars. The dealer tells me she could not believe the collector was probing so openly, saying things like "Is this a similar artist? Is she Black?" She asked these questions while admitting she was only interested in purchasing works by Black artists. Finally, the growing market for Black artists is also the result of greater demand for museums to diversify their collections, which has pushed many institutions to purchase works by underrepresented artists, especially women and African American artists, to "remedy" the lack of such artists in their collections. Think here of the headline-making move by the Baltimore Museum of Art when it deaccessioned works by white male artists to fund the acquisition of works by underrepresented artists (Halperin 2018).

Still, no one knows whether the trend will continue in the long term. It is also telling that white dealers and curators seemed far more excited about this supposed turn to identity than most art professionals of color I talked to did. As one of the latter put it: "For every show

like the Brooklyn Museum's *We Wanted a Revolution* on Black radical women artists, there are many more shows in the pipeline that are tone deaf." Others felt that the move toward showing artists of color was "forced and specific." David Castillo is a longtime gallerist from

Miami who is a regular presence in art fairs and represents many African American and, of late, a few Latinx artists. He admits, "The art world is cyclical, like any other market, like real estate, or fashion." He feared the trend may be more tokenistic than organic or transformational and questioned its effects on the broader inclusion of diverse artists.

Dealers representing Black artists also expressed concerns about the way stereotypes were shaping market trends. For instance, a preference for figurative art that "reads" easily as "African American art" reinforced long-standing debates about authenticity that have historically affected the appreciation of artists working in abstraction and conceptual art (Harper 2015). I discussed these issues with Joeonna Bellorado-Samuels at the Jack Shainman Gallery. This white-owned gallery has gained commercial success and an international reputation by representing Black artists from all over the world. Bellorado-Samuels has over fifteen years of experience in the art world and was far from impressed by the growing interest in Black artists. She tells me, "When you hear about something for the first time, even a whisper sounds like a scream," cautioning that Black artists remain a minority in places like Art Basel. Months later, when I visited at her gallery she offered

the example of the historic Sotheby's 2018 auction she had just witnessed where the record-breaking sale of a painting by Kerry James Marshall for $21.1 million (Freeman 2018) shifted the entire energy of the room, while previous slots on dead white masters had sold for millions "like everybody's business." Granted, it was white "dead masters," she tells me, specifying that white contemporary artists achieve high prices similar to Marshall's without these prices ever becoming newsworthy.

Bellorado-Samuels was especially critical about the preference for artists working in figuration against abstraction, seeing it as more indicative of the limited scholarship around African American art that makes it easy to hide its diversity. She warned me, "This has more to do with the markets' favor for categorizations, than with what artists are actually doing." Foremost, she was critical of dealers', curators', and collectors' "lazy" reliance on artists' story and biography instead of positioning their work in more ambitious ways that delved into artists' material or technique or the actual themes explored in their work. Finally, the dealer regretted the growing number of solicitations from all over the world requesting their artists for shows that seemed haphazardly curated. To her, this was clearly the outcome of tokenism and evidence that all they want is to have "Black artists" in their show.

In sum, my talks with the few dealers of color active in the commercial circuit of art fairs and galleries taught me to question the current "identity" turn. Research confirms their fears. A recent report shows that despite their current visibility, work of African American artists remains vastly undervalued, a mere 1.2 percent of the global auction market and less than 3 percent of all acquisitions by thirty museums surveyed (Halperin and Burns 2018b). Latinx Artists are even less valued. The high profile sales of works by Basquiat remain anomalies, not evidence of trends.

Nevertheless, this moment of apparent celebration and discovery of differences provides a fruitful opportunity to explore the workings of whiteness in contemporary art markets. What we see is a marked emphasis on the market's globalization and diversification, while diversity is managed and inhibited from becoming fully visible. In this context, whether artists' race and identity are seen as something to be hidden or highlighted should be considered part of similar whitewashing processes, because none of these positions change the fact that it is pretenses to "universality"—in other words, whiteness—that is most rewarded and remains the norm. This is evident when we study the

few instances where Latinx artists have entered into contemporary art markets, when we explore the terms of their entry, their level of visibility, and whether it is helping to create new spaces for valorizing and sustaining a more diverse art world.

The Illegibility of Latinx Artists

I set out to learn how Latinx artists are branded by visiting the few galleries that were representing Latinx artists. I also attended major art fairs like Frieze, Armory, Art Basel, and secondary fairs taking place around them from 2016–2019 paying special attention to the sections focusing on new galleries and emerging artists, which are more likely to include nonwhite artists. Looking to see whether any galleries showed or presented Latinx artists was like finding needles in a haystack. At art fairs, diversity was evoked primarily through programs, with talks and performances by artists of color; this representation seldom carried through to the selling booths. When I inquired directly, I was pointed to a few Latin American artists, but no Latinx artists. This exercise exposed some predictable and unsurprising patterns. As a general rule, Latinx artists were never discussed or named as such; instead they were nationalized (i.e., presented as Latin American) or "Americanized," with little attention to their Latinx background or identity. I put "Americanized" in scare quotes because it was used as synonymous with white artists from the United States, the only artists who were called "Americans" without hesitation or without any sort of qualification. This dual representation was the main strategy for whitewashing artists, because both "Latin American art" and "American art" are constructed in opposition to racial diversity and to diasporic identities, two of the key aspects that characterize Latinx artists.

Virginia Jaramillo, the Mexican American geometric painter at the booth of Hales Gallery at the 2017 Frieze Art Fair, was even labeled as both Mexican (wrongly) and "American." I distinguished her work immediately, after having seen it at the Brooklyn Museum's *We Wanted a Revolution: Black Radical Women 1965–85*, where, with Ana Mendieta, Jaramillo was one of the few Latinas shown working at the intersection of the avant-garde art world and radical political movements. But at Frieze, she was contextualized very differently. The woman tending the booth went on at length about her significance as "postwar American artist," admiring the cleanest of her geometric paintings and

her identity as part of Los Angeles art scene. When I asked about her background, she Anglicized the pronunciation of her surname, but then mistakenly added that she had been "born in Mexico" (the artist was born in El Paso, Texas). The fact is that Jaramillo is very much a Mexican American and proud of it, and when I spoke with her, she insisted she had no relation and knowledge of Mexico. Instead, the background and inspiration for her work is very much based on her experience in the United States—both in Watts, Los Angeles, where she raised biracial kids with her African American husband, artist Daniel LaRue Johnson, and was actively involved in the civil rights movement, and in New York City, where she has lived since the mid-1960s.

Jaramillo is most known for her large minimalistic abstract paintings, work that is more formally recognized as part of a West Coast minimalist art movement, and this also helped her gain recognition for her work. "Somehow when you're in a gallery people forget that you're Mexican," she tells me, though sexism and race and racism were always present. She laughed when recalling how she once signed her work "V. Jaramillo" because male artists had more clout. Jaramillo recalled feeling ostracized within the Chicano community of 1960s Los Angeles. Her geometric work did not fit the expectations of Chicanx art of the times, and she was raising two biracial kids. Instead, it was the African American artistic community, via her partner, that opened opportunities to her, along with her move to New York City in the late 1960s at a time when there were very few Mexican Americans and Latinx groups, beyond Puerto Ricans, and she was freer to work and be recognized as an artist. In all, Jaramillo's story is loaded with meaning about Los Angeles multicultural art worlds and about sexism and racism in both postwar art and the Chicano art movement. Foremost, her story is telling with regard to the whitewashing effects that occur once works are included in a gallery, and how "people forget that you're Mexican" when one's work is indexed as commercially valuable.

I met with Stuart Morrison, the English head of sales at Hales New York, who passionately defended his gallery's commitment to uncovering Jaramillo's rightful place in postwar abstraction. As he put it, this required "being bold and consistent" to challenge the male- and white-centrism of art criticism around postwar art and the stereotypes that she should paint more about her culture. These were familiar challenges confronted by other artists of color represented by the gallery. Yet the question of why even acknowledging Jaramillo's Mexican

her identity as part of Los Angeles art scene. When I asked about her background, she Anglicized the pronunciation of her surname, but then mistakenly added that she had been "born in Mexico" (the artist was born in El Paso, Texas). The fact is that Jaramillo is very much a Mexican American and proud of it, and when I spoke with her, she insisted she had no relation and knowledge of Mexico. Instead, the background and inspiration for her work is very much based on her experience in the United States—both in Watts, Los Angeles, where she raised biracial kids with her African American husband, artist Daniel LaRue Johnson, and was actively involved in the civil rights movement, and in New York City, where she has lived since the mid-1960s.

Jaramillo is most known for her large minimalistic abstract paintings, work that is more formally recognized as part of a West Coast minimalist art movement, and this also helped her gain recognition for her work. "Somehow when you're in a gallery people forget that you're Mexican," she tells me, though sexism and race and racism were always present. She laughed when recalling how she once signed her work "V. Jaramillo" because male artists had more clout. Jaramillo recalled feeling ostracized within the Chicano community of 1960s Los Angeles. Her geometric work did not fit the expectations of Chicanx art of the times, and she was raising two biracial kids. Instead, it was the African American artistic community, via her partner, that opened opportunities to her, along with her move to New York City in the late 1960s at a time when there were very few Mexican Americans and Latinx groups, beyond Puerto Ricans, and she was freer to work and be recognized as an artist. In all, Jaramillo's story is loaded with meaning about Los Angeles multicultural art worlds and about sexism and racism in both postwar art and the Chicano art movement. Foremost, her story is telling with regard to the whitewashing effects that occur once works are included in a gallery, and how "people forget that you're Mexican" when one's work is indexed as commercially valuable.

I met with Stuart Morrison, the English head of sales at Hales New York, who passionately defended his gallery's commitment to uncovering Jaramillo's rightful place in postwar abstraction. As he put it, this required "being bold and consistent" to challenge the male- and white-centrism of art criticism around postwar art and the stereotypes that she should paint more about her culture. These were familiar challenges confronted by other artists of color represented by the gallery. Yet the question of why even acknowledging Jaramillo's Mexican

American descent represents a compromise to her value and positioning remained unanswered. Also, how do we account for other artists who do not fit so neatly into an accepted American art script as "post-war abstraction" and remain illegible on account of who they are and what they do?

These questions followed me to Los Angeles, where I was happy to come across Charlie James, one of the few galleries that regularly shows and represents Chicanx LA-based artists, such as Patrick Martinez, Gabriella Sanchez, and Ramiro Gomez. The gallery was a pioneer of Los Angeles' gentrifying Chinatown art district, which has been attracting galleries with more competitive rents. Though small, it has been making waves for discovering what were described to me as "crossover Chicanx artists," whose work is popular among Anglo-American clients. Ramiro Gomez, in particular, has been all over the news since debuting its first one-artist show at the gallery. His story of growing up as the son of Mexican immigrants (his father worked as a trucker, his mother as a school janitor), of working as a nanny in some of the toniest sectors of Los Angeles, and how all of this informs his paintings of migrant workers has gained him much national press, including a *New York Times Magazine* feature article and a book-length monograph (Weschler 2015, 2016).

Gomez's commercial success is especially remarkable given the undeniably Latinx content of his story and the subject matter of his work. The figures of maintenance workers, nannies, and working-class Brown Latinx bodies adorning his paintings stood out loudly at the glitzy exhibition of PPOW gallery in Miami Art Basel, and at the gallery's headquarters in Chelsea. The "out-of-placeness" of his paintings in these spaces has not escaped Gomez, who, despite the speculation and the hype around his work, continues his practice of gifting small portraits to the workers he paints. I saw him do this at Art Basel Miami and also at the PPOW gallery New York City show. For Gomez, gifting small works was one way he could intervene in the market and maintain a connection with the subjects of his work. As he explained, if his work keeps rising in value, the workers who posed for him will also have something of value to cash in. "I know having something of value would have made a big difference for my family and maybe this could make a little difference to some family too."

I probed the mostly white audience of viewers and collectors, as well as the gallery representatives selling Gomez's work, about what

made it so special, and their responses revealed how artists are white-washed in their public representation. Art stakeholders had hinted at or openly outlined common strategies for whitewashing artists. These ranged from positioning artists in more "universal" ways, avoiding any mention of their particular backgrounds or histories, to highlighting anything that is "achievement based," such as fellowships and prizes, or else that is global, such as international residences or exhibitions. As one dealer told me while browsing at a Sotheby's preauction show (and in the most nonchalant way), "Take away its roots, and it sells better."

Ensuring that whoever writes about the artist is not Latinx, even if the scholars or writers who may have first written about the artist were Latinx, was also a must. Rafael DiazCasas, the curator we met earlier, has researched and written about Carmen Herrera, but has never been asked to write for exhibition catalogues. He tells me in a resigned tone that "having a Latinx artist is more than enough," hinting to the need for white stakeholders (writers, dealers, etc.) to broker these artists and secure their value.

Other examples of whitewashing at work include describing the work in formal ways and in relation to dominant art tendencies, such as geometric abstraction or minimalism, while minimizing the topics and issues guiding the work. When Freddy Rodríguez was shown by Isabella Hutchinson, who specializes in modern Latin American art, the bio of the Dominican Latinx artist likened him to a Latin American artist who works on Dominican, Caribbean, and transnational issues, with no mention of how his fifty-plus years in New York are reflected in his work, beyond his "rigorous concerns" with hard-edge painting, geometric abstraction, and minimalism.[4] For artists born outside the United States, another strategy is emphasizing histories of exile or political persecution, or anything that gives artists an authentic link to regional and international histories or adds to their global political pedigree. Also emphasized are moments in an artist's career that resonate with more recognized art movements or collaboratives, even if they may not have been as important to an artist's creative life. A good example is the emphasis paid to Félix González-Torres's involvement in the New York City collective Group Material, presented as an aesthetic project devoid of any mention of its involvement in AIDS activism, and the exclusion of his formative years in Puerto Rico from his gallery bio. Another example is focusing on an artist's "global" experiences—stating where they lived or traveled, and avoiding any

ethnic identification or any dialogue they may have had with other artists of color. The fact that Calzadilla (from Allora and Calzadilla) is most often presented as a Cuban "residing" in Puerto Rico, in ways that erase how his studies at San Juan's Escuela de Artes Plásticas in Puerto Rico and his decades of living and working in Puerto Rico have influenced their work, is a good example here. Another is how Jean-Michel Basquiat's Puerto Rican mother, Haitian father, and Nuyorican heritage are rarely talked about or acknowledged as part of his Latinx background. These examples evidence the continued exclusion of Haiti and Blackness as part of Latin American identities.[5] They also signal the continued erasure of vibrant Puerto Rican art worlds that exist on the island and in the diaspora, as if expunging these roots functioned as the entry price for gaining artistic international recognition and success.

When Latinx artists are packaged as "American," they are presented as exceptional, through "against all odds" success stories that separate them from the rest. As a dealer at Untitled Fair in Miami put it: "I don't work with other Latinx artists, but I don't have to. I already have 'the good one.'" Oftentimes, they are described as an "atypical Latinx artist who is more open to conversations," assuming most Latinx artists are inherently narrowed off from the world. These are the exact words a dealer used with regard to the one Latina conceptual video and multidisciplinary artist he represents, clearly implying that there's such a thing as a "typical" Latinx artist who is not engaged in similar openings. When I asked what he meant by a "typical" artist, I was met with similar stereotypes to those exposed throughout this book: "a lot of incubations of, well, I don't want to say nationalism, but that's the word, you see it in the color tones, symbolism, it is very graphic and it references Latinx culture but only for its own purposes." Yet like the dealer we met in chapter 1 who summoned quick stereotypes of Diasporican artists without offering a single example, this dealer admitted that he had worked with very few Latinx artists, making his ability to summon stereotypes of what a "typical" Latinx artist looks like extremely revealing. Notably, his description is not even very different from what a cursory Google image search for "Latino" or even "Latinx art" would yield—an excess of Frida Kahlo images, calaveras, vivid colors, and figurative art. This is not to say that contemporary artists may not also draw on these visual images, but when even the *Houston Chronicle* fronted its coverage of the 2019 Latino Art Now! conference with a calavera painting, the sense of letdown was palpable.

As a Houston artist put it: "Yes, we do work like this, but this is not all there is. Some editor picked this image."[6] In other ways it is easy to understand why dealers will summon similar images so easily. They are sedimented by the media and digital search engines as the only "look" of Latinx art and, not surprisingly, are equally engrained in the mental visual archives of dealers, curators, and the public at large.

Art historian Charlene Villaseñor Black's description of the types of dualities that impact the reception of Latinx art at a keynote delivered at the Getty Center in Los Angeles echoed some of the reasons I was given for Latinxs so called unmarketability (Villaseñor Black 2017). Among them, the idea that Latinx art is too political to be commercially viable, or too parochial to be considered "cosmopolitan," too representational and lacking intellectual rigor, or too ethnic identified. All of these stereotypes stand as excuses for the exclusion of Latinx artists as one that is "self-imposed," never structural, that has nothing to do with how racism frames the reception of Latinx artworks.

Many of these stereotypes derive from dominant ideas about Nuyorican and Chicanx art that accompanied social movements in the 1970s and onward. At this time, many artists placed emphasis on the development of a visual and aesthetic vocabulary that reevaluated Latinx culture, especially its most debased African and Indigenous aspects. The dominance of graphic arts and muralism as the best-known and most defining elements of Latinx art has also contributed to the stereotype that, as a dealer put it, "Latinx art is hitting you in the face with the issues" and that "no one wants to live with such political art" in their living rooms. Juan Sánchez, one of the most celebrated Nuyorican artists, was one of the artists dismissed by a New York City dealer in this manner. Sánchez is one of the most recognized formative figures of Nuyorican and Latinx art, and one of the few artists whose work is included in the collections of major institutions, from the Whitney to the Smithsonian (albeit mostly prints, since few museums invest in paintings and more expensive works by Latinx artists). Nevertheless, an art market professional said she would not "touch him" because his work was "too politically radioactive."

The racist underpinnings in gallerists' concern about Latinx art being "too political" or too off-putting became more evident the more I visited galleries and art fairs. Then it was clear that not only are these assessments entirely subjective, but work with seemingly off-putting confrontational content is common in the commercial gallery circuit. Even Chris Ofili, whose *Black Madonna* painting with elephant dung

fueled a national culture war, has gained commercial success, powered by the very controversies the work helped launch in the late 1990s.

I discussed this issue with Anna Stothart, director of Lehmann Maupin, who was straightforward about the cultural anxiety that surrounds Latinx art, in particular, the problem of visualizing Latinx Brown bodies on canvas. "I don't know what it is about the Latinx body being visualized on canvas that is so disruptive to people," she concurs. She recalled the national scandal over Chicana artist Alma López's work *Our Lady* as one instance that had scared off collectors. In 2001, this work featuring performance artist Raquel Salinas as a Virgin de Guadalupe, cloaked in a bikini of roses, with activist Raquel Gutierrez as a nude butterfly angel became embroiled in a national debate: protesters demanded that the "blasphemous," "offensive" work be removed from the Museum of International Folk Art in Santa Fe, New Mexico. The debate perplexed the artist and many supporters. "Many churches, in Mexico, Europe, and the United States, house images of nude male angels and most prominently, a Crucifixion practically naked except for a skimpy loincloth," the artist countered, so why then is this work so offensive?[7] As a point of contrast, Stothart offered the example of white female artist Joan Semmel and her paintings featuring sexual poses and self-nudes. These works are highly coveted by collectors, which underlines how, on their own, nudity and controversial content are never obstacles to commercial success, at least when white artists are concerned.

This lack of tolerance around Latinx artists' use of social, religious, and political references is one of the direst outcomes of the general lack of knowledge of Latinx culture and history in society, and of the lack of awareness of Latinx artists as artists from, and working in, the United States. As Adriana Zavala notes, viewers, having never been taught about these artists' works at schools or elsewhere, are prone to view any political sign that does not signal Anglo-American "Americana" as politically charged, or "radioactive," in the words of the aforementioned dealer. She made this point in relation to Latinx artists' use of flags, which is common among many artists and one of the political and formal elements of their work. However, when Latinx artists such as Juan Sánchez use the Puerto Rican flag (as in his painting *¿Dónde esta mi país ?*[1990]), or when Chicano artist Salvador Roberto Torres uses the United Farm Workers flag (in *Viva la raza* [1969]), it is not understood as an accepted artistic intervention, as are, for instance, Anglo-American Jasper Johns's paintings with the US flag.[8] As

she notes, Johns's use of the flag is unequivocally praised and understood by critics and accepted as an artistic intervention, but the racialization and marginalization of Latinxs makes the flags used by Sanchez and Torres illegible.

Back to whitewashing, another common approach was likening Latinx artists to well-known and (commercially approved) Anglo-American or internationally known artists. For instance, I was told that New York–based Chicano artist Jose Delgado Zúñiga was like a "post-Chicano James Rosenquist" because his work "resembled" the better-known white male artist. Similarly, during Carmen Argote's solo show at the New Museum (Carmen Argote: As Above, So Below 2019) we are told that some of her work was produced during two residencies "including one in the former home and studio of renown Mexican muralist José Clemente Orozco." With this show, Argote became the first Latinx artist to have a solo show at the New Museum in New York City, yet we are told about Orozco's garden and nothing about other important Latina artists from Ana Mendieta to Teresita Fernández, who have similarly transformed materials from their surroundings in their work, themes that may be more visible and palpable in her work than Orozco's Mexican garden.[9]

Again and again, the positioning of Latinx artists only in relation to recognized white or internationally known artists or "art historical" movements, points to an art world that cannot imagine discussing them on their own with any complexity, and much less in reference to other artists of color. This treatment also triggers a politics of "overcompensation" to fit them into whatever dominant, canonical art history script might work, even when this canon continues to shun them. Similar overcompensation strategies were evident in the different amounts of literature, including catalogues and secondary materials, that were regularly summoned around Latinx artists. While it was common for dealers to have little to no literature, or even labels, when selling the work of white or international artists, Latinx artists were almost always accompanied by fliers detailing their bios and backgrounds and describing their work. For Freddy Rodríguez's debut at Frieze (2019), dealer Isabella Hutchinson had even readied herself with two large binders with copies of every single exhibition he had participated in since the 1970s, highlighting in particular that Rodriguez had shown with the now–market darling Carmen Herrera. Then there is the even simpler strategy of omission, of not bringing up an artist's race or ethnicity or background.

Discussions of Gomez's work brought many of these strategies to the forefront. First, a dealer once touted Gomez as "the Latino David Hockney that everybody likes," pointing to the artist's spoof of Hockney's backgrounds as the element that most guarantees his artistic legibility. I was intrigued about how often he was called a pop artist—a label that highlights art historians' favor of form and art historical genre recognition and bypasses entirely the social and political content of the work. Charles James, his primary dealer, praised him as a rare "crossover" artist, and one of the few Chicano artists who had eliminated the distance between Chicanx art and the collector class. In his view, Gomez's genius was in abstracting the "Latino thing" in a way that white collectors can appreciate, and making the collecting class feel comfortable with his work.

I was confused by how exactly this is happening: while I appreciate the "all art is abstraction" argument, which refuses the distinction between realist and abstract work, Gomez's work is not easily described as an "abstraction of the Latino thing." His paintings of beautiful luxurious surroundings may index Hockney's "Americana," but they are nevertheless openly spiked by figures of Mexican workers. The lifestyle contrast and the stories of inequality gleaned in Gomez's work couldn't be more stark, yet according to this dealer, the message is transmitted in a way that tells the collecting class that this work is of them, "it is not this other thing coming to you," as he went on to generalize about how traditional Chicano art is too didactic, "too much in your face." In his view, Gomez operates in a medium that is closer to Anglo audiences. Yes, he brings up social issues of oppression and inequality like other Chicano artists, but in "beautiful ways, without yelling at you." I immediately thought that perhaps people would be less open to the work if workers were not pictured on Madison Avenue or in luxury homes in LA; how much we should credit this background for making his work and message more "beautiful"? Commenting also on Patrick Martinez, the Chicano artist known for his neon illuminated text-based work, the dealer goes on to laud the fact that Martinez and Gomez are handsome, can network, and look good in front of cameras, adding, "They have star quality and people like them."

It was pretty obvious that as dealers gushed over Gomez's work and singled him out as a rare star-artist exception from most Chicano art, they were also maintaining whiteness as the norm for quality by reinforcing stereotypes of Chicano art as narrow, didactic, and stuck

in the past. In other words, this presentation communicates the still-unbridgeable distance between "the rare exceptions" like Gomez and "the bulk of unsophisticated Chicanx artists," whose work, by implication, could never appeal to audiences as broadly. By the same token, the politics of exception we saw at play in the reception of Teresita Fernández's work bolsters whiteness doubly, this time by implying that if a Chicanx artist "makes it," it is ultimately because they are not like the rest, not really Chicanx. In this context, narratives about artists of color who make it end up reinforcing the same canon, especially when their arrival and acceptance is couched in the same terms or gauged by their entrance to white mainstream museums. The result is the permanence of Eurocentric hierarchies of values that dominate art criticism, where Latinx art is poised as permanently inferior, derivative, and only intelligible as a mimicry of Anglo-European art or as embodiment of tradition or authentic non-European culture (see Davalos 2017; L. E. Pérez 2007).

People's belief that most Chicanx art is "coming at you" and confrontational is also quite revealing. Much of this criticism was leveled at figurative art as if the presence of anything that visually indexed Chicanx culture constituted an "affront" or assault on the viewer. This assessment evinces the ease with which Latinx artists can be dismissed with the much-maligned label of "identity politics" in ways that may have little do with the content of their work, and more to do with stereotypical ideas about these artists, or with audiences' low tolerance for anything Latinx. One artist observed that people will "read" identity from an abstract sculpture if they know the author is named Pérez or González. White artists, whose names, "culture," and references are more likely to be known and considered part of the canon of what is "American," are less marked in this manner.

Then there is the over-the-top drama that accompanies the exhibition of work by Latinx artists when they engage directly with matters of racism. In 2018, Vincent Valdez's exhibition of his painting *The City I*, depicting people in Ku Klux Klan garb and addressing the topic of racism and hate crimes against Latinos, required almost a year of preparation by the Blanton Museum of Art in Austin, Texas, to ensure that people could handle the work's content. The museum hosted intimate meetings with scholars in sociology, media, anthropology, and more; built a facade to protect the painting; included a content warning for viewers; and organized an extensive public programming to qualm any concerns the "controversial" painting would raise (Weber 2018).

Not surprisingly, the expectation that Latinx art will be "over-the-top-political" also affects the appreciation of many Latinx artists whose work is "not political with a capital P." Hence, some dealers also complained that artists of color doing abstract or conceptual work are often more difficult to brand, given the expectation that their work should be easily read as political.

At Art Basel I got a glimpse of the politics of omitting and not discussing the artist's racial or ethnic background at their best. For instance, I was struck with the ease and enthusiasm displayed by a dealer discussing Gomez's work in relation to the issues of economic inequality and insecurity without once mentioning that the working people portrayed were the Brown bodies of Mexican migrants. Instead, he spoke at length about the economic aspects of his critique and mentioned that Gomez is a queer-identified artist; he seemed hesitant to use the descriptor "Latino." I asked him whether it is not also important that the figures he painted were migrants, specifically Mexican and Latinx, just like Gomez, and was given more clues about what may be ultimately guiding the politics of omission in the first place. The first piece of evidence was the dealer's physical show of discomfort. A more honest clarification followed when he hesitated between calling Gomez "Mexican" and "Latino." "Is this the right term?" he asked me as if he had just uttered a slur, admitting that as a white person he simply did not feel comfortable talking about Mexicans, did not know what would be an appropriate name to call them or an appropriate way to tell their story.

I was having this conversation at Art Basel Miami, where most gallery dealers, representatives, sellers, and staff were white. Most collectors there were also white, as were all the surrounding walls and booth dividers, and even the carts running around selling champagne. In this context, Gomez's canvases with Brown bodies of maintenance workers, some of which had been painted in situ, were even more powerful, as the rare visible representation of all the Brown bodies working behind the scenes, keeping the spectacle of whiteness in place. In other words, this is not the space where one would expect anyone "to know how to talk about Latinos." Yet we were also in Miami, which is a majority Latinx city. And the gallery worker had grown up in Southern California, where Latinxs (especially Mexicans and Mexican Americans like Gomez) are impossible to miss. In other words, Gomez's story is also this dealer's story, making it so poignant that he felt so uncomfortable even identifying him as Mexican or Latinx, names that to him seemed to sound like a slur.

I immediately thought about how the self-imposed silence of discussing an artist's identity and background might affect a dealer's ability to champion and sell their work. Telling a great story about an artist or their work is always central to the process of marketing and selling an artwork. At art fairs, I was offered lengthy stories about works and artists that suggested gallerists had read about artists' works, knew them, and felt comfortable and enthusiastic talking about them publicly. In fact, this was all part of their job. In the gallery world this is referred to as the "positioning" of an artist—that is, branding artists and getting the story right so that everyone on staff can represent them according to the agreed-upon "position." Even when my buying identity was suspect at best—I browsed outside of VIP previews days, and I was unknown in their networks—whenever I prompted dealers to tell me about a work or an artist I was still offered elaborate stories about artists' backgrounds, where they come from, what their nationality was, or even their sexual preferences. In fact, the same gallerist who failed to say much about Gomez's ethnic background had offered *Whitewashing* information about Gomez's sexuality, and how he fit well in a gallery *at Work* that represents a lot of queer artists doing figurative work. He also had no difficulty discussing at length the David Wojnarowicz photographs that were also displayed in the booth: I overheard him talking about 155 Wojnarowicz's life as a writer, his anger, and his activism and involvement in New York's avant-garde and queer-identified movements.

In other words, it dawned on me that if dealers do not say much about the backgrounds of the few Latinx artists represented in these spaces, it was not necessarily because backgrounds and identities are not valuable to artists' positioning, or because dealers are not comfortable or used to discussing these topics. In fact, once artists and their works have appeared in a gallery or in an art fair, they are regarded as "commercially" valuable and of interest to collectors no matter their identity, hence talk about artists' backgrounds was not uncommon. I recall the London gallerist at Art Basel who not only offered the nationality of an African artist she represented without my asking, but also revealed that she was doing so without the artist's permission because he did not want to be identified in identity terms. The artist had thought this nonidentity position would make him more marketable, but the dealer had clearly felt otherwise. In other words, the silence around Latinx artists and their backgrounds was indicative not of the purchase of identities in the art market, but of the general ignorance and lack of comfort people in the art world seemed to feel about

discussing something they knew little about or that seemed so foreign to them. Or perhaps it is a sign of how maligned, invaluable, and out of place Latinx identity seemed to be in these spaces. Dealers were eager to tell life stories and backgrounds of international artists, and artists who had legible nationalities, but Latinxs were too slippery. In other words, they indexed race.

I was sharing these thoughts with a friend, the artist David Cruz, while browsing around Art Basel when he saw his friend Donnamarie Baptiste, a Black independent arts director, producer, and events planner. He insisted that I meet her. It took one minute before the conversation turned to the marketing of artists of color in the art world, a subject she was eager to discuss. Pointing around, she noted, "Most of the artists you see here are white, as are the dealers, many of who simply do not know how to interpret works of artists from different backgrounds. . . . Imagine a world where we had more gallerists of color selling work from artists from all over the world, then we would not have to worry about being ghettoized." She added, "You can't represent an artist if you can't talk about who they are, or you don't feel comfortable talking about them or their work regardless of who they are, or the topic of their work. You need to talk about artists' work with genuine enthusiasm. That's how you sell art."

Dealers' unfamiliarity with the work of Latinx artists came up repeatedly during my conversations when artists shared tales of their difficulties finding people who "got" their work or were able to talk about it and sell it to audiences with enthusiasm. For instance, prior to joining Charlie James in Los Angeles, Patrick Martinez struggled to sell work out of some Westside galleries with a roster of primarily white artists: "They showed me because there was a buzz behind the work, but they did not know how to talk about it. I once heard them talk about the work and it was very superficial and they were talking about color and shape, without saying anything about the content." Now Patrick keeps in constant contact with his gallerist about each step of his process to ensure there is a clear understanding of what he intends with each piece. Like Patrick I learned of many Latinx artists who do extra work for the galleries they work with to ensure their work is contextualized appropriately. Some admitted even writing the press release or the curatorial statement to their exhibitions effectively taking on the work of dealers and curators. Unfortunately this close level of artist-gallery involvement is extremely task intensive for artists, and not always possible to achieve. The more likely scenario was

for artists to have had unfortunate experiences with dealers who could not appropriately represent the subject matter of their work, or who were unable to translate culturally or historically based details without falling into stereotypes or flattening out rich subject matters into tropes of "Latino" culture. Carmen Argote echoed the wish of many artists who felt their work was often limited to narrow issues and positionings, and wished more than anything to be treated with expansiveness, just as white artists are treated. "I want to work on whatever I want without being pigeonholed about it being about my father or my immigrant experience. It is not that we are denying who we are, it is just that we are asking for an expansiveness that is denied."

At the same time Carmen's case highlights how this expansiveness often comes at the cost of erasures. In fact, curator Margot Norton thought Carmen was a Latin American artist, just as other artists she had previously worked with, until queries from art writer Carolina Miranda from the *Los Angeles Times* brought up the significance of a solo art show by a Mexican American artist at the New Museum. In "Targeted in El Paso, vilified by Trump. Why the Latino culture vacuum is dangerous" Miranda discusses the political implications of the "Latino culture vacuum" even in such Latinized cities as New York and Los Angeles, where the author could not recall a single solo show featuring a Chicano artists in the past decade, beyond the 2017 solo show on Carlos Almaraz at Los Angeles County Museum of Art (Miranda 2019). Carmen's case also highlights the importance of exhibiting in the "white airports" or mainstream spaces that curators are more tuned into. While the artist had enjoyed some well-deserved visibility since her inclusion in LACMA's Home: So Different So Appealing (2017) one of the flagship exhibitions of the PST LA/LA it was the Hammer Museums "Made in LA 2018," and her residency with the international nomadic gallery Ballon Rouge, that brought her to the attention of Morton, in other words, repeated exposure in the type of "mainstream" spaces that are so key to bestowing the "right" exposure that is so necessary for artists of color to be actually "seen."

Related to this point of being noticed, I noticed a favor for works that were either colorful or had "strong narratives," especially paintings that could be described in terms of anecdotes or stories, or works that were easily accessible within art history terms, such as pop art. These types of work seemed to ease dealers' ability to translate for their primarily white clientele by allowing them to focus on the works' formal attributes, such as shape or color, or on whatever story was told

by the work, or else on fitting it into more generic and recognized art rubrics. Artists also complained about their work being reduced to either form or content and seldom seeing these two aspects of their work discussed in tandem. Others complained about the penchant for simple descriptions and stories; as one put it, "They want to say the painting is about this and that, and have the white collector recognize and say 'Oh, I see that, I understand that, and I'm going to take it.'" It seemed that where Latinx artists are concerned, simple narratives to make works and artists narratable and relatable were a must. Thus, when addressing work that depicted Brown and Black bodies, dealers focused on issues of urban culture and masculinity or the "bold" use of color. They seemed to be especially interested in work with clear references that could be recognized to be indigenous, archeological, or historical and be pointed to as signs of authenticity. Anything Basquiat-like raised interest, as one of the few references well known to dealers and collectors. It was also interesting that instead of talking about their work, dealers offered numerous cute, interesting, and legitimating stories about the artists that ranged from whether they had been nannies, played in rock bands, were appreciating in value, were "cool," or had gone to Yale. Other times my queries yielded more instrumental responses, especially in the more commercial spaces of art fairs. Comments such as "This artist will go places," or "There's support around him" (always him), or "He works hard and is connected," or "A number of us are working together to ensure he succeeds," or even "Get it now before it goes up in price" put on display the speculation that was beginning to develop around some individual Latinx artist. The result is a concerning tendency to instrumentalize the work of Latinx artists as always being about something specific, whether it is related to their "culture" or their background or something else, or as only significant if it will accrue value based on very limited criteria for evaluation, such as whether the artist had gone to Yale.

This fetish and reliance on easily accessible narratives speaks to the segregated workings of the art market, where those selling and purchasing works by artists of color are primarily doing so "in the abstract," without direct knowledge of their history or cultural references. An artist echoed what others had told me: "They like work about things that are easily identifiable because they don't know how to talk about us. They are either afraid, and don't know how to do it, or don't have the context or historical experience." Larry Ossei-Mensah spoke to this same issue when discussing the lack of legibility around

themes of migration and movement, common among Latinx artists but greatly misunderstood in the art world: "What it is to move back and forth between two countries or to remit money to family members in your motherland? These things we find to be familiar if you are an immigrant (foreign born or first generation). For someone who has not experienced this, these situations are totally abstract." Larry warned that artists of color must be vigilant about how their practice is understood by curators and dealers in order to avoid their work being misrepresented, "I've seen situations where artists are doing work about pleasure, what it is to be Latinx and oscillating between two worlds, and a curator/dealer misreads the work being about struggle and it has nothing to do with that. Maybe the work is about the aesthetic purity of the Caribbean landscape."

These issues add another layer to the process of positioning and whitewashing artists in the market. Artists and dealers work at very different and contrasting fields in the art world, and most artists remain at the margins of the actual processes involved in selling and purchasing their works. Despite artists' attempts to control their narrative, they are not involved in the dealer-collector relationship and communication process, in which dealers "position" and brand works to individual collectors. These processes are also marked by the race, class dispositions, and personal relationships between dealers and collectors, among other factors that remain outside the purview of individual artists.

This was a growing concern among artists who had gallery representation, such as Firelei Báez, Ramiro Gomez, and Vincent Valdez. These artists hailed from working-class backgrounds and produced work informed by their larger concern with the empowerment and reevaluation of devalued histories and communities. However, none of them could entirely control how they and their work are positioned to clients, as this process takes place behind closed doors and is based on whatever theme or position may resonate more with a particular collector, without artists being able to intervene in the narratives circulated about their work.

Firelei Báez, a rising art star during my research, has worked with various galleries and has thus had multiple experiences in which her work has been mischaracterized, beginning with the tendency to pit her Afro-Caribbean background against her Dominican and Latinx identity part and parcel of Latin American stakeholders' lack of recognition of Haitians as Latinx artists. The artist was born in the Dominican Republic and had the opportunity to travel to both Haiti and the DR, and

was raised in the United States, yet she finds people most resistant to her Latinx identity, which to her "represents all of these things." She tells me, "They want me to be real Latino/a or really Black. The moment I mention Haiti, I get resistance from Dominican Republic and Latin American art spaces. And when I highlight my Black heritage, people see me as Black, never as Latina." Báez is committed to showing the interlinked histories of the DR and Haiti, challenging any adversarial positioning between the two. Hence, the separation of her work as being either Dominican (i.e., Latin American) art or Haitian (i.e., Black diaspora) art was especially frustrating, since it is directly against the impetus of unity that drives her artistic practice.

Báez was also troubled to see that her Afro-Caribbean identity carries a lot more purchase among many collectors of Black art than her Latinx identity does with any category of collectors. In fact, her initial support and commercial success has come via collectors of Black art and Caribbean art and institutions like the Studio Museum or the Pérez Museum, under the leadership of Franklin Sirmans, not from Latin American museums or collectors. She asked, "Why is it so sexy to take part of the narrative, and why is making work at this interstitial place, not being either/or, somehow dirty?"

Used to the lack of legibility around her work and her background Báez has learned to communicate as clearly as possible with dealers. "I will say one thing to them, and I will have very clear parameters about what the work is and what discourse around the work should be. I'll give them notes: 'this is what this means to me.'" Still, to Báez's surprise (though predictably), what most resonates with her collectors are narratives that emphasize her female figures, feminism, and empowerment rather than the larger historical references around colonialism, Caribbean history, and racism. Báez is flattered her work is conceptualized beyond what she intends, but when a collector shared that her work had made her feel "good" at a party, she was simply astonished. "I have dealers even tell me they like the work because it is 'Caribbean' and not grounded in the American discourse of race, ignoring that the stories that inform the work are one and the same." In sum, Báez's work is both whitewashed and "powerwashed," belying how much her beautiful, colorful, figurative work featuring Black females so indistinguishably indexes complex histories of racism.

Finally, Latin American gallerists are also implicated in the erasure of "Latinx" culture, undercutting the idea that there is more "cultural congruence" between Latinx and Latin American art. For instance, at

Frieze 2018 I was excited to see the Colombian gallery Instituto de Visión represent the work of Carmen Argote—a rare instance of a contemporary Latinx artist being exhibited by a Latin American gallery and introduced to international audiences. At the same time, the way Argote's work was described and discussed at the fair seemed miles away from the artist I met in Los Angeles. On display was a painting from her *Arrangement of Wares* series which, as the accompanying flyer described, was inspired by the compositions street vendors create when they arrange their wares to sell on the street. Yet when I remarked at this detail, the gallerist dismissed street vending as a topic of conversation, or the aesthetics involved in street vending arrangements. Instead, she limited her comments to the paintings' muted colors and beautifully abstract, almost geometric composition. I was not surprised by the formal approach to the painting. Street vending is one of the most berated and racialized aspects of popular culture in Bogotá and other parts of Latin America, as I quickly learned while doing research on shopping mall cultures in Latin America. In other words, this is not a topic that a middle-class Latin American dealer would easily remark on while marketing artworks in the context of an art fair.

As a point of contrast, I remember the ease, detail, and enthusiasm with which a dealer from London talked about the work of Mexican American artist Eduardo Sarabia exhibited as part of Maureen Pauley booth at the 2018 Independent Art Fair in New York. The piece (from his *Untitled [Jitomate]* series) was a hand-painted ceramic sculpture on top of a wooden box, the type migrants use to box agricultural products like tomatoes. This piece screamed of local histories and economies of work and labor on both sides of the border. And to my surprise, the English dealer approached the artist's background and trajectory with ease, addressing the topic of the US/Mexico border and flows of economies that informed the work without hesitation and even with curiosity. He excused himself for not knowing more about the artist while telling me he was planning to read more before the next showing of his work. This exchange reminded me of the numerous Latinx artists who shared a longing to be exhibited or represented by international and European galleries after having traveled or lived abroad. There, they felt their Latinx and American identity was more understood, legible, and accepted, and less conscripted to single narratives whenever they traveled, than in the United States. Abroad, Latinx artists felt understood as American artists, insofar as their Latinx identities were not seen as being in opposition to their American identity. I marveled at

the historical and political conditions that make European dealers and audiences more able and excited to talk about Mexican American artists than were many of the North American US-based gallerists I met.

For now, whether they feel they or their work is understood by wider audiences, all artists I spoke to experienced great joy in what some described as "infiltrating" homes and collections with their work. Patrick Martinez made this point about his neon signs, which are popular with collectors: "Some collectors may buy the work because it is beautiful or colorful, but my messages are bittersweet." Martinez's signs are inspired by the neon signage of mom-and-pop storefronts, but they are combined with protest and political language. He sees them as paintings of contemporary landscapes dealing with change and gentrification in Los Angeles, a city that like many other majority-Latinx cities is undergoing rapid change. As he put it, "I may not agree with the political views of some collectors. They may not fully get the work, but if I can get it into their homes, hopefully my work will spark a conversation." Similarly, John Rivas, a working-class first-generation-to-go-to-college Salvadoran artist from Newark, who I witnessed transitioning from his first gallery show to multiple gallery shows, art fairs, and an ivy league MFA program, was very strategic about how he was inhabiting these white spaces. "The art world is a white man's game, but I want to change the rules of the game, and how people see Latinx artists. I want to break the stigma." He adds, "They don't know what my work is about. They like the color and aesthetics, but as long as I'm speaking to my people, that's all I care about. I want to bring light to my community, because artists can shape the world and how people see things.

So What Will It Take?

At the end of the day, gallery work is advocacy work. / JOEONNA BELLORADO-SAMUELS

Right now Black artists are in, and it is just a matter of time until Latinx artists are discovered by the market. / GALLERIST AT ART BASEL

Anna Stothart, the director of Lehmann Maupin Gallery, is one of the few arts professionals I met who knows about Chicanx and Latinx artists and is openly supportive of the Latinx art movement. As a student

at Tufts, she wrote about Chicana artist Alma López and took classes with Adriana Zavala, and of late she had been hearing a lot about Latinx art and artists from Teresita Fernández, who is represented by her gallery. Branding Chicano and Latinx artists was a topic she had been obviously considering. "Markets like what's identifiable in the larger art historical narrative," she tells me. But Latinx art? Stothart continues, "It has no nationality, no geographic location, no single visual identifying characteristic. Artists take different forms and media. There's no institution that focuses on it. So where is a curator to start?" She asked this question to make the point that even if curators wanted to feature Latinx artists in their shows, they would probably not even know where to find them. She emphasized, "The problem with Latinx art is that it is not rooted in art history." With these words Stothart acknowledged the key role art history plays in branding artists and the huge price paid by those at the margins and "unrooted" from art history. At the same time, Stothart was clear about the importance of naming and using Latinx as a resource and was hopeful that "Latinx is becoming a thing." She felt the "x" was making people question it in ways that allow less taking for granted and more room for identification. Like everyone else I talked to, she had also seen artists more receptive to being positioned as such. She had even witnessed Latinx artists who had historically downplayed their background becoming more open to adopting a category that is more visible, open, and, many felt and hoped, also more marketable.

Stothart's comments about Latinxs' invisibility in art history brought me back to the reasons my colleagues at the US Latinx Art Forum have been so focused on intervening and changing the discipline. Recognition brings collectors and museum acquisitions. We have seen this for Latin American art, with the art historical canonization of many artists. Today, the recognition of Chilean Roberto Matta and Cuban Wifredo Lam as "surrealist artists" assures that it is not only their countries' wealthy who champion these artists, but also international collectors, exactly because they are recognized within rubrics that are identifiable in art historical terms. At the same time, these examples of historical assessments also point to Stothart's comments on art history's complicit role in furthering art markets and commercial recognition, suggesting that it is not scholarship but also markets, and white dominance in the arts more generally, that is advanced by calls to promote art history without change or scrutiny. Moreover, I am skeptical that becoming recognized in art historical terms is the best solution for

Latinx artists' lack of recognition and evaluation, considering the slow rate of scholarly production. When art historians are barely noticing Latinx artists, it could take years, if not decades, before scholarship translates to the larger ecosystem of symbolic and economic evaluation. Most important, it seems to me that Latinx artists supersede the terms of recognition and discussion within art history, and moreover that this is exactly why they are so powerfully compelling and exciting. Krista Thompson's discussion of African diasporic art is relevant here. She prompts us to find broader ways to understand the aesthetic practices of communities who are undocumented, underarchived, understudied, and marginalized. She calls on art historians of the African diaspora to challenge disciplinary structures that erase African diasporic practices in academia, while praising "institutional illusiveness" as an important resource for communities of color (K. Thompson 2015). In particular, she makes a compelling case for the need to go beyond recognition in art historical paradigms to fully understand African diasporic visual cultures. Instead, she expands her analysis to popular culture and to alternative visual cultures and practices of image making and media developed in video, popular culture, and other practices designed to be ephemeral, like the very act of posing for a camera. Latinx visual cultures are similarly informed by reservoirs of knowledge embedded in vernacular cultures and communities that have yet to be written about and documented in ways that would be resonant in art historical terms.

This reminds me of the lesson shared by Chicano theorist Tomás Ybarra-Frausto, at the 2019 US Latino Art Now Conference in Houston: "The real basis for an archive is chisme." As he described, it was personal stories, narratives, and observations from popular culture that were most foundational to his thinking about rascuachismo.[10] I believe that we are in a very exciting moment when similar calls for expanding how we think about art and creative culture, and what constitutes expertise and how knowledge is produced, are echoed in younger generations of scholars daring to be "undisciplined" and "intellectually promiscuous," because no single discipline or methodological approach can encompasses all of our stories and histories (Beltrán 2014).

Still, I hope to have made clear that to engage and understand Latinx art demands foregrounding issues of race and equity in the primarily white spaces that dominate the art world. As we have seen, these issues are visible in the experience of artists maneuvering markets, where race and racism remain determinant issues Latinx artists must grapple with,

whether consciously, or not, because they are always in the background and are constantly imposed on them and their work. In this way, this chapter serves as a warning that until we acknowledge and confront the type of structural issues that continue to downplay the practices of artists of color, subscribing their evaluation to art historical terms is tantamount to dooming these artists to continuing marginalization, because their legibility demands a radical transformation not only of art history and art spaces but of society at large. More important, validation within mainstream spaces is not what most contemporary artists are after. At least from my conversations with artists and creators, their demands are nothing short of revolutionary. They seek to be accepted as they are, they reject being subsumed in currents and canons, they want to exhibit and sell their work—and, more than anything, they do not want to be reduced to a single aesthetic or a stereotype; they seek to explore and work freely and widely. As such, we could follow their lead and resist the tendency to reduce Latinx art to something that can be visibly recognized or identified in ways that essentializes and narrows it as more consumable. I think challenging this impulse is necessary to fully understand Latinx art, and potentially all art at the borders of art history.

Finally, throughout this book I have argued that value in art is a cultural, social, historical, and political product. It emerges from institutions such as museums, art schools, and art criticism that support artists, creates audiences, shapes tastes, and fuels collectors. As this chapter showed, more and more the market is a central component of these processes, making it imperative that we question its premises and operations. As we saw, white artists have long enjoyed access to these spaces, and in the past decades the creation of categories for "Latin American art," "Black art," "Cuban art," and "Caribbean art," among others, have been doing the same for other artists, most of them around rubrics imagined around national and geographical lines. Yet where Latinx art is concerned, we stumble. I will never forget the comments of one of the first dealers I interviewed—that Latinx art was too ghetto, and he could not think of any acceptable art reference for it. These are the same ideas that make it unimaginable to think of Latinx art and that render Latinx artistry as an exception, not the norm. These are the same views that require backgrounds be lessened, denied, or explained away and that makes whiteness the price Latinx artists have to pay, or that is imposed on them, if they want to achieve symbolic recognition and commercial success.

At the same time, much has happened since the unfortunate comment of the first dealer and I do not want to end this chapter without considering the growing interest I witnessed among some of the dealers interviewed at the close of my research and whether it is really just matter of time until Latinx artists are discovered by the market.

Amanda Uribe, is the co-founder of Latchkey Gallery, a nomadic space that has a solid roster of emerging Black artists, one of the only dealers that at time of writing consistently showed Latinx artists in fairs in a roster of primarily Black and POC artists. As a white Latina, Uribe's Peruvian-American background was imperceptible in an industry where Latinx dealers are rare. Yet in the two years I followed her trajectory she had experienced a new sense of solidarity with overlooked Latinx artists. She stopped Anglicizing her name to accommodate those who could not pronounce the r in Uribe as a self described pushback to the invisibility of Latinx culture and welcomed the current reckoning over what makes American art. In fact, she had

increased her roster from two to six Latinx artists, the highest number of any other dealer I spoke to since the previous year I saw her at a fair. For her it is just a matter of time and inevitable that Latinx artists get the overdue attention. When we last spoke, she was planning to take John Rivas to an art fair in Latin America alongside the African American Patrick Alston. Uribe is familiar with racism in the region, but felt that it is up to those who have power to advance these artists to do so. Similarly, in the last year my Instagram has become filled with invites to Lower East Side galleries sprinkled with shows by Latinx artsits I know. It was evident that many white dealers were betting on the trend of looking at overlooked artists and positioning themselves squarely ahead of the tide betting that just as people overcame racism to buy works by African American artists, they would do the same with the works of Latinx artists. It will be interesting to see how this trend develops.

However, I hope to also have made clear why we must resist the impulse to celebrate Latinx artists becoming the "next new thing." As we saw, hype in art markets is a terrible benchmark for equity because it is a signal of how rare, extraordinary and fleeting this attention is, and oftentimes comes at the cost of distinguishing the "exceptional" from the largely disparaged majority. It should not be a fad or newsworthy that Black, Latinx and POC artists get attention and markets. However, it is very hopeful to have witnessed a greater awareness that Latinx artists must be at the center of any conversation, and for people to be more

willing to name and discuss racism in art markets. These issues necessarily came to the fore in any reckoning about their absence making me hopeful that more awareness can help usher substantive change.

One dealer once told me that people should buy art because it speaks to them and because they love it, not because of who makes it. I agreed with him but added, "People can't love what is never shown, what no one can name, or ever see." This is why, "at the end of the day, gallery work is advocacy work," and so is writing, curating, collecting, and creating.

At the Vanguard of Arts and Museum Activism in the Twenty-First Century

As I close this book, matters of money and lack of diversity in the arts are seemingly everywhere in the art news. In New York City, #DecolonizeThisPlace protests at the Whitney and Guggenheim Museums have raised questions about the composition of boards and the ethics of artwashing when monies come from the opioid crisis or the manufacturing of weapons of war. Similarly, art and museum cultural politics continue to expand more broadly toward matters of equity in creative sectors, including the demand for fair wages and matters of gentrification and displacement. Meanwhile, El Museo del Barrio's fiftieth anniversary (2019) was accompanied by the most united and public critique of the racist and classist exclusions ensuing from the institution's turn to Latin American elites and collectors. Signed by almost 600 artists, educators, students, workers, and others from all over the United States, the "Mirror Manifesto: On the Future of El Museo del Barrio and Who It Belongs To" provides an unprecedented challenge to the invisibility of the Latinx diasporic artistic community in New York City and beyond.[1] At their core, these debates expose how entrenched matters of money and white privilege remain in the con-

temporary art world, and why it is so important to foreground these issues as we struggle to shape more equitable, open, and diverse art worlds, within our "own institutions" and beyond.

In this spirit, I want to return to a topic where these issues come especially to the forefront: the politics of patronage and of purchasing and collecting art so central to the goal of diversifying all museums and institutional spaces. Throughout my writing, the lack of collectors was repeatedly mentioned as the biggest obstacle to the evaluation of Latinx artists. However, in probing deeper I learned that it was not "collectors" but, rather, "proper collectors"—or the type that make trends and make it fashionable for others to purchase Latinx art—that are most needed: for instance, collectors of the type that changed the mission and workings of El Museo del Barrio. One dealer echoed this view: "What you need for things to happen with Latinx artists is to have a few champions, a star collector, or a star curator, to trickle down in markets. It does not happen naturally. You need powerful advocates." That she felt even one powerful collector could make a difference testifies to the power of collectors in the contemporary art ecosystem. I flinched at the market logic that this recommendation normalizes, fearing that marginalized art communities would be entrapped to play a game they would join at a disadvantage and hence would be set to lose.

Thus, while this book does not discuss collectors outright, I hope to have made clear that the lack of collectors of Latinx art is a direct result of the historical lack of validating institutions that create value at universities, museums, and more. Latinx art and artists are almost entirely shut out from "the market" as it is increasingly narrowly defined around the world of galleries, auction houses, and art fairs, the primary spaces that lead artists to accrue a market history that adds economic value to their subsequent work. They are also missing from all the spaces where people regularly learn about artists and ascertain their work and their value such as museums and universities, which makes it impossible for people to know where to find them. In this context, we do need Latinx art collectors who push for Latinx art, akin to how Black and Latin American collectors built, validated and internationalized these formerly marginalized collecting categories. However, I believe that having more Latinx art collectors is only the start.

Instead, I propose a forceful questioning of the primacy of collectors. Treating them as the solution to the inequities in art markets

ignores how much markets and processes of production, circulation, and consumption are politicized and racialized in ways that limit the "choices" of any new prospective collector. It also ignores the highly segregated nature of the arts, where people of color have access to art worlds, just not necessarily those of galleries, museum shows, and art fairs that most validate artists commercially or symbolically. And I purposefully consider the two types of value simultaneously because in our current neoliberal art world, gaps between the supposedly more academic or consecrated world of museums and the market are more myth than reality. Increasingly, it is collectors who shape the conversation about scholarship and museum collecting, as we saw with Latin American art, where collectors underwrite curatorial positions, museum acquisitions, and even museums themselves.

I hope to have shown that whenever we limit our recommendations to accessing the "market" as narrowly defined around galleries and auction houses, we feed on the same system that marginalizes all artists, especially artists of color. This view constrains valorization to an exclusive sector that only few artists can access, while limiting artists' ability to make a livelihood or profit from their work, irrespective of where it is sold. As a result, arguing for diversity in art markets is a must, but not without also advocating for the types of policy changes that are needed to benefit the majority of artists, especially those who remain at the borders of the gallery system.

For instance, US tax and copyright laws contribute to artists' disenfranchisement by treating artists and collectors very differently. The United States is one of the few countries that do not recognize visual artists' royalty rights when works are resold, unlike it does for composers, writers, filmmakers, and other types of creators (Svachula 2018). To make matters worse, in 2018 the California Resale Royalty Act, the only state law that recognized artists' rights to be paid resale royalties, was struck down by a federal appeals court, hindering future legislation to address market inequities between artists and collectors (Svachula 2018). Similarly, in regard to work donated and sold at benefits, artists can deduct only the cost of the materials (which might range from nothing to a mere hundred dollars), not the full value of the work. By contrast, collectors can deduct the "market value" of the work if they donate it, or the full price paid for the work if it is purchased at a charity auction. This makes collectors the only beneficiaries of the added value from an artist's labor, or from any future value accrued by their work.[2] Collectors can also deduct donations of

artworks to museums, which is one of the key ways they help shape the content of collections and wield influence in the public sphere. Think here of the many museums built around individual collections and their taste, or the example of major collector Patricia Phelps de Cisneros's shaping narratives of Latin American art through donations to targeted museums across the world.

Attempting to solve the lack of visibility of minoritized artists through collecting also ignores the intangible issues and motivations that lead many artists to limit their contact with markets, or refuse altogether to engage with them. Here, I am not invoking the incommensurability of art and economics. This position is a value-making strategy, akin to the idea that art and identity should never mix. Both views define value as a transcendental thing that simply is, rather than as something that is created and shaped by social forces, such as those of political economy. Similar ideas are at play in the creation of supposedly race-free art markets. These ideas have historically sustained a segregated white-dominated art world, one free from scrutiny, by hindering discussions of how much questions of value are guided by the normalization of whiteness in the makeup of museum boards, tenured faculty in art history programs, gallery owners and dealers, and the collecting classes and their taste and judgments about what is valuable. These segregated networks have historically fed the evaluation of primarily white artists and of selected artists of color valorized by the same networks. This is why these "transcendental" ideas of art as being untouched by either economic or race-based concerns must be exposed and challenged: they hinder criticism and analysis.

In this manner, I suggest deeply listening and considering the reasons why people remain skeptical about markets, and the different ideas about what art means and how it functions in contemporary society, among other values than art references that are being espoused. I think of the Chicanx collectors interviewed by Karen Davalos who bemoaned commercial logics by distancing from the category of "collectors," to challenge the elitist and possessive investment connotations of the term. For these collectors, collecting is best seen as an act of reclamation and critical witness to the marginalization of Chicanx culture, an act that embodies what she calls a "poetics and politics of love and rescue" (Davalos 2017: 7). I also think of artists' continued search for alternative ways to market their work, to account for non-economic issues, such as the accessibility of their work within their communities.

Generations of Latinx artists continue to contend with noneconomic concerns regarding the circulation and exhibition of their work, even at their own financial and professional peril. As we saw, some artists even choose not to sell to collectors who stereotype their work. Others seek control of how their work is discussed and of the types of narratives summoned, either because they care about the stories they tell or because they do not want their work to be whitewashed. Latinx artists are also working collectively to advance other artists of color, maximizing invitations in galleries and museums to open up opportunities, and ultimately to diversify these spaces. Some Latinx artists work as curators, art entrepreneurs, and even as dealers in order to bring visibility to artists below the radar of professional curators. Still others challenge inequality outright, for example by protesting in front of museums to expose their board members' links to industries promoting warfare weapons, private prisons and mass incarceration, or by kicking out museums from their communities for parachuting "social practice" initiatives that promote gentrification.

I bring to mind the work of Shellyne Rodriguez, the Diasporican artist we met earlier, whose canvas of Lisa Ortega, an activist from the anti-gentrification group Take Back the Bronx, lingers unfinished as

I write. "Archive and Survive" is Shellyne's maxim for creating large scale paintings bearing witness and honoring a community that is under siege. Her paintings capture Bronx residents' looks, styles, tattoos, and their stance of endurance and fortitude in interiors of New York City prewar architecture, but these days she is putting out too many fires to get back to work, from the fight against policing of NYC subways to the endless struggle to keep landlords from displacing old-time residents like Lisa Ortega from the Bronx. The fact is that New York City would be miserable without artists like her who challenge the individualizing impulse of markets to ensure there is fairer, more diverse, and more inclusive art worlds and a more fair society. Today, as financial logics envelop art markets and collectors, artists' efforts to challenge the narrowing evaluating structures of the market are powerfully necessary because they advance values that we must be careful to protect as we promote the greater evaluation and marketability of Latinx art and artists. Only then can we ensure that their recognition in art history, art markets, and society as a whole will transform these spaces to be more open and democratic—for everyone.

This larger reference for equity is necessary because Latinx artists, art professionals, and communities are not immune to the seductions

of the market. Every day our dreams and ambitious are co-opted by capital to reproduce distinctions, hierarchies, and inequalities; to further gentrification; to reinforce white supremacy in art institutions and more. The precarity of jobs and opportunities in the art world and the polite silence that dominates art spaces hinders criticism and makes many of us complicit and structural change almost impossible. Latinx artists and artists of color are constantly pushed apart and divided from one another by the individualizing impulse of markets that tends to valorize certain artists and set artists apart from one another. Oftentimes those who conform to the status quo are often rewarded, while others struggling to open doors remain in the shadows. This is one reason that developing alternative, collaborative, and more open pathways to participating in creative economies is so necessary. In other words, our interventions have to be strategic, united, and forceful, and not limited to getting a space at the table. They must be directed at creating antiracist and equitable art worlds, not only for the sake of Latinx artists and communities but also for society at large.

Finally, I want to return to the two main goals of this book: the needs to (1) challenge the silence around matters of race in conversations of contemporary art and the market and (2) contest the view that "Latin" culture is one and the same. I already addressed how silencing discussions of race contributes to the historical devaluation of artists of color relative to white, "unnamed" artists. However, we also must consider the global ramifications of this discussion. Today the growing financialization of art and its treatment as an asset class has made the diversification of contemporary art worlds an even more challenging goal. Global collecting classes are increasingly incentivized to purchase works that have been vetted and valorized by the same exclusive networks. Hence, when we talk about the global turn to contemporary international collections, we are really talking about a turn toward buying and collecting mostly white—often North American and European—artists, or international artists who study in, reside in, or are legitimated by these very networks.

This is why I am critical of the growing boosterism around the globalization of art markets as a panacea for the Eurocentric trends and US dominance of contemporary art markets. With regard to the forces of race and nationalism that continue to shape art markets, it is evident that the "globalization" of art markets has not challenged the dominance of a few art cities (countries) and collectors, and of market logics as primary criteria for access. This is why the globalization of art

markets is not the utopian solution to inequality. On the contrary, the globalization of art markets is directly implicated in the reproduction of inequalities, making it necessary to develop more and better lenses to analyze its rubrics. One reason is that the exclusions generated within the art worlds of specific cities and nation-states are no longer reinforced by individual nations alone, but by an increasingly global and even more powerful network of international players.

Hence the need to challenge the tendency to homogenize all "Latin" artists and couple Latin American and Latinx art in global art markets. As I showed, the homogenization of the diverse artists working across the hemisphere veils the racialization of Afro-Latinx, Indigenous, and diaspora artists within the category of Latin American art. It erases Latinx artists, who, lacking what I've called "national privilege," are most dependent on the evaluation of the US art ecosystem, which has historically excluded them. Thus my point is to be vigilant about the specificities that are continually erased by the market's demand for consumable culture. With respect to the Latinx–Latin American formula, I call for a rejection of all such easy formulas and for the development of a more diverse and open understanding of Latin American art that accounts for racial minorities within this category, as well as Latinx artists, and with the same rigor.

We must ask why some categories are so compelling and more easily institutionalized and thus accepted, while others are so maligned? And what do we learn about the workings of race in contemporary art markets when we refuse to accept the currency of some categories over others? Why are the categories of "contemporary art" and "American art" the dominant reference for recognition and success? And why do these categories also remain the most white? I believe that it is urgent and necessary that we ask these questions with rigor in order to push back against the ideas that historically have been used to either build up or relegate artists across the Americas, and throughout the world.

I also want to think about the "X factor" in "Latinx," and how it can provide a powerful rejoinder to the most exclusive, essentialist, and nationalist tendencies of the contemporary art world. This book argues that recognizing Latinx art demands a generative impetus to eschew strict categories and defy narrow nationalist positioning in order to appreciate complex, multiplicitous, and transnational identities within art and society at large. Foremost, the Latinx art movement can serve as a call for anchoring the realities of racism and fully appreciating how it affects the positioning and creativity not only of

Latinx artists but also of anyone else at the margins. In particular, the X factor helps to center the experience of Latinx diasporic identities, which remain most invisible in a contemporary art world trafficking in the currency of identities and nationalities. In sum, thinking through Latinx art can help sensitize everyone about the workings of race and racism in shaping what we regard as normative and valuable in contemporary art worlds. More powerfully, Latinx art can help us to think in broader terms about what art is, how it functions, where it should live and be visible, and how it should be talked about so that it is an equitable presence in communities, in collections, in museums, and in the world. These are perennial questions that have been raised about Chicanx art, that many others now ask about Latinx art. In *Chicano and Chicana Art: A Critical Anthology*, Jennifer González and colleagues (2019) wonder if recognizing, archiving, collecting, and institutionalizing it would result in compromises of the community and critical stance advanced by the artists of the past, or in the transformation of institutional structures of museums and the market. They do not have definite answers to these questions, but they agree that openly considering these issues can lead us to imagine what might be possible if we suspend dominant hierarchies of value, of identity, and of art historical recognition. Like them, I urge readers to keep asking these questions, confident of the transformative challenge engaging with Latinx artists in their diversity and on their own terms represents to white-centric art worlds. This alone is a necessary and a worthy goal.

In the end, the key issues we tackle are not of categories—Latino/a, or Latinx, or whatever new names we summon for the diverse artists of Latin American backgrounds in the United States. What is most interesting are the politics and projects advanced, and whether they are directed to challenging racism in the arts, and in society at large. I will be very curious to learn how Latinx artists are included, archived, catalogued, and discussed in libraries, museums, and books, and more as part of all types of histories, topics, and rubrics. What new names will be summoned for these artists?—who knows? Maybe fifty years from now there will be less of a need for identity placeholders to claim a space at the table. But today, we're far from challenging entrenched racism in all domains of representation, and that makes me far less interested in names than in the types of projects they reflect and help generate. The issue is whether Latinxs will be part of the problem or agents of change, and how central we will be in shaping the new arts and museum activism of the twenty-first century.

In this regard, the lesson learned from Latinx artists and stakeholders is that embracing an imaginary white art world (where identity, race, gender, and background remain unaccounted for) is not the answer. Postracialism and color blindness have never been the best way to battle racist thinking, and this is the big lesson of most contemporary antiracist movements: that decolonizing our minds is a necessary step toward the cultural revolution involved in any antiracist movement. In this spirit, I hope this book helps illuminate the efforts of so many Latinx artists and stakeholders and the larger artistic community to stop tiptoeing around issues of race in the art world. I also hope these pages inspire readers to decolonize our minds from our classist and racist thinking that makes us believe that Latinx art and our history and communities are unworthy of recognition and visibility.

In today's "global" art landscape we must challenge the myth that identities compromise value and that they are problems to be managed, either hidden or highlighted, while only white and "unmarked" artists are vested with unqualified worth. I hope this book helps readers to debunk these ideas and to create a world where identities are recognized, but never differentially valued. Only then can we achieve more diverse art worlds and finally begin to fill in the Latinx part of the "American art" stories told in the United States, across the Americas, and throughout the world.

Noncomprehensive List of Artists Everyone Should Know

ARTIST	BORN	LOCATION
Manuel Acevedo	1964, Newark, NJ	Bronx, NY
Elia Alba	1962, Brooklyn, NY	Queens, NY
Francisco Alvarado-Juárez	1950, Tela, Honduras	New York, NY
Candida Alvarez	1955, Brooklyn, NY	Chicago, IL
Sol Aramendi	1968, Casilda Sante Fé, Argentina	Queens, NY
Francheska Alcantara	1983, Santo Domingo, DR	Bronx, NY
Angel Alvarado	1992, Los Angeles, CA	Los Angeles, CA
Carmen Argote	1981, Guadalajara, Mexico	Los Angeles, CA
Eddie Arroyo	1976, Miami, FL	Miami, FL
Isabel Avila	1979, Los Angeles, CA	Pasadena, CA

ARTIST	BORN	LOCATION
Nicole Awai	1966, Port of Spain, Trinidad and Tobago	Brooklyn, NY; Austin, TX
Judith Baca	1946, Huntington Park, CA	Los Angeles, CA
Firelei Báez	1981, Santiago de los Caballeros, DR	New York, NY
Felipe Baeza	1987, Guanajuato, Mexico	Brooklyn, NY; New Haven, CT
Roy Baizan	1996, Sunset Park, Brooklyn, NY	Bronx, NY
Diógenes Ballester	1957, Ponce, PR	New York, NY
Raul Baltazar	1972, Los Angeles, CA	Los Angeles, CA
Sabrina Barrios	1981, Santa Maria, Brazil	New York, NY
Alex Becerra	1989, Los Angeles, CA	Los Angeles, CA
Francisca Benítez	1974, Santiago, Chile	New York, NY
Leonardo Benzant	1972, Brooklyn, NY	Brooklyn, NY
Maria Berrio	1982, Bogota, Colombia	New York, NY
Chaz Bojorquez	1949, Los Angeles, CA	Los Angeles, CA
Margarita (Margo) Cabrera	1973, Monterrey, Mexico	El Paso, TX
Rocio Marie Cabrera	1992, Santo Domingo, DR	Bronx, NY
Barbara Calderón	1987, Houston, TX	New York, NY
Melissa Calderón	1974, New York, NY	Bronx, NY
Rodríguez Calero	Arecibo, PR	New Jersey

ARTIST	BORN	LOCATION
William Camargo	1989, Anaheim, CA	Los Angeles, CA
Karlos Cárcamo	1967, San Salvador, El Salvador	New York, NY
Rafael Cardenas	Jalisco, MX	Los Angeles, CA
Luis Carle	1962, San Juan, PR	New York, NY
Barbara Carrasco	1955, El Paso, TX	Los Angeles, CA
Carolyn Castaño	1971, Los Angeles, CA	Los Angeles, CA
Oscar Castillo	1945, El Paso, TX	Los Angeles, CA
Vladimir Cybil Charlier	1967, Elmhurst, Queens	New York, NY
Yanira Collado	1975, Dominican Republic	Miami, FL
Nayda Collazo-Llorens	1968, San Juan, Puerto Rico	Kalamazoo, MI
Máximo Colón	1950, Arecibo, PR	New York, NY
Stephanie Concepcion Ramirez	1984, Prince George's County, MD	Houston, TX
Giannina Coppiano Dwin	1953, Guayaquil, Ecuador	Miami, FL
William Cordova	1971, Lima, Peru	Miami, FL; New York, NY; Lima, Peru
Pepe Coronado	1965, Santo Domingo, DR	New York, NY
Adriana Corral	1983, El Paso, Texas?	Houston, Texas
Esperanza Cortés	Bogotá, Colombia	New York, NY
Beatriz Cortez	1970, San Salvador, El Salvador	San Fernando, CA

ARTIST	BORN	LOCATION
David Antonio Cruz	1974, Philadelphia, PA	Somerville, MA
Danielle de Jesus	1987, Brooklyn, NY	New Haven, CT
Sharon Lee de la Cruz	1986, Bronx, NY	New York, NY
Pablo Delano	1954, San Juan, PR	Hartford, CT
Robert "Beto" de la Rocha	1937, Wilmar, CA	Los Angeles, CA
Teresita de la Torre	1989, Guadalajara, Mexico	Los Angeles, CA
Victoria Delgadillo	San Diego, CA	Los Angeles, CA
Elizabeth Delgadillo-Merfeld	San Diego, CA	Los Angeles, CA
José Delgado Zúñiga	1988, Ventura, CA	New York, NY
Marcos Dimas	1943, Cobo Rojo, PR	New York, NY
Maria Dominguez	1950, Cataño Puerto Rico	Brooklyn, NY
Alex Donis	1964, Chicago, IL	Honolulu, HI
Francisco Donoso	1988 Quito, Ecuador	New York, NY
Morel Doucet	1990, Pilate, Haiti	Miami, FL
Patricia Encarnacion	1991, Santo Domingo, DR	Bronx, NY
Aaron Douglas Estrada	Los Angeles, CA	Los Angeles, CA
Florencia Escudero	1987, Singapore	Brooklyn, NY
rafa esparza	1981, Los Angeles, CA	Los Angeles, CA
Edgar Fabián Frías	1983, Los Angeles, CA	Los Angeles, CA
Justin Favela	1986, Las Vegas, NV	Las Vegas, NV

ARTIST	BORN	LOCATION
Christina Fernandez	1965, Los Angeles, CA	Los Angeles, CA
Teresita Fernández	1968, Miami, FL	New York, NY
Monica Flores	1996, Bronx, NY	Bronx, NY
Coco Fusco	1960, New York, NY	Gainesville, FL?
Diane Gamboa	1957, Los Angeles, CA	Los Angeles, CA
Harry Gamboa Jr.	1951, Los Angeles, CA	Los Angeles, CA
Iliana Emilia Garcia	1970, Santo Domingo, DR	Brooklyn, NY
Lillian Garcia Roig	1966, Havana, Cuba	Tallahassesse, FL
Scherezade García	1966, Santo Domingo, DR	New York, NY
Maria Gaspar	1980, Chicago, IL	Chicago, IL
Daniel Gibson	1977, Yuma, AZ	Los Angeles, CA
Roberto Gil de Montes	1950, Guadalajara, MX	Los Angeles
Ramiro Gomez	1986, San Bernadino, CA	Los Angeles, CA
Alfonso Gonzalez Jr.	1989, Los Angeles, CA	Los Angeles, CA
David Gonzalez	1957, South Bronx, NY	New York, NY
Jorge González	1981, San Juan, PR	Puerto Rico
Ken Gonzales-Day	1964, Santa Clara, CA	Los Angeles, CA
Alicia Grullón	New York, NY	Bronx, NY
Adler Guerrier	1975, Port-au-Prince, Haiti	Miami, FL
Elmer Guevara	1990, Los Angeles, CA	New York, NY
Marina Gutierrez	1954, New York, NY	Brooklyn, NY

ARTIST	BORN	LOCATION
Martine Gutierrez	1989, Berkeley, CA	Brooklyn, NY
Alejandro Guzmán	1978, Puerto Rico	New York, NY
Muriel Hasbun	1961, San Salvador, El Salvador	Washington, DC
Judithe Hernández	1948, Los Angeles, CA	Los Angeles, CA
Sebastian Hernandez	1991, Los Angeles, CA	Los Angeles, CA
Yasmin Hernández	1975, Brooklyn, NY	Moca, PR
Cristina Hernández Botero	1977, Bogotá, Colombia	New York, NY
Carmen Herrera	1951, Havana, Cuba	New York, NY
Willie F. Herrón III	1951, Los Angeles, CA	Los Angeles, CA
Lucia Hierro	Washington Heights, NY	Bronx, NY
Dulce Soledad Ibarra	1991, Chino, CA	Los Angeles, CA
Eilen Itzel Mena	1994, South Bronx, NY	Los Angeles, CA
Tlisza Jaurique	1972, Phoenix, AZ	New York, NY; Westhaven, CT
Fabiola Jean-Louis	1978, Port au Prince, Haiti	Brooklyn, NY
Leslie Jiménez	1984, New York, NY	New York, NY
Cheyenne Julien	1994, Bronx, NY	Bronx, NY
Jessica Kairé	1980, Guatemala City, Guatemala	Brooklyn, NY
Monica Kim Garza	1988, Atlanta, GA	Atlanta, GA
Jessica Lagunas	1971, Nicaragua	New York, NY

ARTIST	BORN	LOCATION
John Jota Leaños	1969, Pomona, CA	San Francisco, CA
Robert Legorreta	1952, El Paso, TX	Los Angeles, CA
Alma Leiva	1975, San Pedro Sula, Honduras	Brooklyn, NY; Miami, FL
Nery G. Lemus	1977, Los Angeles, CA	Los Angeles, CA
Shaun Leonardo	Queens, NY	Brooklyn, NY
Rejin Leys	1966, New York, NY	Brooklyn, NY
Carmen Lomas Garza	1948, Kingsville, TX	Austin, TX
Alma López	1966, Los Mochis, Mexico	Irvine, CA
Evelyn López de Guzmán	New York, NY	New York, NY
Manuel Lopez	1983, Los Angeles, CA	Los Angeles, CA
Miguel Luciano	1972, San Juan, PR	New York, NY
Roberto Lugo	1981, Philadelphia, PA	Philadelphia, PA
Estelle Maisonett	1991, Bronx, NY	Bronx, New York
Mark Malave	1997, Bronx, NY	Bronx, New York
Pepe Mar	1977, Mexico	Miami, FL
Guadalupe Maravilla	1976, San Salvador, El Salvador	New York, NY; Richmond, VA
Hiram Maristany	1945, New York, NY	New York, NY
Carlos Martiel	1989, Havana, Cuba	New York, NY
Daniel Joseph Martinez	1957, Los Angeles, CA	Los Angeles, CA
Leslie Martinez	1985, McAllen, Texas	Dallas, TX

ARTIST	BORN	LOCATION
Patrick Martinez	1980, Pasadena, CA	Los Angeles, CA
Victoria Martinez	1987, Chicago, IL	New Haven, CT
Carlos Jesús Martínez Domínguez	1974, North Carolina	New York, NY
Yvette Mayorca	1991, Silvis, IL	Chicago, IL
Glendalys Medina	1979, Ponce, Puerto Rico	New York, NY
Groana Melendez	1984, New York, NY	Bronx, NY
Harold Mendez	1977, Chicago, IL	Los Angeles, CA
Amalia Mesa-Bains	1943, Santa Clara, CA	San Juan Bautista, CA
Troy Michie	1985, El Paso, TX	Brooklyn, NY
Joiri Minaya	1990, New York, NY	Bronx, NY
Melissa Misla	1989, New York, NY	New York, NY
Star Montana	1987, Los Angeles, CA	Los Angeles, CA
Raphael Montañez Ortiz	1934, Brooklyn, NY	New Brunswick, NJ
Delilah Montoya	1955, Fort Worth, TX	Albuquerque, NM; Los Angeles, CA
Julio Cesar Morales	1966, Tijuana, Mexico	Tempe, AZ
Nicole Mouriño	1987, Miami, FL	Brooklyn, NY
Jaime Muñoz	1987, Los Angeles, CA	Pomona, CA
Eddie Negron	1987, Boston, MA	Miami, FL ; Carolina, PR
Alex Nuñez	Miami, FL	Miami, FL
Pierre Obando	Belize City, Belize	New York, NY

ARTIST	BORN	LOCATION
Ruben Ochoa	1974, Oceanside, CA	Mexico City, Mexico; San Diego, CA
Noé Olivas	San Diego, CA	Southern California
Charo Oquet	1952, Santo Domingo, DR	Miami, FL
Eamon Ore-Giron	1973, Tuscon, AZ	Los Angeles, CA
Wilfredo Ortega	New York, NY	New York, NY
Dionis Ortiz	1979, New York, NY	New York, NY
Ruben Ortiz-Torres	1964, Mexico City, MX	Los Angeles ; San Diego
Pepón Osorio	1955, San Juan, PR	New York, NY
Angelo Otero	1981, Santurce, PR	Chicago, IL; New York, NY
Francisco Palomares	Los Angeles, CA	Los Angeles, CA
Elle Pérez	1989, Bronx, NY	Bronx, NY
Lady (Sandra) Pink (Fabara)	1964, Ambato, Ecuador	New York, NY
Gala Porras-Kim	1984, Bogotá, Colombia	Los Angeles, CA
Lina Puerta	1969, Englewood, NJ	New York, NY
Ronny Quevedo	1981, Guayaquil, Ecuador	New York, NY
Vick Quezada	El Paso, TX	Western Massachusetts
Lee Quiñones	1960, Ponce, PR	New York, NY
Wanda Raimundi-Ortiz	1973, Bronx, NY	Orlando, FL
Chelsea Ramirez	Ft. Lauderdale, FL	Brooklyn, NY

ARTIST	BORN	LOCATION
Vincent Ramos	1973, Santa Monica, CA	Los Angeles, CA
Carlos Reyes	1977, Chicago, IL	New York, NY
David Rios Ferreira	1982, Bronx, NY	Queens, NY; Jersey City, NJ
John Rivas	1997, Newark, NJ	Newark, NJ
Sophie Rivera	1938, Bronx, NY	Bronx, NY
Kenny Rivero	1981, New York, NY	New York, NY
Marton Robinson	1979, San Jose, Costa Rica	San Jose, Costa Rica
Antonio Andres Rodriguez	1987, Santurce, Puerto Rico	Bronx, NY
Freddy Rodríguez	1945, Santiago de los Caballeros, DR	New York, NY
George Rodriguez	1937, Los Angeles, CA	Pico Rivera, CA
Jorge Luis Rodriguez	1944, San Juan, PR	Brooklyn, NY
Joseph Rodriguez	1951, Brooklyn, NY	New York, NY
Sandy Rodriguez	1975, National City, CA	Los Angeles, CA
Shellyne Rodriguez	1977, Bronx, NY	New York, NY
Stephanie Rodriguez	1988, New York, NY	Queens, NY
Yelaine Rodriguez	1990, Bronx, NY	Bronx, NY
Coralina Rodriguez Meyer	1982, Homestead, FL	Brooklyn, NY ; Miami, FL
Frank Romero	1940, Los Angeles, CA	Los Angeles, CA
Guadalupe Rosales	1980, Los Angeles, CA	Los Angeles, CA

ARTIST	BORN	LOCATION
Gabriela Ruiz	1991, San Fernando Valley, CA	Los Angeles, CA
Shizu Saldamando	1978, San Francisco, CA	Los Angeles, CA
Gabriela Sanchez	1988 Pasadena, CA	Los Angeles, CA
Juan Sánchez	1955, Brooklyn, NY	New York, NY
Ana Serrano	1983, Los Angeles, CA	Los Angeles, CA
Edra Soto	1971, Puerto Rico	Chicago, IL
Lisa Soto	Los Angeles, CA	West New York, NJ
Stanley Steel	1991, New York, NY	Bronx, NY
Marlene Tafoya	Los Angeles, CA	Los Angeles, CA
Michael Tafoya	Los Angeles, CA	Los Angeles, CA
Joey Terrill	1955, Los Angeles, CA	Los Angeles, CA
Nitza Tufiño	1949, Mexico City, Mexico	New York, NY
Vargas-Suarez Universal	1972, Mexico City, MX	New York, NY
Juana Valdes	1963, Cabañas, Cuba	New York, NY
Patssi Valdez	1951, Los Angeles, CA	Los Angeles, CA
Vincent Valdez	1977, San Antonio, TX	Houston, TX
Mariana Valencia	1984, Chicago, IL	Brooklyn, NY
Patricia Valencia	1971, Los Angeles, CA	Los Angeles, CA
Rodrigo Valenzuela	1982, Chile	Los Angeles, CA
Linda Vallejo	1951, Los Angeles, CA	Los Angeles, CA

ARTIST	BORN	LOCATION
Mary Valverde	1975, Queens, NY	New York, NY
Jehdy Vargas	Dominican Republic	New York, NY
Raelis Vasquez	1995, Mao Valverde, DR	NJ/NYC
Gerardo Velázquez	1958, Mexico	Los Angeles, CA
Omar Velazquez	1984, San Juan, PR	Chicago, IL
William Villalongo	1975, Hollywood, FL	Brooklyn, NY
Didier William	1983, Port-au-Prince, Haiti	Philadelphia, PA
Mario Ybarra Jr.	1972, Los Angeles, CA	Wilmington, CA
Sarah Zapata	1988, Corpus Christi, TX	New York, NY
Marcus Zilliox	1972, Phoenix AZ	New York, NY; West Haven, CT

Additional Resources

This list includes some of the museums and institutions with the most compre-hensive archives and collections on Latinx artists, as well as research centers and Instagram accounts and other digital sources where readers can learn more about Latinx artists and their work. It is not a comprehensive list. More locally, readers should reach out to Latinx-focused or culturally focused community organizations in their area, as well as libraries, universities, and nonprofit organizations, and should stay tuned about their programming.

Museums, Cultural Centers & Galleries

Archives of American Art, Smithsonian Institution, Washington, DC

BRIC, Brooklyn, New York

California Ethnic and Multicultural Archives (CEMA), UC Santa Barbara

Centro de Estudios Puertorriqueños, Hunter College, New York City

Clemente Soto Velez Cultural Center, New York City

Coronado Print Studio, New York City, Austin, TX

Cuban Research Institute, Florida International University, Miami

El Museo Latino, Omaha, NB

Guadalupe Cultural Arts Center, San Antonio, TX

Hispanic Research Center, Arizona State University, Phoenix

Institute for Latino Studies, University of Notre Dame, Notre Dame, Indiana, IL

Inter-University Program for Latino Research (IUPLR), University of Illinois at Chicago

La Plaza de Arte y Cultura, Los Angeles, CA

Latino Art Museum, Claremont, CA

Latino Museum of History, Art and Culture, Los Angeles, CA

Loisaida Center, New York City

Los Angeles County Museum of Art/Center for Art of the Americas, Los Angeles, CA

Mexic-Arte Museum, Austin, TX

El Museo del Barrio, New York City

Museo de Arte y Cultura Latinoamericana, San José, CA

Museum of Fine Arts, Houston/International Center for Art of the Americas

National Hispanic Cultural Center, Albuquerque, NM

National Museum of Mexican Art, Chicago, IL

Oolite Arts (Previously ArtCenter/South Florida), Miami, FL

Pérez Art Museum, Miami, FL

Self Help Graphics, Los Angeles, CA

Social and Public Art Resource Center, Los Angeles, CA

Vincent Price Art Museum, Monterrey Park, CA

Research Centers and Organizations

A Ver: Revisioning Art History book series. Chicano Studies Research Center, University of California, Los Angeles, CA

Center for Latino Arts and Culture, Rutgers University, New Brunswick, NJ

International Center for Art of the Americas at the Museum of Fine Arts, Houston, TX

Latino Art Now! Conference, organized by the Inter-University Program for Latino Research, headquartered at the University of Illinois at Chicago, and the Smithsonian Latino Center

National Association of Latino Arts and Culture, San Antonio, TX

Rhizomes of Mexican American Art since 1848: An Online Portal lead by co–Project Directors, Karen Mary Davalos (UMN) and Constance Cortez (University of Texas, Rio Grande Valley)

Smithsonian Latino Center, Washington, DC

The Latinx Project, New York University, New York City

US Digital Humanities Center, University of Houston, TX

US Latinx Art Forum

Instagram Archivists

@100latinxartists

@angelik.wiki

@archivotrans

@atomicculture

@atx_barrio_archive

@colectivacosmica

@gallerygurls

@hiphopphotomuseum

@ITZELALEJANDRA.gif

@latinainmuseums

@latinoswholunch

@latinxcurated

@latinx_diaspora_Archives

@mantecahtx

@map_pointz

@nepantla.usa

@nuevayorkinos

@purochingoncollective

@rockarchivola

@robincembalast

@spanishharlem_1975

@Veteranas_and_Rucas

Projects and/or Conferences Available Online

Artsy Window,
http://www.artsywindow.com/

Latinx Art Sessions, a two-day program led by South Florida's cultural arts leaders, ArtCenter/South Florida, and Pérez Art Museum Miami, *https://latinxsessions.org/*

Latinx Spaces,
https://www.latinxspaces.com/latinx-art

St. Sucia, collaborative zine project founded by Isabel Ann Castro and Natasha I. Hernandez,
https://stsucia.bigcartel.com/

LatinoUSA.org

US Latinx Arts Futures Symposium, Ford Foundation,
https://latinx-art.tumblr.com/

Podcasts

Anzaldúing it

Cabronas y Chingonas

Café con Pam

De Colored Radio

Latinos Who Lunch

Locatora Radio

Top Rank Podcast

Songmess

Radio Menea

Acknowledgments and Reader Instructions

1 A summary of the first report can be found in Schonfeld and Sweeney 2016. Dafoe and Boucher 2019 discuss a follow-up survey by the New York City Department of Cultural Affairs showing demographics of the city's arts and culture staff unchanged since the first study.

Introduction

1 For a discussion of Haitians' Afro-Latinx identity, see Legros 2018; and on the erasure of Basquiat's Latinx identity, see Guerrero 2017. Additionally, when locating Basquiat as part of Nuyorican art worlds, I am referring to a wider Nuyorican art scene that also includes the emergent New York City hip hop scene and is not limited to the traditional Nuyorican art world most associated with visual arts and poetry. On this point see Rivera (2003)

2 There are no reliable studies on Latinx artists representation in museums because Latinxs are even missing in the categories researchers use to conduct studies on issues of diversity in the arts. A recent study showing that 85.4% of artists represented in museums are white and that Hispanic/Latino make up 2.8% of artists represented provides a good example (Topaz et al. 2019). When one examines the study closely one learns the actual number of Latinx artists represented in US museums is less than 1% considering the 2.8% results were obtained from a sample of 230 artists where there were only 12 Latinx artists born in the US, the most narrow definition of Latinx and where most of the artists in the study were born in Latin America and even Spain, to the point that even Spaniard Salvador Dalí was counted as Hispanic/Latino/a. In sum, the study shows the overwhelming representation of white artists in US museum collections but does little to help us understand the fate of US Latinx artists—because the vague and inaccurate treatment of Latino/a/ Hispanic category entirely erases them as a variable of analysis.

3 See, for instance, important works on contemporary art markets, such as B. Davis 2013; Thornton 2009; D. Thompson 2010, 2015; and Graw 2010. All of these works take primarily Anglo-American and international artists as the norm and are incomplete because they do not account for racial dynamics, which are a key element of value making in contemporary art markets. Important exceptions include works focusing on African American artists, such as Cheryl Finley's interdisciplinary project "Black Market: Inside the Art World" and her online course on the art market; and works by Patricia Banks (2010, 2019). My goal is to promote more research about Latinxs and art markets, a hugely overdue subject of study that seems to be slowly getting attention. See for instance a recent master's thesis on Mexican American artists (Ledesma, 2016).

4 Matters of race and inequality have long been ubiquitous in the contemporary art world. However, in recent years these issues have received renewed urgency and attention among cultural commentators and the public at large. I point readers to scholarship by art historians and interdisciplinary scholars such as Susan Cahan (2016), Karen Mary Davalos (2017), Laura E. Pérez (2007), Kellie Jones (2017), Aruna D'Souza (2018), Mabel Wilson (2012) and Bridget Cooks, among others, for important research exposing the racist foundations that have informed the exhibition and representation of African American, Chicanx, and Latino/a artists in North American museums.

5 See, for example, the project by the UCLA Chicano Studies Research Center, "A Ver: Revisioning Art History" (2002–present). The project includes a book series that highlights the art and individual histories of Latinx artists to both document their work. See also the Latino Art Now! conference, launched as part of the Inter-University Program for Latino/a Studies in 2005. Some key Latinx art stakeholders include a younger generation of Latino/a art historians, such as the founders of the US Latinx Art Forum (founded by Adriana Zavala, Josh Franco, and Rose Salseda) as a space to challenge to the College Art Association's lack of panels and spaces devoted to Latinx art. In 2016, the US Latinx Arts Futures convening at the Ford Foundation was foundational in bringing the conversation to wider audiences. Organized by artist Teresita Fernández, the event gathered artists, curators, scholars, and other stakeholders of the art world to explore what accounts for the invisibility of Latinx art and how we can change this. Finally, Latinx artists have been foundational in these conversations by creating works and collaborations making Latinx art and matters of race and identity central to their work as I discuss in chapter 1.

6 Myers (2002) develops his insights in relation to aboriginal Australian art and the trails for becoming recognized as "contemporary art" but his major theoretical insights about the making of value for work that is devalued and racialized on account of its identity are relevant for the case at hand.

7 For a discussion of the marketing of Latino/a identities; their co-optation by corporations, government, and institutions; and their insertion into projects of whiteness, see all of my previous works, especially *Latinos Inc.* (2001) and

Latino Spin (2008). There I also discuss the consistent challenge to insert it into more civil rights and antiracist moments. See also Morales 2018 for a discussion of Latinx as a racially progressive movement.

8 Zavala made these comments in a presentation on April 6, 2019, in the "USLAF: Latinx Art Is American Art" session at the Latino Art Now! conference hosted by the University of Houston and the Inter-University Program for Latino Research, in Houston, Texas, and will develop them further in her forthcoming book.

9 This impetus led to the rise of long-standing collections and infrastructures for collecting and exhibiting African American art from the early turn of the twentieth century, especially within historical black colleges and universities and libraries. The inclusion of African American art in mainstream museums has been more contentious and mired in racist debates. For a history of African American activism to expand museums' engagement with African American arts and visual culture, see Cooks 2011, Wilson 2012, and Cahan 2016. https://blackmuseums.org/history-2/.

10 See Fox 2013; Fusco 1995; and Goldman 1995 for a discussion of the cultural policies and corporate business practices that fueled Latin American art from the Cold War era onward. See Cullen 2009 for a discussion of New York City as an example of transnational connections among Latin American artists. And see McCaughan 2012 for exchanges between Mexican and Chicano artists from the 1960s and 1970s. Looking at the 1990s literature examining the boom of Latin American art, it is uncanny how similar tensions to those I document in this book were already apparent. I also discuss these issues in Dávila 1999.

11 For the concept of aesthetic cosmopolitanism, and the role of festivals and museums in shaping it, see Delanty, Giorgi, and Sassatelli 2011; Sassatelli 2012. A key concern is the tension between imaginary and consumption-driven imaginaries of cosmopolitanism, and how they impact on issues of participation, and the creation of cultural public spheres.

12 See McRobbie 2016 and Pham 2015 among others who have analyzed the global hierarchies involved in arts and creative industries.

13 See Manthorne 2009 for art schools as contact zones; and see Levitt 2015 among other works discussing the global conditions shaping global art worlds, including the permanence of a nationalism-cosmopolitanism continuum (where nationalism is expressed and reinforced through "universal" and international references).

14 See Reinoza 2017 for a discussion of the transnational sensibilities of immigrant Latinx artists, and Herrera and Gaztambide 2017 for an analysis of Latin American and Latino/a art that centers on creating bridges with attention to matters of movement, exchange, and circulation. In this work, I add the lens of the market, class, and race to these conversations.

15 Artist Ronny Quevedo, as quoted in Adriana Zavala's presentation on April 6, 2019, in the "USLAF: Latinx Art Is American Art" session at the Latino Art Now! conference hosted by the University of Houston and the Inter-University Program for Latino Research, in Houston, Texas.

16 Ed Morales 2018 provides the best overview of Latinx as a progressive racial identity project.

17 Some of these auctions were discontinued in 2018 as part of an impetus to insert Latin American art in global art world. See chapter 3 for a larger discussion of these dynamics.

18 See Appadurai 1988 for a discussion of the importance of regimes of value and institutions for creating value. Today Latin American art is recognized as a subject of study at major universities, which has contributed to a rise in specialized Latin American scholars. Studying the output of PhD dissertations between 2002 and 2015, Adriana Zavala (2016) points to 131 dissertations on Latin American completed, versus a mere 17 dissertations on Latinx art—which, as many scholars have noted, remains generally unrecognized in both the US and the Latin American art canons.

19 For a good example of these dynamics in Peru, see Borea 2016.

20 See Dávila 2001a; Y. Ramirez 2007. See also Cahan 2016 for a larger discussion of the historical context and larger conversations around museums and representation at the height of civil rights and the age of Black Power. See also Davalos 2001 for the development of Mexican American museums in the United States.

21 Hence, Yasmin Ramirez has argued for Nuyorican artists to be seen as an arts vanguard who introduced new aesthetics, and new social contexts and ways of producing and circulating work into New York City art worlds, including Afro-Taíno, engaging with the working class, and the creation of alternative spaces for unrecognized artists. See also, e.g., Cortez 2010; González 2013; Indych-López 2018; and the entire A Ver series edited by Chon Noriega at the Chicano Research Center, which focuses on Latinx artists who are underrepresented in art scholarship. See also the new journal *Latin American and Latinx Visual Culture*, edited by Charlene Villaseñor Black and published by UC Press.

22 Here I repeat the same arguments I develop in greater detail in Dávila 2004 focusing on urban development and gentrification in El Barrio/East Harlem, and in Dávila 2012 on creative work across the Americas.

23 See Alden 2015 for discussion of Uovo, the art storage company, and its influence in transforming the role of collecting and the financialization of art markets.

24 I refer readers to my previous works, *Latinos Inc.* (2001) and *Latino Spin* (2008), where I discussed marketable Latinidad. See also C. Rodriguez 1997 (the classic study); Baez 2018.

25 Banks describes the role that the Studio Museum in Harlem played in the valorization and the creation of a market for contemporary African art. She cautions against the boosterism around the so-called boom and internationalization of African art by noting that the African art market still lags in appreciation in the contemporary auction market, and that it is African artists located in the West who tend to get more visibility in markets (Banks 2018).

Chapter 1

1 See Ybarra-Frausto 1990 for a discussion of rascuache aesthetics, the inventive art interventions based on "making do."

2 I thank curator Maria Elena Ortíz for this insight.

3 See text of the installation Pyramids 2007 reproduced in the artist's website accessed November 2, 2019. http://carmenargote.com/series/pyramids/.

4 David Antonio Cruz returned to Puerto Rico in 2017 as one of the few Latinx artists at MECA Puerto Rico. He was invited by the curator of the Mecanismos artists–led curated program after meeting him during a performance of his work in St. Croix, pointing to the currency of international connections (in this case Caribbean) over US-based ones. Cruz felt more welcomed during this visit and was hoping to return in 2018. But in this fair, there were only a couple of Latinx artists, only two Diasporican artists, Eddie Negron from Miami and Cheyenne Julien from the Bronx.

5 For a discussion of this biennial see M. Gónzalez 2013; and see Dávila 1997 for the historical context that led to the foundation of the Instituto de Cultura Puertorriqueña.

6 See González 2013. My examination of the 2015 triennial showed no Diasporican artists, only a couple of Latinx within a roster that is still largely dominated by Latin American and Caribbean artists and curators.

7 See M. Ramos 2018, which examines the omission or censorship of artists from the avant-garde in Puerto Rico, 1960–1970, including Carlos Irizarry, Domingo López de Victoria, Suzi Ferrer, Joaquin Mercado, Rafael Ferrer, and Arturo Bourassaeau, and how narrow definitions of nationalism excluded their recognition on the island. Even Raphael Montañez Ortíz, one of the most internationally renowned New York–based Puerto Rican artists, faced pushback to his work, which challenged aesthetic sensibilities on the island. This issue of nationalism and authenticity has also affected the recognition of Puerto Rican artists in art history more generally. See, for instance, Cullen's (2009) discussion about how artists such as Rafael Ferrer and Jean-Michel Basquiat who were very much involved in New York arts scenes were excluded from the exhibitions generated by the "Hispanic" arts boom in the 1980s and 1990s, because they were not recognized as Latin American due to their Caribbean roots (Basquiat) or the subject matters of their work (Ferrer).

8 This topic has received a lot of attention, but I point readers to Godreau 2015, a landmark book that reviews and examines much of the ongoing debates around race, racism, and cultural nationalism on the island.

9 See Caragol-Barreto 2013 for an overview of these early Puerto Rican organizations in New York and their curatorial vision.

10 This position is very typical of transnational artists from Latin America living in New York. See Phillips 2018 for an instructive dialogue in which Tania Bruguera and Lilliana Porter (from Cuba and Argentina, respectively), who are New York–based transnational Latin American artists, emphasize their

national identities, disavowing any Latinx or Hispanic identity despite their long-standing histories of living and working in New York.

11 The example of El Museo del Barrio comes up repeatedly throughout this book because it is the largest and oldest Latinx institution and was under most debate during my research. However, there are many other examples too. The Clemente Soto Velez, founded by Puerto Ricans and Latinxs in the Loisaida/Lower East Side, was also undergoing a heated debate around the same time that a Coalition to Save Clemente put out a press release declaring itself "Under Siege by Non Latinos Motivated by Promises of Gentrification," in protest of the subordination of Latinx over Anglo-American artists in the distribution of artists' studios and space. In San Francisco, Galeria la Raza, one of the oldest art spaces, was also in processes of eviction during my writing, having succumbed to processes of gentrification, and is now currently seeking new space. Most artists I spoke to identified similar trends in their cities, where Latinx artists (whether Chicanx, Central American, and/or US-born Latinx voices north of the border), especially community-based artists, were struggling to find exhibition venues amid threats of gentrification and in arts landscapes that favor more-established international artists and commercial ventures.

12 See Noel 2014 for the first comprehensive study of Nuyorican poetry and its key role in the Nuyorican art movement.

13 See Reyes Franco 2018 for a description of the types of cultural projects and developments geared at attracting visitors, tourists, and expats who are moving to Puerto Rico attracted by tax incentives, giveaways, and amenities for leisure, entertainment, and consumption.

Chapter 2

1 See Smithsonian Institution Task Force on Latino Issues 1994. Over twenty-five years later, this pattern of exclusion continues apace. In 2018 a study by UCLA's Chicano Research Center found that while the Smithsonian's Latinx workforce grew from 2.5 percent to 10.1 percent, this rise failed to keep pace with the growth of the Latinx population, which had doubled, to almost 18 percent of the total population, since the first report was issued. The 2018 report also found that Latinx people are still missing from executive positions. See Vera et al. 2018.

2 Important examples include *Chicano Art: Resistance and Affirmation* (1990–1993), the first major show of Chicano/a artists (organized at the Wight Art Gallery at the University of California, Los Angeles) and Taller Alma Boricua's (1989) retrospective at El Museo del Barrio, which sought to make similar arguments about Chicano art and Puerto Rican art, respectively. See also Davalos 2017.

3 See Graw 2010: 64. As she notes, this symbolic value of being talked about and written about can accrue over the short term or the long term, and can constitute a long-lasting credit to their eventual success.

4 On this development as a global trend, see McRobbie 2016.

5 The community response to El Museo del Barrio's change of mission, and its coverage by mainstream outlets like the *New York Times*, is a perfect example. The first iteration of Moynihan 2019b (using "tug of war" and loaded language) was ultimately changed, but the piece still shows ignorance and confusion about the definition of Latinxs. See also Dávila 2019.

6 See, for instance, the symposium for the show *Radical Women* at Phillips in New York, where she was asked to discuss her identity and where she acknowledged the importance of the category of "Latin American artist living in New York" to her trajectory. Poignantly, an audience member who is Argentinian probed her on the certainty of her identification after living in New York for so many years, given that the audience member herself had experienced changes after living barely three years in New York. The artist responded by doubling down on her close connections, family, and friends in Argentina (Phillips 2018).

7 See artist Adrian Piper's rebuttal letter to the ArtNews report about the status of women in the Art world (Piper 2019), chastising the publication for failing to account for their own role in contributing to the invisibility of women artists by not covering their exhibitions and their achievements and for perpetuating the status quo.

8 Key hires that have significantly shifted the conversation around Chicanx and Latinx art in major publications include Carolina Miranda and Laurie Ochoa (hired by the *Los Angeles Times*) and Max Durón (*ARTNews*). Arguably the rise of digital journalism and blogs, where there are more writers of color publishing criticism, has also had an impact, though we must acknowledge the economic vulnerability of independent writing and the differential value of blogs situated at the margins compared to the more "established" print media or art news journals.

9 Great historical overviews of the foundation of the Studio Museum and other African American culturally specific museums are provided by Susan Cahan (2016) and Mabel Wilson (2012).

10 See Gaspar de Alba 1998. See also Mesa-Bains 2016, where Amalia Mesa-Bains discusses "white airports" in relation to her conversation with Anthony Appiah. This point is a recurrent concern in colonial contexts, where elites have historically looked toward Europe and the United States rather than toward each other, and where travel and contact is dominated by a center-periphery paradigm—as is Caribbean scholarship and postcolonial thought.

11 At UCLA, for instance, there are at least five Latinx art scholars—Chon Noriega, Gaspar de Alba, Joshua Guzmán, Judy Baca, and Charlene Villaseñor Black— but most are located in Chicano Studies and other departments rather than in the art history department. Villaseñor Black is the only one of these five who is doubly appointed in art history and Chicano Studies.

12 Safiya Noble (2018) makes the same argument for the fields of technology where people from underrepresented backgrounds are rendered invisible

by arguments that blame the lack of diversity on the lack of talent, despite evidence showing the existence of tech professionals of color that remain untapped.

13 I elaborate this argument in *Latino Spin* (Dávila 2008).

14 These categories represent that state of the field during Zavala's presentation in 2016. As a result of the activism of the Latinx Art Forum, the CAA included a Latinx category in 2018. However, the organization obviously missed the distinction the group tried to make: it mistakenly filed dissertations in both Latin American and Latinx studies under the "Latinx" label. It also kept South America and Central America in the "regional" categories, reinforcing geography as the major art historical rubric.

15 Rodriguez made these remarks at a panel titled "Pre-Latinx: The Veterano Avant Gardes" held at the New School on May 9, 2018, organized by Rocío Aránda Alvarado for El Museo del Barrio.

16 The scholars and curators informing this section straddle diverse museums and institutions from culturally specific institutions, like El Museo del Barrio, or neighborhood institutions like BRIC Arts, to mainstream museums like LACMA, the Whitney, and the Smithsonian, with specific limits and challenges posed by the various sources of support (e.g., government funding, private funders, and collectors).

17 A variety of national and transnational interests and corporations have been involved in funding Latin American art exhibitions in the United States from the Cold War era onward. The intersection of national policies and museum exhibitions has also been expedited by the growing expediency of culture in the cultural policies of Latin American nations across the region from the 1990s onward. On this point see Yúdice 2004.

18 See exhibition reviews by Cascone (2018a); B. Davis (2017); and Quiles (2018), among others. The problem of representation with regard to the category of Latin American art, the range of countries represented, and the lack of Latinx artists is picked up by some of these reviews. It is notable that when the *Radical Women* show came to New York, it was supplemented by the addition to Nuyorican artists such as Marta Moreno Vega, the Afro-Cuban filmmaker Sara Gomez, and Chicana artist Judith Hernandez, who was in other Getty exhibitions but not in *Radical Women*.

19 On this point, see T. Flores 2019 for a discussion of the whitewashing of the category of Latin American art, evidenced in most of the PST exhibitions, which excluded entire regions like Central America and the Andes.

20 Cecilia Fajardo-Hill, remarks made at Frieze Symposium on Latin American/ Latino Art, NYU Institute of Fine Arts, May 12, 2017, https://frieze.com/media /part-2-frieze-symposium-latin-americanlatino-art.

21 There was ample debate about the actual number of Latinas in the show. Publicly I heard estimates that ranged from zero to as few as eight, estimates which signal the burden of representing underrepresented groups in mainstream museums, which become so easily reduced to matter of number. I list

eleven as listed from the catalogue, although some like Ana Mendieta were counted as Cuban and not Latina. It is important to note that a few Latinx artists, especially Nuyorican Marta Moreno Vega were added when the show traveled to New York.

22 See Flores and Stephens 2016 for a larger discussion of the interventions of the exhibition *Relational Undercurrents* in regard to Caribbean artists' marginal position in Latin American art, and how Eurocentrism has shaped Latin American art criticism. See also Miranda 2018 for a review of the exhibition emphasizing the threads that make the exhibition such a great redefinition of the Caribbean.

23 See also Ramirez 2019 for a discussion of Jack Agüeros's tenure at El Museo. Ramirez shows that Agüeros opened the institution to Latin American art without challenging its focus on Puerto Rican art and culture and community work, contrasting that move with the institution's shift (starting in 1996) toward more market-driven efforts, which continue to be at the heart of debates over the institution's mission.

24 See Nilda Peraza's presentation on April 5 on the Cayman/MoCHA Recovery Project at the Latino Art Now! conference hosted by University of Houston and the Inter-University Program for Latino Research, in Houston, Texas.

25 For instance, Amalia Mesa-Bains was part of the Decade Show (1980), organized by MoCHA along with the New Museum and the Studio Museum. Additionally, her installation *Grotto of the Virgins* appeared in 1987 at INTAR Latin American Art Gallery, another New York City cultural space founded in 1966.

26 I discuss some of these clashes over class in Culture Works (Dávila 2012). See also E. Morales 2013. For the poetry series using a racial slur see Gonzalez 2009.

27 See Moynahan 2019 and Weber 2019 for El Museo's failed plan to honor Princess Gloria von Thurn und Taxis in its fiftieth-anniversary gala, where I was quoted as one of the sources who agreed to hold them publicly accountable by talking to the press.

28 "Latinx Art is American Art" panel was organized by Rocío Aranda Alvarado for El Museo del Barrio and held at the New School on April 11, 2018. Panel "Our Curated Scene: DIY Publishing, Zines & Archives" was organized by Barbara Calderón for The Latinx Project, on October 8, 2019.

29 See Y. Ramirez 1999. Ramirez organized/curated *Pressing the Point: Parallel Expressions in the Graphic Arts of the Chicano and Puerto Rican Movements* at El Museo del Barrio; authored the institution's historical timeline; and contributed a large part of the archival documentation on Latino art for the Museum of Fine Arts Houston's digital archive on Latin American and Latino art (see http://icaadocs.mfah.org/icaadocs/).

30 The exhibition was divided into three more nimble and affordable citywide and site-specific collaborations with colleagues at El Museo del Barrio in East Harlem and the Loisaida Center on the Lower East Side. Curators of these shows include Rocío Alvarado for El Museo and Wilson Valentín for Loisaida Center.

31 See Naiomy Guerrero's website, https://www.naiomyguerrero.com/english.

32 See the ArtsyWindow website, https://artsywindow.weebly.com/about
.html.

Chapter 3

1 See the ProjectosLA website, http://www.proyectosla.com/index.php/the
-project.

2 These comments were voiced during the Art Basel Conversation on LA/LA
Institutional Collaborations. And see Halperin 2012 for her observations of
the Los Angeles initiative impact on the market.

3 See also Graw 2009, which also identifies this trend as part of the marketiza-
tion of art evaluation.

4 See also American Alliance of Museums 2018, which found that in 2017,
46 percent of museum boards were all white.

5 See M. Ramirez 1992. On the dominance of abstraction, see the debate mod-
erated by Pérez-Barreiro (2014).

6 See the debate "Economía de la Amistad, Chévere?," posted on June 10, 2015,
by the Cisneros Collection, http://www.coleccioncisneros.org/es/editorial
/debate/economia-de-la-amistad-chevere.

7 See Angotti 2017 and Dinzey-Flores 2013. I also explore this when discussing
shopping malls' role in furthering enclave urbanism throughout the region;
see Dávila 2016.

8 The *La cartografia y otras narrativas abiertas* exhibition, held in Proa 21's Gale-
ria Acéfala 21, in La Boca Buenos Aires featuring Coni Castagnet, Juan Gug-
ger, Andrés Lima, and Nacho Unrrein. I visited it on January 7, 2019.

9 "Becoming a Young Collector" and "Collecting Latin American Art" were
held at New York's Americas Society in October and November 2016. See
https://www.as-coa.org/watchlisten/video-becoming-young-collector.

10 See Valentin 2011 for a discussion of the "Columbusing effect" in response to
and critique of the "discovery" of Buena Vista Social Club in the 1990s.

11 See, for instance, Cuba Art Tours, https://www.cubartours.com/.

12 The sales of these Roche paintings took place at Phillips 20th-Century Con-
temporary Art Day Sales on November 12, 2013, and March 8, 2013.

13 On this trend see Levitt 2015.

14 See the Proxyco Gallery website, https://www.proxycogallery.com/about/.

Chapter 4

1 See Creative Independent, n.d.; Sutton 2018a. The Creative Independent
study is not representative for racial diversity or the fate of Black and Latinx
artists, but it indexes racism by documenting that respondents who identi-

fied as Asian and Middle Eastern had a median income of $10,000–20,000 less than white artists.

2 See Davalos's (2017, 2019) insightful reappraisal of the work of the Goez Art Studios and Gallery in Los Angeles, a commercial endeavor that was central to the empowerment and education of Chicano artist and youth. Davalos highlights the different tactics employed by the various groups involved in the Chicano movement, which also included those seeking economic autonomy and those seeking opportunities for the employment of artists.

3 For a classic discussion of the gatekeeping institutions creating value and prices and the social networks that feed into value, see Velthuis 2005.

4 See Mitali and Ingram 2018. Their research on the "art of fame" showing the preeminent role of social networks and contacts focuses on European abstract artists at the turn of the century, though it is arguably even more applicable today, given the importance of social media in the branding of artists and the role Instagram plays in distinguishing artists with "the right presence." See also Lesser 2019, a discussion of the Mitali and Ingram study.

5 I refer readers to Taina Caragol's dissertation (Caragol-Barreto 2013). As she notes, the network of alternative institutions focusing on Latin American and Latino/a art and trying to establish art markets for Latinx and Latin American artists in New York City spans the 1970s. Not surprisingly, the boom for Latin American art did not result in a similar level of collector support for and attention to Latinx art. See also chapter 3 in this work.

6 One feature that raised a lot of debates at the time of writing was a *New York Times* photographic piece on Latinx artist and their process, which failed to feature any Afro-Latinx artists (see De León, 2019).

7 See, for example, Davalos 2017 for a discussion of Chicano artists' attitudes toward the market during the Chicano art movement.

8 See Sokol 2018 for an interview in which Lee Quiñones describes the hard times he faced after galleries turned away from graffiti art and credits Martin Wong for his vision to support and collect graffiti art.

9 See Huang 2014 for a discussion of Ramiro's exchange with George Lipsitz and Chon Noriega, both of whom were early supporters of his work. See also coverage of George Lipsitz's discussion of Ramiro's work in *Huffington Post* (Long Chavez 2012), which piqued the interest of gallerist Charlie James.

10 See the People's Cultural Plan for Working Artists and Communities in New York City, May 18, 2017, https://docs.wixstatic.com/ugd/8c7daf_c9c9a291aed 945788a2d862fa1d68634.pdf.

11 On the rise and use of neoliberal culture- and arts-based strategies and their effects on gentrification in communities of color see, e.g., Dávila 2012; Londoño 2019; Rodriguez 2019.

12 See, for instance, the classic exhibition *The Decade Show: Frameworks of Identity in the 1980s*, a collaborative exhibition by the New Museum, the Studio Museum, and the Museum of Hispanic Art in 1990. Important exposés of

the cultural production of this moment are included in J. González 2008 and Fusco 1995.

13 Classic studies on this topic are Marcus and Myers 1995; Rosaldo 1993.

14 This is how people talked about her work. Notice, too, how her gallery highlights Chile and her history there as primary reference and influence to her work. See the Cecilia Vicuña biography at the Lehmann Maupin website, accessed October 23, 2019, https://www.lehmannmaupin.com/artists/cecilia -vicuna/biography.

15 See an interview with Max Durón and a review of his career in M. Durón 2018.

Chapter 5

1 For more discussion on the whitewashing of Gonzalez-Torres in contemporary art, see Cerejido 2017 and the panel titled "Felix González-Torres, a Latinx Case Study" at the Pérez Museum's Latinx Art Sessions (https:// latinxsessions.org/program-information/) on January 24–25, 2019, especially the presentation by Joshua Takano Chambers-Letson, drawn from his 2018 book, which provides a textured analysis of how his work was nonetheless "charged with queerness and the sense of brown" (2018: 116).

2 See Transcript of interview between artist Teresita Fernández, Darren Walker from the Ford Foundation, and host Charlotte Burns in In Other Words, where the artist discusses her own experiences of being whitewashed and her identity erased throughout her career, similarly to her friend artist Félix González-Torres, who she knew as a "a brown man with a thick accent," very different than the way he is known today. In Other Words. November 1. https://www .artagencypartners.com/transcript-69-darren-walker-and-teresita-fernandez/.

3 A recent example of the illegibility of Afro-Latinx artists within dominant definitions of Blackness is the landmark *Among Others: Blackness at MoMA* (2019), addressing the museum's historical disregard of Black artists. While featuring well-known Latin American artists such as Wifredo Lam and Alvaro Barrios, and even white Latin Americans such as Hélio Oticica, the volume fails to mention the few Afro-Latinx artists that are represented in MoMA's collections such as Juan Sánchez or María Magdalena Campos-Pons (English and Barat 2019). In this regard, Afro-Latinx artists are also the forefront of current reconceptualization of Blackness within Art History. On this point, see Williams 2019.

4 See the press release for *Freddy Rodríguez: Five Decades of Geometry* by Hutchinson Modern for Frieze New York, May 1–5, 2019. https://frieze.com /fair-programme/freddy-rodriguez.

5 See Legros 2018 for a great analysis of Haiti's Afro-Latinx identity.

6 The online link to the article shows more varied images and representations, contextualizing Lizbeth Ortiz's *Looking Up*, among some of the other art-

works featured. The selection of this image for the print newspaper arts front page, however, focuses on the more commoditized elements of Latinx art, not to mention that describing this talent pool as "sprawling" in the headline also casts doubts on its value (Glentzer 2019). In particular, this image ties neatly into Houston's Frida Festival, one of the city's growing tourist draws, which attracts Frida lookalikes from all over Houston and beyond.

7 See Alma López's website (http://almalopez.com/ORnews/0104011c.html) and Alba and López 2011 for an in-depth analysis of all the different factors that came to bear in this debate.

8 Zavala's presentation during the "Latinx Art Is American Art" panel organized by Rocio Aranda-Alvarado for El Museo del Barrio at the New School, April 11, 2018, https://www.youtube.com/watch?v=51fTJE8_EJo.

9 In fact, a previous show by artsit Teresita Fernández was also titled "As Above, So Below" (Mass MOCA 2014), a connection that was surprisingly missing from Argote's curatorial contextualization and speaks to the general lack of knowledge about Latinx artists to put their work and practices in conversation. See https://www.newmuseum.org/exhibitions/view/carmen-argote-as-above-so-below.

10 Tomás Ybarra-Frausto in conversation with Roberto Tejada on April 5, 2019, at the plenary session of the Latino Art Now! conference hosted by University of Houston and the Inter-University Program for Latino Research, in Houston, Texas.

Conclusion

1 See "Mirror Manifesto," El Museo del Barrio. April 1, 2019. https://elmuseode losbarrios.home.blog/; the website also contains links to major articles and a series of blogs with quotes describing supporters' reasons for signing the statement.

2 See Woodham 2019 on the different tax treatments under US law at play for artists and collectors.

REFERENCES

Adam, Georgina. 2018. *Dark Side of the Boom: The Excesses of the Art Market in the 21st Century.* London: Lund Humphreys.

Alba, Alicia Gaspar de, and A. López. 2011. *Our Lady of Controversy: Alma Lopez's "Irreverent Apparition."* Austin: University of Texas Press.

Alba, Elia. 2014. "Uncaged: Coco Fusco and Planet of the Apes." *Art 21 Magazine,* June–August. http://magazine.art21.org/2014/08/05/uncaged-coco-fusco -and-planet-of-the-apes/#.XJ-ljBNKi8W.

Alden, William. 2015. "Art for Money's Sake." *New York Times,* February 3.

American Alliance of Museums. 2018. *Facing Change: Insights from the American Alliance of Museums' Diversity, Equity, Accessibility, and Inclusion Working Group.* Arlington, VA: American Alliance of Museums. https://www.aam-us .org/wp-content/uploads/2018/04/AAM-DEAI-Working-Group-Full-Report -2018.pdf.

Anderson, Maria. 2017. "A Lesson in 'Rasquachismo' Art: Chicano Aesthetics and the 'Sensibilities of the Barrio.'" *Smithsonian Insider,* January 31. http://insider.si.edu/2017/01/lesson-rasquachismo-chicano-asthetics-taste -underdog/.

Andrew W. Mellon Foundation. 2015. "Art Museum Staff Demographic Survey."

Angotti, Tom, ed. 2017. *Urban Latin America: Inequalities and Neoliberal Reforms.* Lanham, MD: Rowman and Littlefield.

Anspon, Catherine D. 2016. "A Powerhouse Texas Artist Examines America through the Ku Klux Klan—and the Results Are Beyond Haunting." *Paper City,* September 9.

Appadurai, Arjun. 1988. *The Social Life of Things: Commodities in Cultural Perspective.* Cambridge: Cambridge University Press.

Aranda-Alvarado, Rocío. 2019. Panel discussion comments. "USLAF: Latinx Art Is American Art." Presentation at US Latino Art Now Conference, April 6, University of Houston.

Artnet News. 2017. "Price Check! Here's What Sold—and for How Much—at Art Basel Miami Beach." *Artnet News,* December 11. https://news.artnet.com /market/sales-report-art-basel-miami-beach-1173902.

Association of African American Museums. History. https://blackmuseums.org
/history-2/.

Baez, Jillian. 2018. *In Search of Belonging: Latinas, Media, Citizenship*. Urbana:
University of Illinois Press.

Balfour, Frederik. 2018. "Billionaire's Secrets on How to Make a Bundle in Art."
Bloomberg, May 7.

Bandelj, Nina, and Frederick F. Wherry. 2011. *The Cultural Wealth of Nations*.
Stanford, CA: Stanford University Press.

Banks, Patricia A. 2010. *Represent: Art and Identity among the Black Upper-Middle
Class*. New York: Routledge.

Banks, Patricia A. 2018. "The Rise of Africa in the Contemporary Auction Mar-
ket: Myth or Reality?" *Poetics* 71 (December): 7–17

Banks, Patricia A. 2019a. "Black Artists and the Racial Diversification of Elite
Taste Culture." Unpublished ms.

Banks, Patricia. 2019b. *Diversity and Philanthropy at African American Museums:
Black Renaissance*. New York: Routledge.

Banks, Patricia A. 2019c. *Race, Ethnicity, and Consumption: A Sociological View*.
New York: Routledge.

Becker, N., S. Englander, J. Harrel, C. J. Chueca, P. Juschka, C. Stout, and
J. Waynberg. 2018. "Beyond Price and Prejudice: Ideas about the Future of
Art." Panel held at Lichtundfire, New York, NY, in conjunction with Art
Haps, May 30. Moderator: C. Stout.

Beltrán, Cristina. 2014. "Imagining Latina/o Studies" (Plenary Panel on the
State of the Field). First International Latina/o Studies Initiative Confer-
ence, July 17, Chicago.

Borea, Giuliana. 2016. "Fueling Museums and Art Fairs in Peru's Capital: The
Work of the Market and Multi-scale Assemblages." *World Art* 6 (2): 315–337.

Borea, Giuliana. 2017. *Arte y antropología: Estudios, encuentros y nuevos horizon-
tes*. Fondo Editorial de la PUCP.

Boucher, Brian. 2017. "How One Art Fair Is Getting Argentinian Artists into the
World's Best Museum Collections." *Artnet News*, June 5. https://news.artnet
.com/market/arteba-fair-argentinian-artists-museum-purchases-980087.

Bourdieu, Pierre. 1993. *The Field of Cultural Production*. New York: Columbia
University Press.

Cahan, Susan. 2016. *Mounting Frustration: The Art Museum in the Age of Black
Power*. Durham, NC: Duke University Press.

Caragol-Barreto, Taína. 2013. "Boom and Dust, The Rise of Latin American and
Latino Art in New York Exhibition Spaces and the Auction House Market."
PhD diss., City University of New York.

Cascone, Sarah. 2018a. "For Its Turn at the Brooklyn Museum, 'Radical Women'
Got a Makeover." *Artnet News*, May 11. https://news.artnet.com/exhibitions
/radical-women-brooklyn-museum-1268165.

Cascone, Sarah. 2018b. "Kerry James Marshall Says He's Done Making Public
Art After One Too Many Institutions Tried to Cash In on His Work." *Artnet*

News, November 7. https://news.artnet.com/market/kerry-james-marshall
-done-making-public-art-1389655.

Cerejido, Elizabeth. 2017. "Acts of Contestation: ASCO, Félix Gonzalez-Torres,
and a Dialectical Approach to Latino Art History." PowerPoint presentation,
October 6, for Teaching and Writing the Art Histories of Latin American
Los Angeles, organized by the Art Historians of Southern California and the
Getty Research Institute, Museum Lecture Hall, Getty Center, Los Angeles.

Chambers-Letson, Joshua Takano. 2018. *After the Party: A Manifesto for Queer of
Color Life*. New York: New York University Press.

Chavoya, C. Ondine. 2019. "Part VI: Institutional Frameworks and Critical
Reception." In *Chicano and Chicana Art: A Critical Anthology*, edited by Jen-
nifer A. González, C. Ondine Chavoya, Chon Noriega, and Terezita Romo,
413–416. Durham, NC: Duke University Press.

Cohen-Aponte, Ananda. 2018. "Latinx Artists Are Highlighted for the First Time in
a Group Show at the Whitney." *Hyperallergic*, August 28. https://hyperallergic
.com/456710/pacha-llaqta-wasichay-indigenous-space-whitney-museum/.

Cooks, Bridget R. 2011. *Exhibiting Blackness: African Americans and the American
Art Museum*. Amherst: University of Massachusetts Press.

Coronil, Fernando. 1996. "Beyond Occidentalism: Toward Nonimperial Geohis-
torical Categories." *Cultural Anthropology* 11(1): 51–87.

Cortez, Constance. 2010. *Carmen Lomas Garza*. A Ver: Revisioning Art History,
Vol. 5. Los Angeles: Chicano Research Center, UCLA.

Cotter, Holland. 2018a. "Finding Common Ground at El Museo del Barrio."
New York Times, September 27. https://www.nytimes.com/2018/09/27/arts
/design/el-museo-del-barrio-liliana-porter-review.html.

Cotter, Holland. 2018b. "He Spoke Out during the AIDS Crisis. See Why His Art
Still Matters." *New York Times*, July 12. https://www.nytimes.com/2018/07
/12/arts/design/david-wojnarowicz-review-whitney-museum.html.

Creative Independent. N.d. "A Study on the Financial State of Visual Artists
Today." The Creative Independent, accessed October 23, 2019. thecre-
ativeindependent.com/artist-survey/.

Cullen, Deborah. 2009. "Nexus New York: Latin/American Artists in the Modern
Metropolis. An Introduction, 1900–1942." In *Nexus New York: Latin/American
Artists in the Modern Metropolis*, 10–47. New Haven, CT: Yale University Press.

Cullen, Deborah. 2012. *Rafael Ferrer*. A Ver. Los Angeles: Chicano Research
Center, UCLA.

Dafoe, Taylor, and Brian Boucher. 2019. "New York City Told Its Museums to
Diversify or Lose Funding. Here's How They Plan to Address the Problem."
August 6. https://news.artnet.com/art-world/new-york-museum-diversity
-plans-1615537.

Davalos, Karen Mary. 2001. *Exhibiting Mestizaje: Mexican (American) Museums
in the Diaspora*. Albuquerque: University of New Mexico Press.

Davalos, Karen Mary. 2007. "A Poetics of Love and Rescue in the Collection of
Chicano/a Art." *Latino Studies* 5: 76–103.

Davalos, Karen Mary. 2017. *Chicana/o Remix: Art and Errata since the Sixties*. New York: New York University Press.

Davalos, Karen Mary. 2019. "All Roads Lead to L.A." In *Chicano and Chicana Art: A Critical Anthology*, edited by Jennifer A. González, C. Ondine Chavoya, Chon Noriega, and Terezita Romo, 444–454. Durham, NC: Duke University Press.

Dávila, Arlene. 1997. *Sponsored Identities: Cultural Politics in Puerto Rico*. Philadelphia: Temple University Press.

Dávila, Arlene. 1999. "Latinizing Culture: Art, Museums and the Politics of U.S. Multicultural Encompassment." *Cultural Anthropology* 14 (2): 1–23.

Dávila, Arlene. 2001a. "Culture in the Battlefront: From Nationalist to Pan-Latino Projects." In *Mambo Montage: The Latinization of New York*, edited by Dávila and Agustín Laó-Montes. New York: Columbia University Press.

Dávila, Arlene. 2001b. *Latinos Inc.: Marketing and the Making of a People*. Berkeley: University of California Press.

Dávila, Arlene. 2004. *Barrio Dreams: Puerto Ricans Latinos and the Neoliberal City*. Berkeley: University of California Press.

Dávila, Arlene. 2008. *Latino Spin*. New York: New York University Press.

Dávila, Arlene. 2012. *Culture Works: Space, Value, and Mobility across the Neoliberal Americas*. New York: New York University Press.
Dávila, Arlene. 2016. *El Mall: The Spatial and Class Politics of Shopping Malls in Latin America*. Berkeley: University of California Press.
Dávila, Arlene (@arlenedavila1). 2019. "So the new @nytimes piece removed the racist language of 'tug of war over its mission' & mentions letter, But why don't they just hire more Latinx writers who know how to write about our community in the first place instead of having to repair faux pas like these? Just saying." Twitter, March 29, 2019, 4:06 p.m. https://twitter.com/arlenedavila1/status/1111721239708606464.

Davis, Ben. 2013. *9.5 Theses on Art and Class*. Chicago: Haymarket Books.

Davis, Ben. 2017. "*Radical Women* at the Hammer Museum Is the Kind of Show That Art Critics Live For." *Artnet News*, September 20. https://news.artnet.com/exhibitions/radical-women-hammer-museum-latin-american-art-1086554.

Davis, Sophie R. 2014. "Latino Art: More Questions to Answer." *Art News Paper*, May 10. http://ec2-79-125-124-178.eu-west-1.compute.amazonaws.com/articles/Latino-art-more-questions-to-answer/32595.

Delanty, Gerard, Liana Giorgi, and Monica Sassatelli. 2011. *Festivals and the Cultural Public Sphere*. London: Routledge.

De León, Concepción, with Photographs by Natalia Mantini. 2019. Latinx Artists Explain Their Process. *New York Times*, June 15. https://www.nytimes.com/2019/06/15/style/latinx-artists-designers-new-york-los-angeles.html.

Diaz, Ella M. 2017. "Flying under the Radar with the Royal Chicano Air Force: Mapping a Chicano/a Art History." Austin: University of Texas Press.

Diaz, Ella M. 2018. "Recovering and Rethinking Chicano Art in the Twenty-First Century." *Art Journal* (Summer): 108–112.

Dinzey-Flores, Zaire. 2013. *Locked In, Locked Out: Gated Communities in a Puerto Rican City*. Philadelpia: University of Pennsyvania Press.

D'Souza, Aruna. 2018. *Whitewalling: Art, Race and Social Protest in 3 Acts*. New York: Badlands Unlimited.

Durón, Armando. 2018. "Parallax Views: Analyzing PST LA/LA without the Pom Poms." Paper presented at the CAA annual meeting, February 22, Los Angeles.

Durón, Maximiliano. 2018. "The Artist America Built: Daniel Joseph Martinez Visits Other Places and Other Histories in His Ongoing Critique of These United States." *Artnews*, December 11. http://www.artnews.com/2018/12/11 /artist-america-built-daniel-joseph-martinez-visits-places-histories-ongoing -critique-united-states/.

El Museo de los Barrios. 2019. "Mirror Manifesto: On the Future of El Museo del Barrio and Who It Belongs To." El Museo de los Barrios, November 2, 8:33 p.m. https://elmuseodelosbarrios.home.blog/.

Erigha, Maryann. 2019. *The Hollywood Jim Crow: The Racial Politics of the Movie Industry*. New York: New York University Press.

English, Darby. 2010. *How to See a Work of Art in Total Darkness*. Cambridge, MA: MIT Press.

English, Darby, and Charlotte Barat. 2019. *Among Others: Blackness at MoMA*. New York: The Museum of Modern Art.

Finley, Cheryl. 2019. "Black Market: Inside the Art World" (interdisciplinary project and online course). Cornell University Art History Department, https://arthistory.cornell.edu/cheryl-finley.

Finley, Michael. 2014. *The Value of Art: Money, Power and Beauty*. Munich: Prestel.

Flores, Juan. 2008. *The Diaspora Strikes Back: Caribeño Tales of Learning and Turning*. New York: Routledge.

Flores, Tatiana. 2019. "Disturbing Categories, Remapping Knowledge." In *The Routledge Companion to African-American Art*, edited by Eddie Chambers, 134–143. London: Routledge.

Flores, Tatiana, and Michelle Stephens. 2016. "Contemporary Art of the Hispanophone Caribbean Islands in an Archipelagic Framework." *Small Axe* 3 (51): 80–99.

Fox, Claire F. 2013. *Making Art Panamerican: Cultural Policy and the Cold War*. Minneapolis: University of Minnesota Press.

Freeman, Nate. 2018. "Black Artists Shatter Multiple Records in $392.3 Million Sotheby's Sale." Artsy, May 17. https://www.artsy.net/article/artsy-editorial -black-artists-shatter-multiple-records-3923-million-sothebys-sale.

Fuentes, Elvis. 2006. "Félix González-Torres in Puerto Rico: An Image to Construct." Art Nexus. https://www.academia.edu/8354947/FELIX_GONZALEZ -TORRES_IN_PUERTO_RICO_AN_IMAGE_TO_RECONSTRUC.

Fusco, Coco. 1988. "Hispanic Artists and Other Slurs." *Village Voice*, August 9, 6–7.

Fusco, Coco. 1995. *English Is Broken Here: Notes on Cultural Fusion in the Americas*. New York: New Press.

Fusco, Coco. 2015. "Why Debt? Why Now?" The Artist as Debtor, February 7. http://artanddebt.org/coco-fusco-an-introduction-to-art-and-debt/.

Garcia, J. E., and Ilan Stavans. 2014. *Thirteen Ways of Looking at Latino Art*. Durham, NC: Duke University Press.

Gaspar de Alba, Alicia. 1998. *Chicano Art Inside/Outside the Master's House*. Austin: University of Texas Press.

Getty Museum. 2019. "Getty Museum Acquires Photographs by Laura Aguilar." September 26. http://news.getty.edu/getty-museum-acquires-photographs -by-laura-aguilar.htm.

Glentzer, Molly. 2019. "*Latino Art Now!* Shines Light on a Sprawling Talent Pool." *Houston Chronicle*, March 4. https://www.houstonchronicle.com /entertainment/arts-theater/article/Latino-Art-Now-shines-light-on-a -sprawling-13660971.php#photo-17017944.

Godreau, Isar. 2015. *Scripts of Blackness: Race, Cultural Nationalism, and U.S. Colonialism in Puerto Rico*. Urbana: University of Illinois Press.

Goldman, Shifra. 1995. *Dimensions of the Americas: Art and Social Change in Latin America and the United States*. Chicago: University of Chicago Press.

González, David. 2009. "Poetry Series Spurs Debate on the Use of an Old Slur Against Latinos." *New York Times*, November 20. https://www.nytimes.com /2009/11/21/nyregion/21poets.html.

González, Jennifer. 2008. *Subject of Display: Reframing Race in Contemporary Installation Art*. Cambridge, MA: MIT Press.

González, Jennifer A. 2013. *Pepón Osorio*. A Ver: Revisioning Art History, Vol. 9. Los Angeles: UCLA.

González, Jennifer A., C. Ondine Chavoya, Chon Noriega, and Terezita Romo, eds. 2019. *Chicano and Chicana Art: A Critical Anthology*. Durham, NC: Duke University Press.

González, María del Mar. 2013. "The Politics of Display: Identity and the State at the San Juan Print Biennial, 1970–1981." PhD diss., University of Illinois at Urbana-Champaign.

Gonzalez, Rita. 2003. "The Said and the Unsaid: Lourdes Portillo Tracks Down Ghosts in Señorita Extraviada." *Aztlan: A Journal of Chicano Studies* 2: 235–240.

Graw, Isabelle. 2009. *High Price: Art between the Market and Celebrity Culture*. New York: Sternberg Press.

Guerrero, Marcela. 2018. "Conceptual Blueprints: Artistic Approaches to Indigenous Architecture." Whitney Museum, accessed October 23, 2019. https://whitney.org/Essays/Pacha-Llaqta-Wasichay.

Guerrero, Naiomy. 2016. "Most Artists and Art Critics Are White. Meet the Newest Voice Attempting to Make Diversity in Art a Reality." Her-Agenda.com, August 3. http://heragenda.com/most-artists-art-critics -are-white-meet-the-newest-voice-attempting-to-make-diversity-in-art-a -reality/.

Guerrero, Naiomy. 2017. "America's Most Expensive Artist Is Latinx—but No One Knows It." Artsy, June 16. https://www.artsy.net/article/artsy-editorial-americas-expensive-artist-latinx-one.

Guerrero, Naiomy. 2019. "Q&A with Latinx Art Sessions Organizer Naiomy Guerrero." https://latinxsessions.org/2019/01/02/qa-with-latinx-art-sessions-organizer-naiomy-guerrero/.

Halperin, Julia. 2012. "'It's Like Someone Turned a Tap On': How Pacific Standard Time Transformed the Market for California Minimalism." blouin-artinfo.com, May 2.

Halperin, Julia. 2018. "The Baltimore Museum Sold Art to Acquire Work by Underrepresented Artists." Artnet News, June 26. https://news.artnet.com/art-world/baltimore-deaccessioning-proceeds-1309481.

Halperin, Julia, and Charlotte Burns. 2018a. "Yes, Basquiat Is an Art-Market Superstar. But the Work of Other African American Artists Remains Vastly Undervalued." Artnet News, September 20. https://news.artnet.com/market/african-american-art-market-data-1350998.

Halperin, Julia, and Charlotte Burns. 2018b. "African American Artists Are More Visible Than Ever. So Why Are Museums Giving Them Short Shrift?" Artnet News, April 20. https://news.artnet.com/market/african-american-research-museums-1350362.

Halperin, Julia, and Eileen Kinsella. 2017. "The 'Winner Takes All' Art Market: 25 Artists Account for Nearly 50% of All Contemporary Auction Sales." Artnet News, September 20. news.artnet.com/market/25-artists-account-nearly-50-percent-postwar-contemporary-auction-sales-1077026.

Harper, Phil. 2015. Abstractionist Aesthetics: Artistic Form and Social Critique in African American Art. New York: NYU Press.

Herrera, Olga, and María C. Gaztambide. 2017. "En Diálogo: Latin American and Latino Art." Diálogo 20 (1): 3–9.

Huang, Josie. 2014. "LA Artist Brings Immigrant Labor into Focus." 89.3 KPCC, Southern California Public Radio, January 21. www.scpr.org/blogs/multiamerican/2014/01/21/15640/Ramiro-Gomez-Los-Angeles-immigrant-labor-UCLA-immi/.

Indych-López, Anna. 2018. Judith F. Baca. Los Angeles; UCLA Chicano Studies Research Center Press; Minneapolis: University of Minnesota Press.

Johnson, Ken. 2010. "They're Chicanos and Artists. But Is Their Art Chicano?" New York Times, April 9.

Jones, Kellie. 2017. South of Pico: African American Artists in Los Angeles in the 1960s and 1970s. Durham, NC: Duke University Press.

Kazakina, Katya. 2018. "Black Art Spurs Gold Rush as Collectors Stampede Drives Up Prices." Chicago Tribune, April 18. http://www.chicagotribune.com/business/ct-biz-black-art-collectors-prices-20180418-story.html.

Kendi, Ibram X. 2019. How to be an Antiracist. New York: One World.

Kennicott, Philip. 2013. "Alex Rivera, Philip Kennicott Debate Washington Post Review of 'Our America.'" Washington Post, November 1.

Ledesma, Diana. 2016. "After the Chicano Rights Movement. Mapping the Art Market for Contemporary Mexican American Artists." Master's thesis, Department of Art and Art Professions, New York University.

Legros, Ayanna. 2018. "As a Haitian-American Woman, I Know I'm Afro-Latina but It's Time for You to Acknowledge It, Too." Fierce Mitu, June 5. https:// fierce.wearemitu.com/identities/why-i-haitian-woman-identify-as-afro -latina-and-my-sisters-should-too/.

Lesser, Casey. 2019. "Study Finds Artists Become Famous through Their Friends, Not the Originality of Their Work." Artsy, February 27. https:// www.artsy.net/article/artsy-editorial-artists-famous-friends-originality -work.

Levitt, Peggy. 2015. *Artifacts and Allegiances: How Museums Put the Nation and the World on Display*. Berkeley: University of California Press.

Lipsitz, George. 1998. *The Possessive Investment in Whiteness: How White People Profit from Identity Politics*. Philadelphia: Temple University Press.

Londoño, Johana. 2019. *Abstract Barrios: The Crises of Latinx Visibility in US Cities*. Durham, NC: Duke University Press.

Long Chavez, Andrea. 2012. "Ramiro Gomez, Public Artist Affirms the 'Human Statement' of Hollywood Hills' Gardeners, Housekeepers." *Huffington Post*, February 29. https://www.huffingtonpost.com/2012/02/29/gardeners -housekeepers-an_n_1310384.html.

López, Alma. 2001 "Alma Lopez Our Lady Digital Art." Alma Lopez. http:// almalopez.com/ORnews/0104011c.html.

Lowe, Charlotte. 1995. "'Panchos' Show Worth the Drive." *Tucson Citizen*, September 14.

Manthorne, Katherine. 2009. "Art School as Contact Zone: Latin American Artists and Their Teachers." In *Nexus New York: Latin/American Artists in the Modern Metropolis*, edited by Deborah Cullen, 48–63. New Haven, CT: Yale University Press.

Marcus, G., and Fred Myers. 1995. *The Traffic in Culture: Refiguring Art and Anthropology*. Berkeley: University of California Press.

Martin, Mary-Anne. 2009. Oral history interview by James McElhinney, July 8–22, at Mary-Anne Martin/Fine Art. New York, NY. Archives of American Art.

McCaughan, Edward. 2012. *Art and Social Movements: Cultural Politics in Mexico and Aztlán*. Durham, NC: Duke University Press.

McRobbie, Angela. 2016. *Be Creative: Making a Living in the New Culture Indus-tries*. Cambridge, UK: Polity.

Méndez Berry, Elizabeth. 2018. "Why Cultural Critics of Color Matter." *Hyperal-lergic*, May 3. https://hyperallergic.com/437068/why-cultural-critics-of -color-matter/.

Méndez Berry, Elizabeth, and Chi-hui Yang. 2019. "The Dominance of the White Male Critics." *New York Times*, July 5. https://www.nytimes.com /2019/07/05/opinion/we-need-more-critics-of-color.html.

Mesa-Bains, Amalia. 2016. Panel discussion comments. U.S. Latinx Arts Futures Panel, Ford Foundation, September 16. New York City. https://latinx-art .tumblr.com/.

Messinger, Kate. 2016. "Meet the Unofficial Leader of L.A.'s Underground Art Scene." *PaperMag*, August 10. http://www.papermag.com/meet-the -unofficial-leader-of-las-underground-art-scene-1967198052.html.

Miranda, Carolina A. 2015. "What Finally Broke the 'No Chicanos' Rule at the Re-emerging Museum of Latin American Art." *Los Angeles Times*, October 12.

Miranda, Carolina. 2018. "Beyond the Island Paradise: A Show That Looks at What Binds Art and Ideas in the Polyglot Caribbean." *Los Angeles Times*, February 22. http://www.latimes.com/entertainment/arts/miranda/la-et -cam-relational-undercurrents-molaa-20180222-htmlstory.html.

Miranda, Carolina. 2019. "Targeted in El Paso, Vilified by Trump: Why the La-tino Culture Gap Is Dangerous." *Los Angeles Times*, August 15. https://www .latimes.com/entertainment-arts/story/2019-08-15/el-paso-mass-shooting -trump-vilified-latinos-culture-vacuum.

Mitali, Banerjee, and Paul L. Ingram. 2018. "Fame as an Illusion of Creativity: Evidence from the Pioneers of Abstract Art (August 1, 2018)." HEC Paris Research Paper No. SPE-2018-1305; Columbia Business School Research Paper No. 18-74. http://dx.doi.org/10.2139/ssrn.3258318.

Morales, Ed. 2013. "El Museo del Barrio's Outgoing Director Sues the Museum for Employment Discrimination." *ABC News*, February 22.

Morales, Ed. 2018. *Latinx: The New Force in American Politics and Culture*. London: Verso.

Moran, Bianca M. 2019. "An Archaeology of Radicality: Victoria Santa Cruz and the Search for Afro-Latina Artists in Radical Women." Contemporary Art—Caribbean and South America, Black Portraiture[s] V: Memory and the Archive Past. Present. Future. New York University, NY, October 17.

Mosquera, Gerardo. 2017. "Collecting Art in a Global World (and Other Predica-ments)." *Art Nexus* 105: 54–57.

Moynihan, Colin. 2019a. "El Museo del Barrio Drops Plans to Honor German Socialite." *New York Times*, January 10. https://www.nytimes.com/2019/01 /10/arts/design/el-museo-del-barrio-princess-gloria-von-thurn-und-taxis .html?fbclid=IwAR0H_3fZGiRxsK45oqJRPMKjdwJt0BfERAqBYeaV40JAQ Ns1xKNAfYohKr8.

Moynihan, Colin. 2019b. "With Plans for New Hire, El Museo del Barrio Reaches Out to Its Critics." *New York Times*, March 28. https://www .nytimes.com/2019/03/28/arts/with-plans-for-new-hire-el-museo -del-barrio-reaches-out-to-critics.html?fbclid=IwAR25gz74712REO _bDS1tRoN9ToCZIICwPJf7gm3f_R-cv3jxfZooBxmY2cM.

Myers, Fred. 2002. *Painting Culture: The Making of an Aboriginal High Art*. Durham, NC: Duke University Press.

Nelson, Steven @snelsonus. 2019a. "Some of us have been writing about these artists for decades. It's the mainstream art establishment that ignored

them. Discovered After 70, Black Artists Find Success, Too, Has Its Price."
11:34 a.m. Mar 25, 2019. Tweet.

Nelson, Steven @snelsonus. 2019b. "With the @nytimes extolling Gilliam's
"discovery" in NYC, we see the deleterious effects of the lack of diversity
among the newspaper's ranks. 2/." 12:22 pm. July 30, 2019. Tweet.

Nieves, Marysol. 2011. *Taking AIM! The Business of Being an Artist Today*. New
York: Fordham University Press.

Noble, Safiya. 2018. *Algorithms of Oppression: How Search Engines Reinforce Rac-
ism*. New York: NYU Press.

Nochlin, Linda. 1995. "From 1971: Why Have There Been No Great Women Art-
ists?" *ARTNews*, May 30.

Noel, Urayoan. 2014. *In Visible Movement: Nuyorican Poetry from the Sixties to
Slam*. Iowa City: University of Iowa Press.

People's Cultural Plan. 2017. "The People's Cultural Plan for Working Artists and
Communities in New York City." People's Cultural Plan, May 18. https://docs
.wixstatic.com/ugd/8c7daf_c9c9a291aed945788a2d862fa1d68634.pdf.

Pérez, Laura E. 2007. *Chicana Art: The Politics of Spiritual and Aesthetic Altarities*.
Durham, NC: Duke University Press.

Pérez Barreiro, Gabriel. 2014. "Is Abstraction the New Muralism?" Cisneros
Collection Debates, May 18. http://www.coleccioncisneros.org/editorial
/debate/abstraction-new-muralism.

Pérez Diez, Gustavo. 2017. "Mariela Scafati brilla con luz propia en Art
Basel Miami Beach 2017." *Arte Informado*, December 11. https://www
.arteinformado.com/magazine/n/mariela-scafati-brilla-con-luz-propia-en
-art-basel-miami-beach-2017-5761.

Pham, Minh-Ha T. 2015. *Asians Wear Clothes on the Internet: Race, Gender, and
the Work of Personal Style Blogging*. Durham, NC: Duke University Press.

Pham, Minh-Ha T. 2019. "China through the Looking Glass: Race, Property, and
the Possessive Investment in White Feelings." In *Fashion and Beauty in the
Time of Asia*, edited by Heijin Sharon Lee, Christina Moon, and Thuy Linh
Tu. New York: NYU Press.

Phillips. 2018. "Art Matters, Part 3: Radical Women in Latin American Art."
Conversation with Curator Carmen Hermo and artists Liliana Porter and
Tania Burguera, May 8. https://www.phillips.com/article/34977578/in-case
-you-missed-it-art-matters%20Inbox%20x.

Piper Adrian. 2019. "Artist Adrian Piper Responds to Our Special 'Women's
Place in the Art World' Report." September 26. *Artnet News*. https://news
.artnet.com/opinion/womens-place-in-the-art-world-artist-adrian-piper
-responds-to-our-special-report-1661554#.XY3jVFCMpWc.twitter.

Pogrebin, Robin. 2017. "It's a Diverse City, but Most Big Museum Boards Are
Strikingly White." *New York Times*, August 22.

Pogrebin, Robin. 2018. "Museums Turn Their Focus to U.S. Artists of Latin
Descent." *New York Times*, April 24. https://www.nytimes.com/2018/04/24
/arts/latinx-museums-artists.html.

Ponce de León, Carolina. 2001. "Interview with Susana Bautista." LatinArt.com, April 26. http://www.latinart.com/aiview.cfm?id=45.

Quiles, Daniel. 2018. "*Radical Women: Latin American Art, 1960–1985*" (review). *Artforum* 56 (5): 206.

Ramírez, Mari Carmen. 1992. "Beyond 'The Fantastic': Framing Identity in U.S. Exhibitions of Latin American Art." *Latin American Art* 51 (4): 60–68.

Ramírez, Mari Carmen. 2016. Presentation at US Latinx Arts Futures Symposium, Ford Foundation, September 16. New York City. https://latinx-art.tumblr.com/.

Ramirez, Yasmin. 1999. "Parallel Lives Striking Differences: Notes on Chicano and Puerto Rican Graphic Arts of the 1970s." In *Pressing the Point: Parallel Expressions in the Graphic Arts of the Chicano and Puerto Rican Movement*, 10–13. New York: El Museo del Barrio.

Ramirez, Yasmin. 2005. "Nuyorican Visionary: Jorge Soto and the Evolution of an Afro-Taino Aesthetic at Taller Boricua." *Centro: Journal of the Center for Puerto Rican Studies* 18 (2): 22–41.

Ramirez, Yasmin. 2007. "The Activist Legacy of Puerto Rican Artists in New York and the Art Heritage of Puerto Rico." ICAA Documents Project Working Papers, No. 1, Houston Museum of Fine Arts, September.

Ramirez, Yasmin. 2019. "The Museo That Jack Built." In *The Jack Agüeros Reader*, edited by M. Agüeros and C. Remeseira. New York: Columbia University Press.

Ramos, Carmen E. 2014. *Our America: The Latino History in American Art*. Washington, DC: Smithsonian Museum of American Art.

Ramos, C., A. Zavala, M. Guerrero, M. Luciano, and L. Hierro. 2018. "Latinx Art Is American Art." Panel at El Museo del Barrio and the New School, April 11. https://www.youtube.com/watch?v=51fTJE8_EJo.

Ramos, Melissa. 2018. "Omission or Censorship: A Review of the Artistic Avant-Garde in Puerto Rico, 1960–1970." Madrid: Universidad Complutense. PhD diss., in progress.

Rivera, Raquel. 2003. *New York Ricans from the Hip Hop Zone*. New York: Palgrave.

Reinoza, Tatiana. 2017. "Immigrant Invisibility and the Post-9/11 border in Sandra Fernandez's Coming of Age." *Alter-Nativas* 7: 1–24.

Reyburn, Scott. 2018. "Small Dealerships Struggle to Survive in the Age of Mega-Galleries." *New York Times*, March 22. https://www.nytimes.com/2018/03/22/arts/small-galleries-art-market.html.

Reyes Franco, Marina. 2018. "Atlas San Juan: Tropical Depression." *Art in America*, October 1. https://www.artinamericamagazine.com/news-features/magazines/atlas-san-juan-tropical-depression/?fbclid=IwAR3v_CABVrK7893rmgcVeVoc-_OQbb4gb4Hi25FMc4gldiD3r7QnPG26_bE.

Rodriguez, Clara. 1997. *Latin Looks: Images of Latinos and Latinas in U.S. Media*. Boulder, CO: Westview Press.

Rodriguez, Shellyne. 2019. "How the Bronx Was Branded." *New Inquiry*, January 29. http://www.shellynerodriguez.com/library/2019/1/29/how-the-bronx-was-branded-the-new-inquiry.

Rodney, Seph. 2018. "The Value of Art Criticism." *Hyperallergic*, November 7. https://hyperallergic.com/469988/the-value-of-art-criticism/.

Rosa, Jonathan. 2018. "(Dis)Possessing Race and Language: Inequity and Ingenuity in the Learning of Latinidad." Paper delivered at Latin American Studies Association Congress, May 25, Barcelona, Spain.

Rosaldo, Renato. 1993. *Culture and Truth: The Remaking of Social Analysis*. Boston: Beacon.

Russell, James S. 2011. "The Art Basel Effect." *Art in America*, December 5. https://www.artinamericamagazine.com/news-features/magazines/the-art-basel-effect/.

Salam, Maya. 2018. "Brooklyn Museum Defends Its Hiring of a White Curator of African Art." *New York Times*, April 6. https://www.nytimes.com/2018/04/06/arts/brooklyn-museum-african-arts.html.

Salseda, Rose G. Panel discussion comments. US Latinx Arts Futures Panel, Ford Foundation, September 16. New York City. https://latinx-art.tumblr.com/.

Sassatelli, Monica. 2012. "Festivals, Museums, Exhibitions: Aesthetic Cosmopolitanism in the Public Sphere." In *Routledge Handbook of Cosmopolitan Studies*, edited by Gerard Delanty, 233–243. London: Routledge.

Sayej, Nandja. 2018. "'We Are Building a Bridge': The Exhibition Shining a Light on Latinx Artists." *Guardian*, July 16. https://www.theguardian.com/artanddesign/2018/jul/16/whitney-museum-ny-exhibition-latinx-artists.

Schonfeld, Roger C., and Liam Sweeney. 2016. "Diversity in the New York City Department of Cultural Affairs Community." Ithaka S+R Research Report. January 28. https://sr.ithaka.org/publications/diversity-in-the-new-york-city-department-of-cultural-affairs-community/.

Sheets, Hilarie. 2019. "Discovered after 70, Black Artists Find Success, Too, Has Its Price." *New York Times*, March 23. https://www.nytimes.com/2019/03/23/arts/design/black-artists-older-success.html.

Sims, Lowery Stokes, and Ana Elena Mallet. 2017. "Introduction: The U.S.-Mexico Border in the Creative Imaginary." In *The US-Mexico Border: Place, Imagination, and Possibility*. Los Angles: The Craft and Folk Art Museum.

Smithsonian Institution Task Force on Latino Issues. 1994. *Willful Neglect: The Smithsonian Institution and US Latinos*. Washington, DC: Smithsonian Institution.

Sokol, Brett. 2018. "Lee Quiñones Brings Street Art to His Living Room." *New York Times*, July 10. https://www.nytimes.com/2018/07/10/arts/design/show-us-your-wall-lee-quinones.html.

Steinhauer, Jillian. 2018. "Pacha, Llaqta, Wasichay." *New York Times*, September 13. https://www.nytimes.com/2018/09/13/arts/design/what-to-see-in-new-york-art-galleries-this-week.html.

Sussman, Anna L. 2017. "Why Old Women Have Replaced Young Men as the Art World's Darlings." *Artsy*, June 19. https://www.artsy.net/article/artsy-editorial-women-replaced-young-men-art-worlds-darlings.

Sutton, Benjamin. 2018a. "Artists Support Themselves through Freelance Work and Don't Find Galleries Especially Helpful, New Study Says." *Hyperallergic*, June 14. https://hyperallergic.com/447056/economics-visual-artist -study-creative-independent/.

Sutton, Benjamin. 2018b. "How Graffiti Artists Are Fighting Back against Brands That Steal Their Work." Artsy, August 3. https://www.artsy.net /article/artsy-editorial-graffiti-artists-fighting-brands-steal-work.

Svachula, Amanda. 2018. "California Tried to Give Artists a Cut. But the Judges Said No." *New York Times*, July 11. https://www.nytimes.com/2018/07/11 /arts/design/art-royalties-ruling-california-circuit-court.html.

Tibol, Raquel. 1993. "La Exposicion Chicana en El Mam (2)." *Proceso*, November 29.

Thornton, Sarah. 2009. *Seven Days in the Art World*. New York: W. W. Norton.

Thompson, Don. 2010. *The $12 Million Stuffed Shark: The Curious Economics of Contemporary Art*. New York: St. Martin's Griffin.

Thompson, Don. 2015. *The Supermodel and the Brillo Box: Back Stories and Peculiar Economics from the World of Contemporary Art*. New York: St. Martin's Griffin Press.

Thompson, Krista. 2015. *Shine: The Visual Economy of Light in African Diasporic Aesthetic Practice*. Durham, NC: Duke University Press.

Topaz C. M., B. Klingenberg, D. Turek, B. Heggeseth, P. E. Harris, J. C. Blackwood et al. 2019. Diversity of Artists in Major U.S. Museums. PLoS ONE 14(3): e0212852. https://doi.org/10.1371/journal.pone.0212852.

Traba, Marta. 1994. *Art of Latin America*, 1900–1980. Washington, DC: Inter-American Development Bank.

Valentin, Wilson. 2011. "Bodega Surrealism: The Emergence of Latin@ Activists in New York City, 1976–Present." PhD diss., Ann Arbor: University of Michigan.

Velthuis, Olav. 2005. *Talking Prices: Symbolic Meaning of Prices on the Market of Contemporary Art*. Princeton, NJ: Princeton University Press.

Vera, Daisy, Chon Noriega, Sonja Diaz, and Matt Barreto. 2018. *Invisible No More: An Evaluation of the Smithsonian Institute and Latino Representation*. Los Angeles: UCLA Chicano Research Center.

Villaseñor Black, Charlene. 2017. "Decolonizing Art History: Institutional Challenges and the Histories of Latinx and Latin American Art." Speech, October 6, Getty Center, Los Angeles.

Viveros-Fauné, Christian. 2018. "Art Basel in Miami Beach Has Become Latin American Art's El Dorado." *Art Newspaper*, December 6. https://www .theartnewspaper.com/comment/art-basel-in-miami-beach-has-become -latin-american-art-s-el-dorado.

Wagley, Catherine. 2018. "Good-Bye to All That: Boyle Heights, Hotbed of Gentrification Protests, Sees Galleries Depart." *ARTNews*, June 6. http://www .artnews.com/2018/06/08/good-bye-boyle-heights-hotbed-gentrification -protests-sees-galleries-depart/.

Wallace, Michelle. 2004. "Why Are There No Great Black Artists? The Problem of Visuality in African American Culture." In *Dark Designs and Visual Culture*, 184–194. Durham, NC: Duke University Press.

Weber, Jasmine. 2018. "Texas Museum Deliberates How to Display a Mural about Hate Crimes against Latinos." *Hyperallergic*, July 27. https://hyperallergic.com/453314/vincent-valdez-the-city-blanton-museum/.

Weber, J. 2019. "El Museo del Barrio Rescinds Philanthropy Award for Rightwing German Princess." *Hyperallergic*, January 9. https://hyperallergic.com/479280/el-museo-del-barrio-rescinds-philanthropy-award-for-rightwing-german-princess/?fbclid=IwAR1kBmYDN5RhuDFbpABbZxlfs_2QgTlvpWlkgd6r8y7tvB_Qek7kKkrJ6vo.

Werbner, Pnina. 2012. "Anthropology and the New Ethical Cosmopolitanism." In *Routledge Handbook of Cosmopolitan Studies*, edited by Gerard Delanty, 153–165. London: Routledge.

Weschler, Lawrence. 2009. *True to Life: Twenty-Five Years of Conversations with David Hockney*. Berkeley: University of California Press.

Weschler, Lawrence. 2015. "Ramiro Gomez's Domestic Disturbances." *New York Times Magazine*, August 14. https://www.nytimes.com/2015/08/16/magazine/ramiro-gomezs-domestic-disturbances.html.

Weschler, Lawrence. 2016. *Domestic Scenes: The Art of Ramiro Gomez*. New York: Abrams Books.

Williams, Lyneise. 2019. *Latin Blackness in Parisian Visual Culture, 1852–1932*. New York: Bloomsbury.

Wilson, Mabel O. 2012. *Negro Building: Black Americans in the World of Fairs and Museums*. Berkeley: University of California Press

Woodaman, Ranald (@ranaldw). "En serio, this article made everybody groan. And yet we'll take acknowledgement, faulty as it is. Así está la cosa." April 30. 6:32 p.m. Tweet.

Woodham, Doug. 2019. "Artists Who Donate Work to Benefit Auctions Get Little More Than Good Karma." Artsy, February 18. https://www.artsy.net/article/artsy-editorial-artists-donate-work-benefit-auctions-good-karma.

Ybarra-Frausto, Tomás. 1990. "Rasquchismo: A Chicano Sensibility." In *Chicano Art: Resistance and Affirmation, 1965–1985*, edited by Richard Griswold del Castillo, Teresa McKenna, and Yvonne Yarbro-Bejarano. Los Angeles: Wight Art Gallery and UCLA.

Ybarra-Frausto, Tomás. 2019. Conversation with Roberto Tejada at plenary session of US Latino Art Now Conference, April 5, University of Houston.

Yúdice, George. 2004. *The Expediency of Culture: Uses of Culture in the Global Era*. Durham, NC: Duke University Press.

Zara, Janelle. 2018. "Why Have There Been No Great Black Dealers." *New York Times*, June 20. https://www.nytimes.com/2018/06/20/t-magazine/black-art-dealers.html.

Zavala, Adriana. 2010. *Becoming Modern, Becoming Tradition: Women, Gender, and Representation in Mexican Art*. University Park: Penn State University Press.

Zavala, Adriana. 2015. "Latin@ Art at the Intersection." *Aztlan: A Journal of Chicano Studies* 40 (1): 125–140.

Zavala, Adriana. 2016. Panel discussion comments. US Latinx Arts Futures Panel, Ford Foundation, September 16. New York City. https://latinx-art.tumblr.com/.

Zavala Adriana. 2019. Panel discussion comments. USLAF: Latinx Art Is American Art. US Latino Art Now, Houston, Texas." April 6, University of Houston.

Zavala, Adriana. Forthcoming. "Unsettling Brown and Black: Decolonial Latinx Aesthetics."

Zelizer, Viviana. 2010. *Economic Lives: How Culture Shapes the Economy*. Princeton, NJ: Princeton University Press.

INDEX

Bold page numbers refer to images.

relationship to galleries, 106–7; role in art world, 14, 101, 106–7, 163, 165; staff, 23–24, 45, 48–49, 52, 60–62, 71–72, 75–76; whiteness of, 18, 20–21, 25, 153, 193n2, 198n4. *See also individual museums*

museum studies, 52

nationalism, 40, 65, 148, 195n13; role in art world, 8, 10, 19, 20, 173–74; role in hierarchies of value, 79–103, 197n7

national privilege, 9, 15–16, 26, 55, 129, 174

Negrón, Jesús "Bubu," 37, 42, 44

Nelson, Steven, 90

neoliberalism: effects on the arts, 37, 40, 52, 101–2, 123, 137, 170; ethnicity within, 5

New Art Dealers Alliance (NADA), 42, 97

New Museum of Contemporary Art, 69, 157; *Carmen Argote: As Above, So Below*, 151; *The Decade Show: Frameworks of Identity in the 1980s*, 131, 201n25

New York City Public Design Commission, 131

New York Times, 56, 199n5; Black art, coverage of, 90, 109; *Down These Mean Streets*, review of, 55; Latinx art, coverage of, 53, 199n6; *Magazine*, 119, 146; *Pacha, Llaqta, Wasichay*, review of, 54; *Phantom Sightings*, review of, 51; *¡Presente!*, review of, 74

New York University: Institute of Fine Arts, 65; King Juan Carlos Center: *Visionary Aponte: Art and Black Freedom*, 126–27; The Latinx Project, 73

Nigeria: Abuja, 12

Noble, Safiya, 200n12

Nochlin, Linda, 13

(non)economics of art, 17–18

nonprofits, 14, 40, 106, 116, 123, 136

Noriega, Chon, 118, 196n21, 200n11

North America, 60, 129, 162; art institutions, 20, 37, 49–50, 98, 194n4; artists from, 2, 82, 106, 173. *See also individual countries*

Nuyorican artists, 1, 6, 35–45, 59, 73–74, 149; exhibitions by, 113–14, 201n21; identity and, 25, 193n1; inclusion in Latin American art markets, 67–68, 200n18; resisting Eurocentrism, 12. *See also* Afro-Boricua artists; Diasporican artists; Puerto Rican artists

Nuyorican Art Movement, 12, 14, 40

OK Harris Gallery, 69

1-54 Contemporary African Art Fair, 11

Ore-Giron, Eamon, 137

Ortega, Wilfredo, 113, 128

Ortiz, Lizbeth: *Looking Up*, 201n6

Ortíz, María Elena, 23–24

Ortiz Torres, Rubén, 61

Ossei-Mensah, Larry, 121, 134, 158–59; *Selections*, 123

Otero, Angel, 37, 66, 119, 141

Otero, Walter, 96

Pacific Standard Time: LA/LA (PST), 8, 26–28, 31–32, 34, 105, 157; emerging artists in, 135; Latin American/Latinx artists' relationship, 63, 65–67, 80–81, 200n19

Patron Gallery, 110

People's Cultural Plan for Working Artists and Communities, 120

Pepe Coronado Studio, 135–36

Peraza, Nilda, 39, 69

Pérez, Elle, 45

Pérez Art Museum Miami, 23, 77, 138, 160; Diversifying Art Museum Leadership Initiative, 76

Peru, 82, 100, 116; Lima, 11, 79, 85

Pham, Minh-Ha T., 61–62, 126

PhD programs, 52–53, 61, 196n18

Phelps de Cisneros, Patricia, 83, 88, 171

Phillips (auction house), 10, 87, 95–96, 199n6

photography, 13, 44, 46, 70, 75, 114, 132; photography exhibitions, 34, 55–56, 66–67, 155

Pietri, Pedro, 38

Pindell, Howardena, 90

CPSIA information can be obtained
at www.ICGtesting.com
Printed in the USA
BVHW011251270121
598897BV00013B/95